Hearts *and* Bones

First published by Unicorn,
an imprint of the Unicorn Publishing Group LLP, 2018
101 Wardour Street
London
W1F OUG
www.unicornpublishing.org

ISBN 978-1-911604-21-1

Photographs are available for exhibition, purchase, and licensing.
tom@tomchambersphoto.com

First Edition October 2018

Printed by Latitude Press Ltd

Cover Image: *Prom Gown #3*

• • •

Hearts *and* Bones

A Retrospective of Tom Chambers' Photomontage Art

Introduction by Elizabeth Avedon

UNICORN

Unicorn Publishing Group, London

Contents

• • •

Introduction

"I invent nothing.
I imagine everything."

— Brassai

Introduction by Elizabeth Avedon

Tom Chambers is a visionary artist, a mystical storyteller. When I was first introduced to his work over a decade ago, I was immediately drawn into his masterful world of staged surrealism, combining ideas and images, the mystery of which only he seemed to have the key to unlock.

Inspired by the Mexican photographers Manuel Bravo and his student Graciela Iturbide, Chambers amalgamates his sense of Bravo conveying the unexpected and ironic, and Iturbide's stark black and white images depicting the relationship between man and nature. His thinking and artwork were also influenced by writers such as Isabel Allende, Gabriel García Márquez, Carlos Fuentes, and Cormac McCarthy, all of whom used "magic realism" in their literature.

Magic realism, the genre referring to magical elements or illogical scenarios appearing in an otherwise realistic or even "normal" setting, has had an important influence throughout all of Chambers' work. He strives to create a final image in which all the elements seem true and believable, but contain one component that creates the likelihood of improbability. In each of his photomontages he has said he intentionally includes at least one facet that might seem a bit incongruous. This allows the viewer space to muse over possibilities.

I see myself as a photographer who is not limited to capturing a moment in time, as do most traditional photographers who create beautiful images. I am a photographer who illustrates stories and dreams by combining images. The end result is that I create photomontages.

Chambers is not the first photographer to have broken barriers creating photomontage works. Camera artists have used a variety of darkroom techniques since the nineteenth century to achieve pictorial images. Earliest examples of combination printing began with Hippolyte Bayard's 1840 *Self Portrait as a Drowned Man*, followed in

1857 by Oscar Gustave Rejlander's seamlessly photomontaged combination print using thirty-two images, *The Two Ways of Life*, and in 1858, Henry Peach Robinson's *Fading Away*. The Dadaists, László Moholy-Nagy's Bauhaus group, and Man Ray's avant-garde photomontages continued to evolve in the 1920s and 1930s. These were in turn followed in the 1960s by Pop Art and Photo-Realism, and then Conceptual Photography in the 1970s. Other more contemporary examples include Jeff Koons' *Photo Lithographs*, Cindy Sherman's *Untitled Film Stills*, and Joel-Peter Witkin's *Narrative Tableaux* in the 1980s.

The common thread expressed in my work addresses the mystery of the reality in which we live. The mystery is perpetuated by the surprising, but significant, connection among all living things.

Chambers grew up in a family of artists on a farm in southeastern Lancaster County, Pennsylvania, and as a river urchin along the Susquehanna River – the area known as the home of the religiously conservative Amish and Mennonite communities. Living among the Amish and heavily influenced by their connection to the animal world and the earth nurtured his connection to the natural world.

The influence of his paternal grandparents, who lived on the family farm and made their livelihoods as painters, played a significant role in Chambers' development as an artist. His grandmother taught him to draw and paint, and gave him great encouragement to experiment in art. His paternal grandfather, Wilson Chambers, was considered part of the Brandywine School along with N.C. Wyeth. Influenced by his grandfather's acquaintance with Wyeth and the art created by the different members of the Wyeth family, he was most affected by Andrew Wyeth, N.C. Wyeth's son, whom he felt incorporates a sense of emotion into his landscapes and whose paintings

Chambers has said influenced his taste in art more than any other artist.

At eighteen, his worldview was altered when he served in the navy for four years during the Vietnam War. After training and beginning his world travels as a sailor, Chambers spent the second year on a Swift Boat patrol base in Qui Nho'n, Vietnam. The base was attacked in the middle of the night by the Viet Cong and he was wounded. The third year was spent aboard a destroyer in the Mediterranean, and his final year on a guided missile cruiser in the South China Sea. Chambers saw first-hand that what he had been reading about in the newspapers and hearing from the United States government was not true, that things are not always what they appear to be. He would never again accept information as being the truth without looking into it for himself. Moving forward, Vietnam inspired Chambers to think for himself.

I am a husband, father, son, brother, friend, traveler, artist, and photographer who uses the photo medium for self-expression. All these different roles impact my perspective on the world.

Beginning with his first major series "Ex Votos" in 2003, Chambers' work was influenced by his many travels to Mexico and the southwestern United States. While in Patzcuaro, Mexico, he came across a basket full of ex votos painted on tin. These Mexican folk art paintings, honoring the power and mercy of the saints, illustrate an occasion when in response to a prayer for help or guidance, the prayer is answered or a miracle occurs. All ex votos contain a picture of the miracle, an image of the saint to whom it is dedicated, and a brief description of the miracle. In learning more about these paintings, Chambers thought to push his work in a similar direction and create photographs with magical or religious overtones.

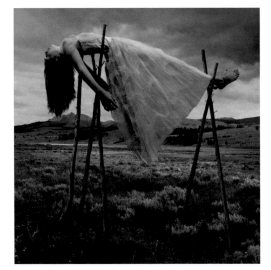

"Prom Gown #3" from the "Rite of Passage" series

Chambers worked on that series over a period of several years. *Stealing Crow* was an early photomontage of "Ex Votos" that I now understand illustrates a miracle in which a child saves an injured bird, but the viewer is left a mystery as to how or why this came to be. Chambers often voices animals as a metaphor for the unknown. In his image, *Black Dog's Retreat*, a Labrador Retriever sits on the prow of a boat watching a stucco house sink into a canyon's murky waters as a little boy peers from a second-story window. "There is ambiguity – are we witnessing a miracle or an unfolding calamity? Is the dog coming to the rescue or floating away? Children appear at once angelic and sinister, vulnerable yet darkly powerful. Worlds where children and animals interact in mysterious ways beyond the reach of adults." Ominous fairy tales.

Chambers states he is proud of *Prom Gown #3* from the series "Rite of Passage", in which he explores the transition from childhood to adolescence and compares the vulnerability of children with the current risk to the environment. He had been intrigued by Native American Indian burials, particularly ones using burial platforms in the desert. He created a sacrificial image in which the subject appears to be presenting herself to the heavens, inducing the viewer to feel the power of nature over humankind.

I am very aware of the balance of nature and disturbed by the negative impact of global warming. This is not only a problem for the animal population, but it's now starting to affect us directly through fires, extreme weather, and scarcity of water. I have a daughter who will be on this planet for years to come. For her I worry about the shift that is happening now.

These works were followed by "Entropic Kingdom" expressing Chambers' concerns for the environment and animal kingdom nega-

tively impacted by climate change, pollution, overpopulation, and man's carelessness. It is here Chambers speaks to the gradual decline into disorder – that man has ignored the fragility of the environment, and that his disregard is causing the animal kingdom to undergo negative changes. The animal population is affected as regular climate patterns are destroyed. Mammals compete for smaller spaces and temperature changes limit fish, bird, and insect migration. He is illustrating how the animal world has been thrown out of kilter. Of *Saccharine Perch*, he says, "I show the positive interaction among the landscape, the animal world, and the young woman. These elements can coexist successfully, but it takes awareness and care."

"Dreaming In Reverse" celebrates the spirituality and beauty in traditional Mexico, as well as lamenting the ongoing cultural loss which is occurring as a result of increasing political and economic challenges. Like the "Ex Votos" series, this work captures the magic that is imbedded in the art, literature, and religion of the Mexican people.

As Chambers traveled through Italy, he was inspired by the art, architecture, and natural beauty of the country and was especially struck by the metaphysical nature of the Italian light – particularly through Tuscany and Venice where the natural daylight radiated colors and timbre in all that he experienced. The series "Illumination" seeks to replicate that sense of wonder, each image a small mystery, a piece of the story left to complete by the viewer.

My work is not used to document, but to illustrate photographically the fleeting moods that can't be captured by a traditional camera or seen with a naked eye…. I came away with the understanding that light exposes possibilities and opens the mind to seeing things differently."

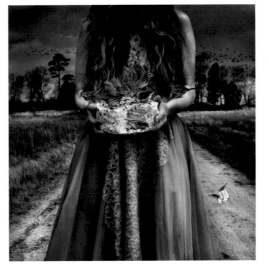

"Saccharine Perch" from the "Entropic Kingdom" series

In his series "To The Edge," Chambers teamed with the Virginia poet, Allen Chamberlain, to create images with text. The series includes the geography and mythical nature of Iceland. The poet spent months exploring language which would fit with Chambers' images. The final result was a poem in an ancient ghazal form using couplets, with the second line always ending with "the edge". Each photomontage is accompanied with a copy of the poem, *To the Edge*, written in both English and Icelandic.

And Chambers' most recent series, "Still Beating," is visually striking, and perhaps more immediate than his earlier work, as if all that came before were foreshadowing the telling of this series. He continues to skillfully tap into viewers' primal fears, and pushes barriers past archetype myths into dreams spun present. The factual interpretation of the images is sometimes elusive, but the story is a profound message about our environment and future – unlocked through Chambers' masterful keys – into beautiful remembrances.

We each have the power to create a reality which is positive, if we choose to make it that way and if we open ourselves to infinite possibilities to experience in life. All of us are joined together in the universe through our connection with nature and the earth. In turn, we need to take care of each other and our environment.

Photography is never only about what we perceive with our intellect, but also about how the images make us feel. From my first introduction a decade ago, the depth of Chambers work has etched a space in my soul; it evokes a deepened understanding of the power of symbolism and offers an unprecedented perspective that reaches each viewer on the spiritual plane.

—Elizabeth Avedon

Ex Votos

1997–2004

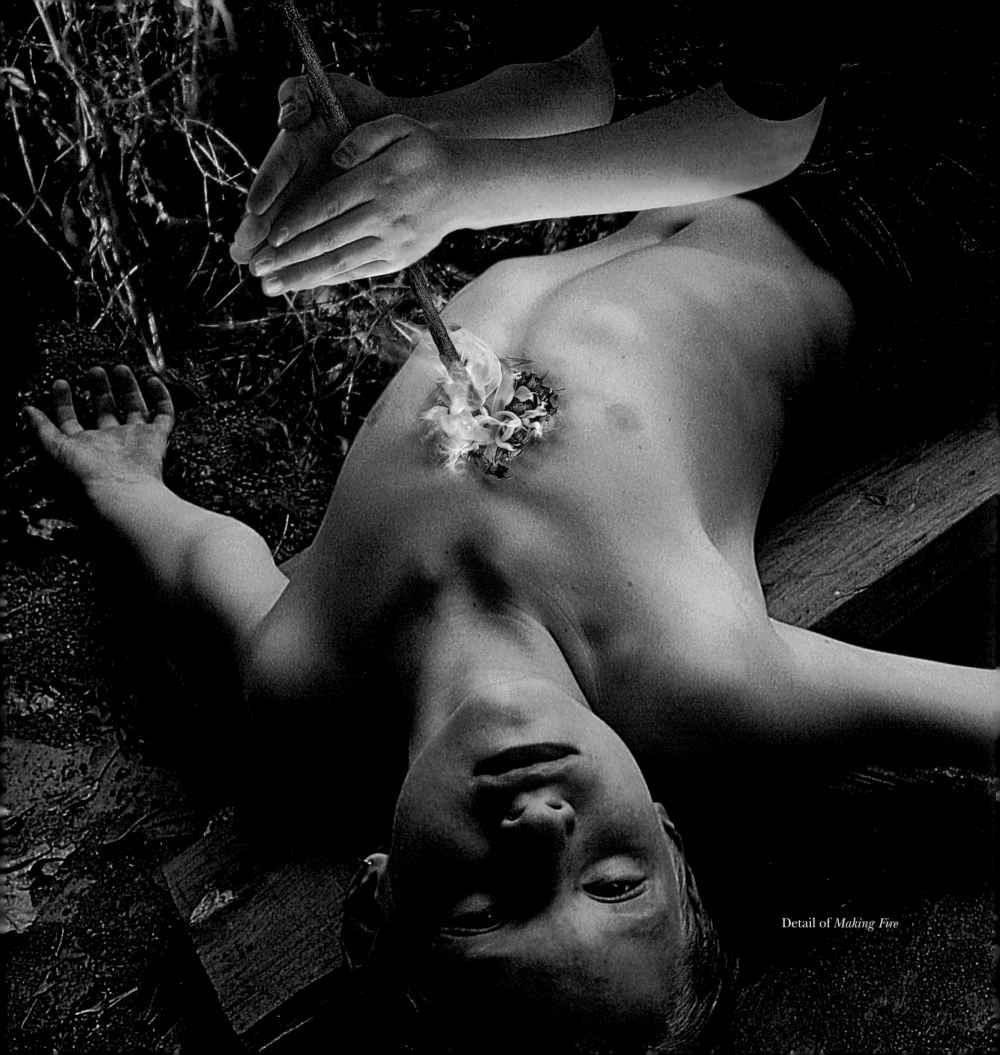

Detail of *Making Fire*

Ex Votos

During a trip to Mexico I was intrigued by small
traditional paintings called ex votos. Ex votos are Mexican folk art
paintings often created on tin, copper, or wood.
They illustrate an occasion when in response to a prayer
for help or guidance, the prayer is answered or a miracle occurs.
These miracle paintings honor the power and mercy of the saints.
Ex voto subjects range from common daily occurrences
to truly dramatic events. The elements common to
all ex votos are a picture of the miracle, an image of the saint to
whom the ex voto is dedicated, and a brief description
of the miracle.

Through digital photography I have taken a different
approach to the ex voto art form. Normally photography is a
method of documentation or a means of recording specific physical
moments in time. My work is not used to document, but to illustrate
photographically the fleeting moods that cannot be captured by
a traditional camera or seen by the naked eye.
With photomontage, I create ex votos that also honor a deity –
the one for imagination.

• • •

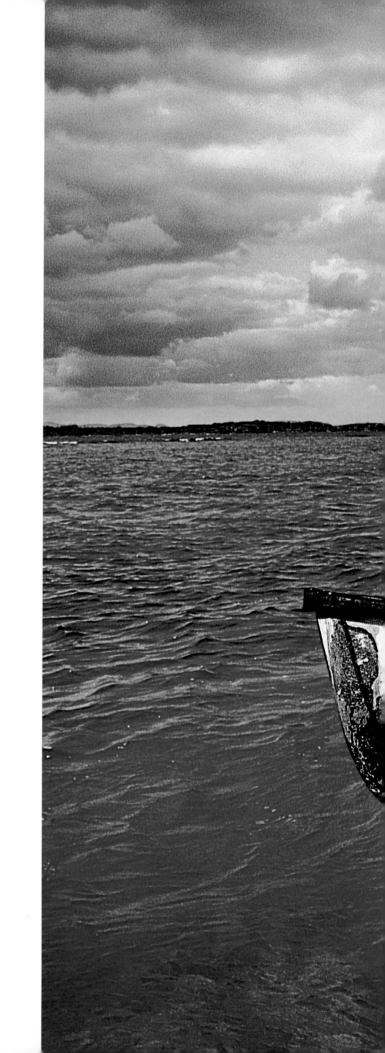

Aground

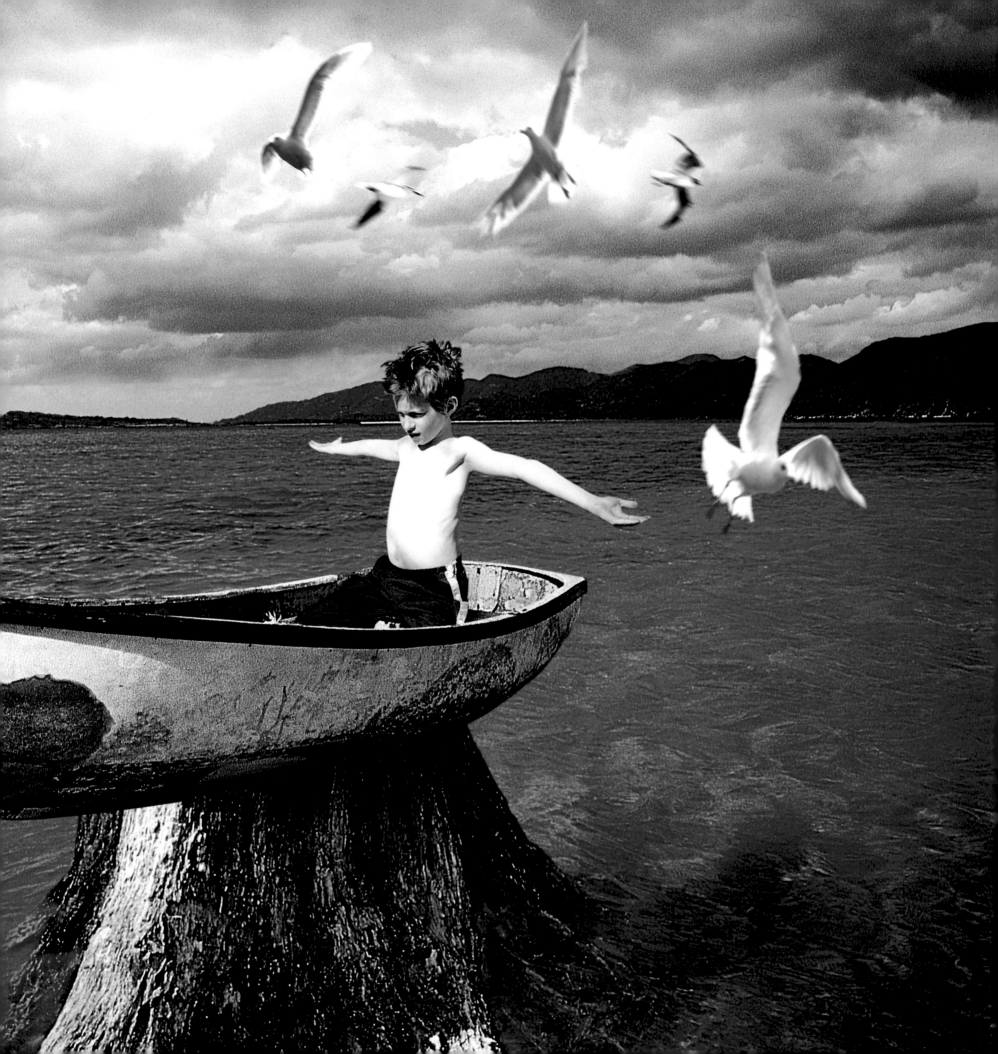

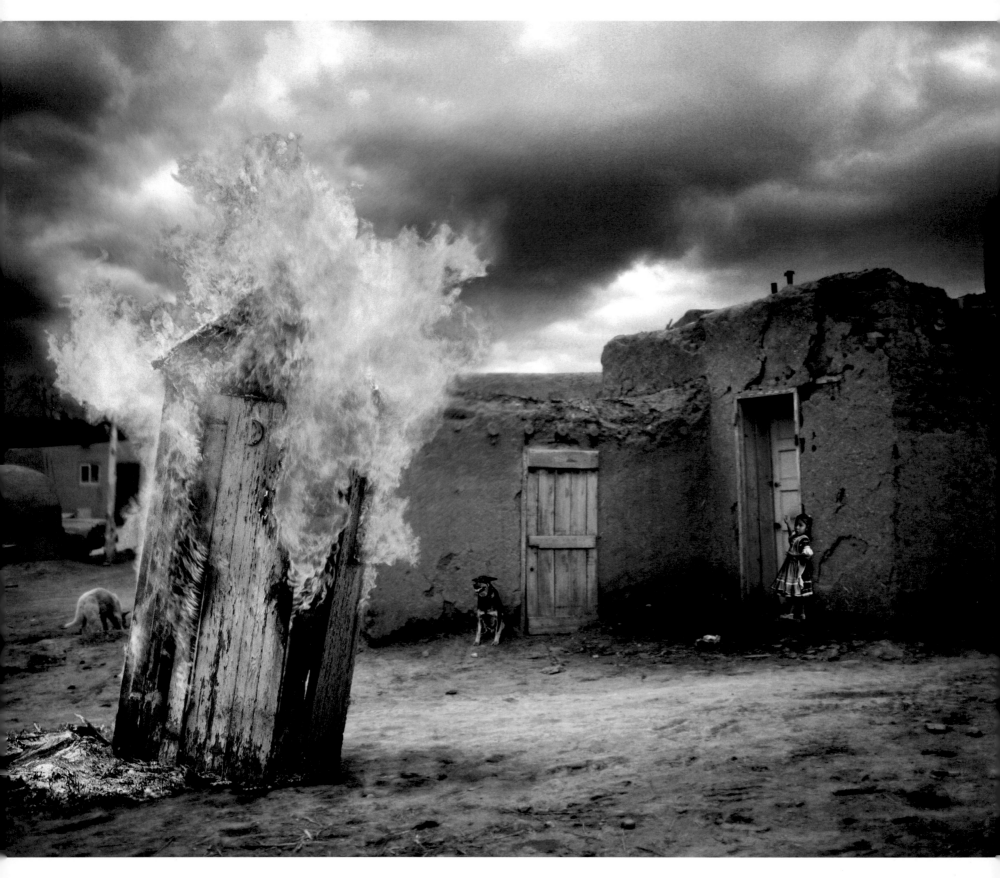

Pueblo Fire

Kiva Horse

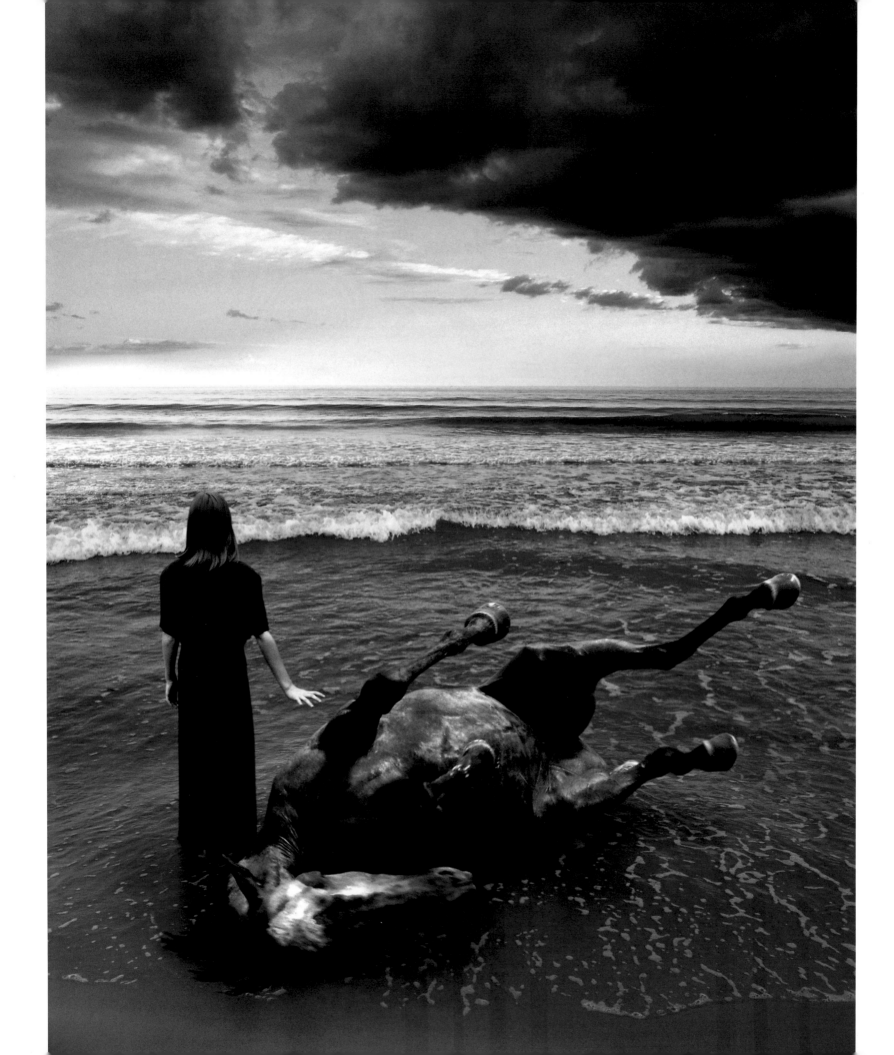

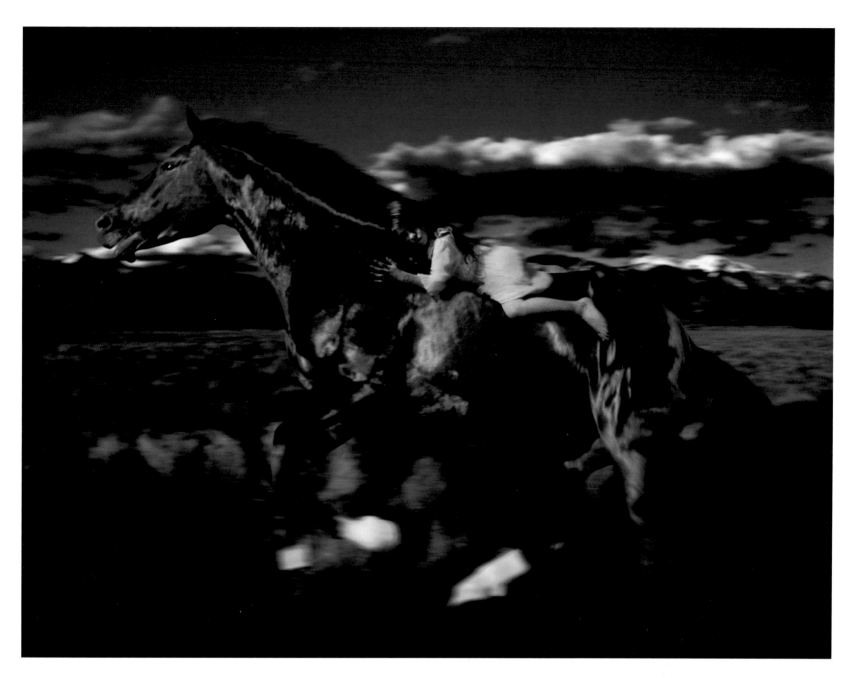

Summer Night Ride

Left: *Sea Horse*

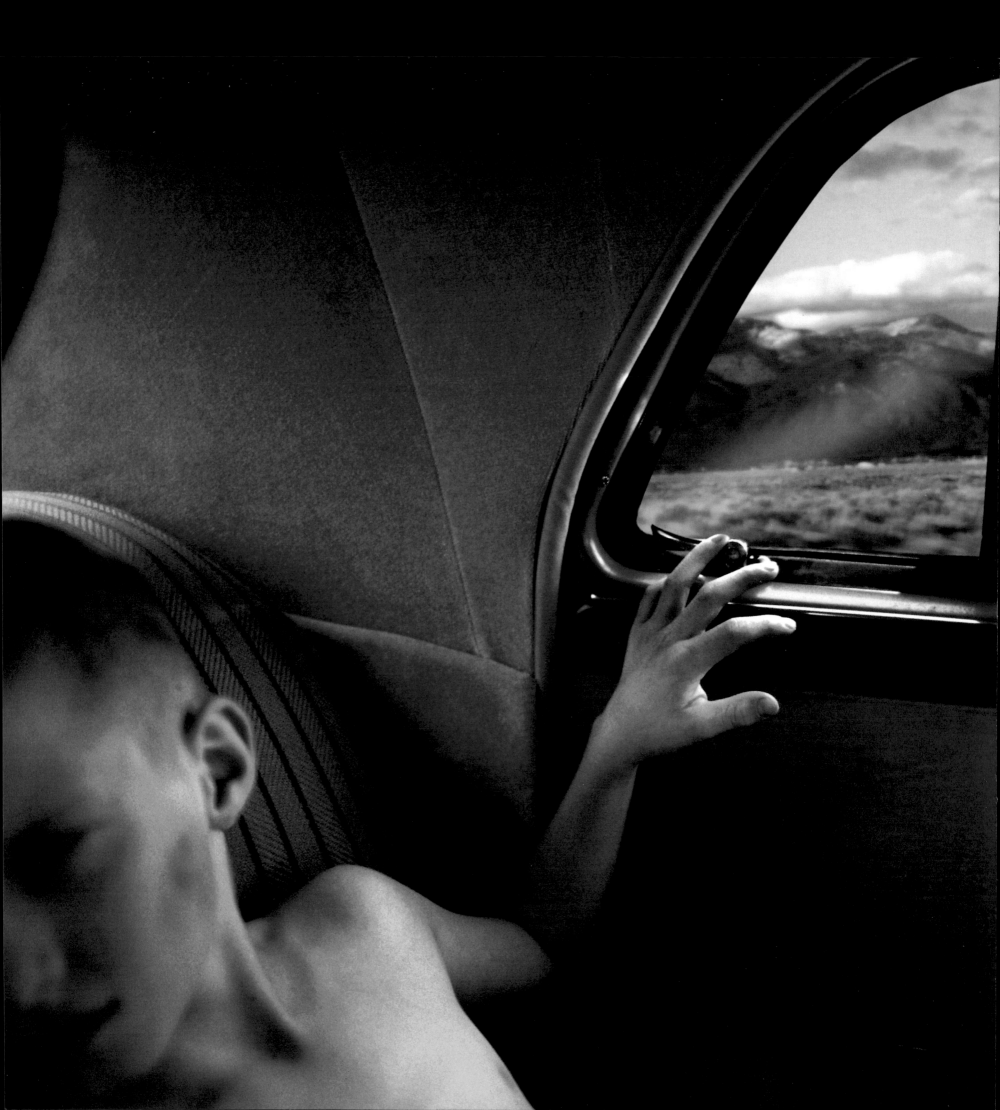

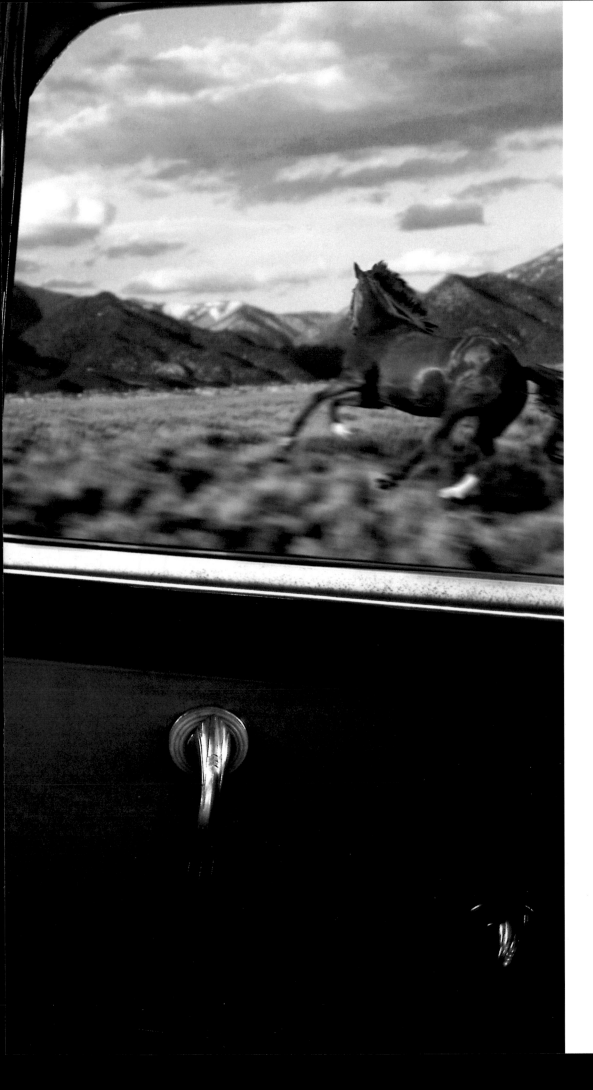

Way Out West

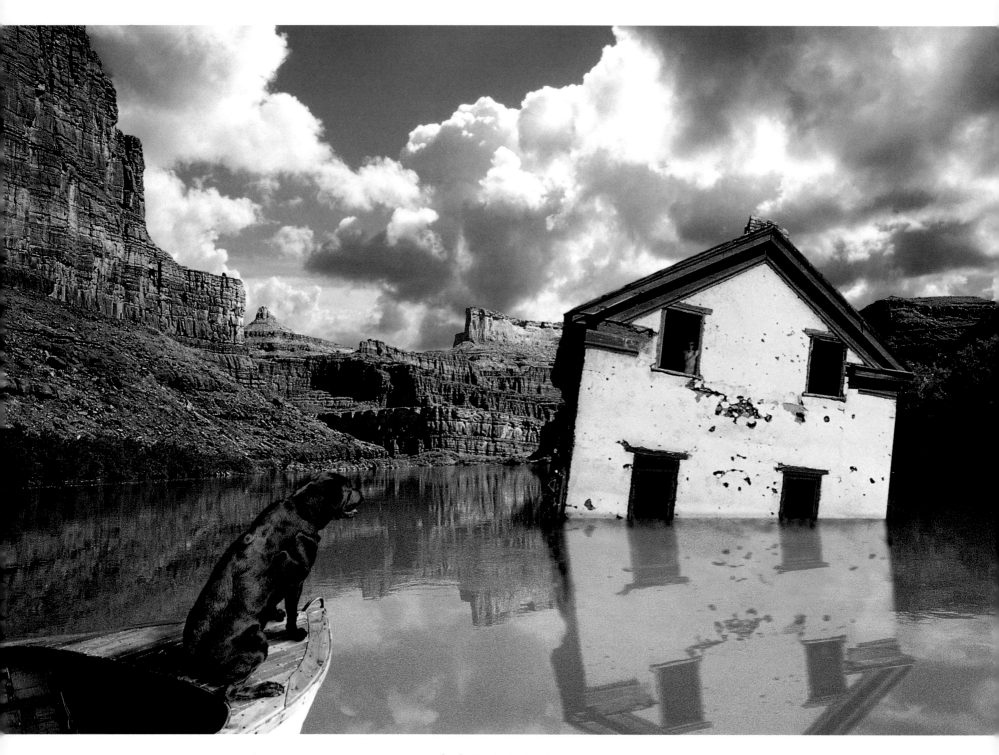

Black Dog's Retreat

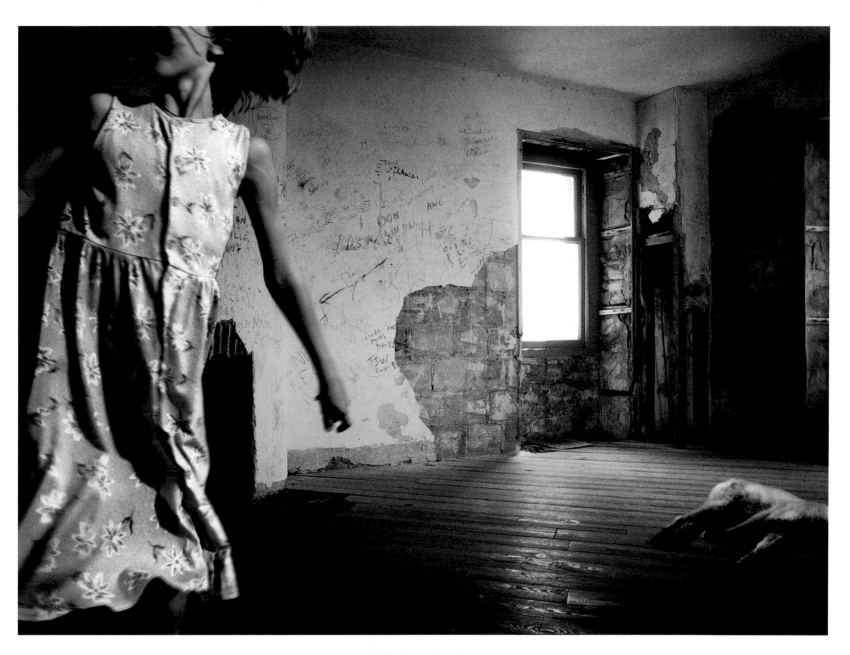

With One Eye Open

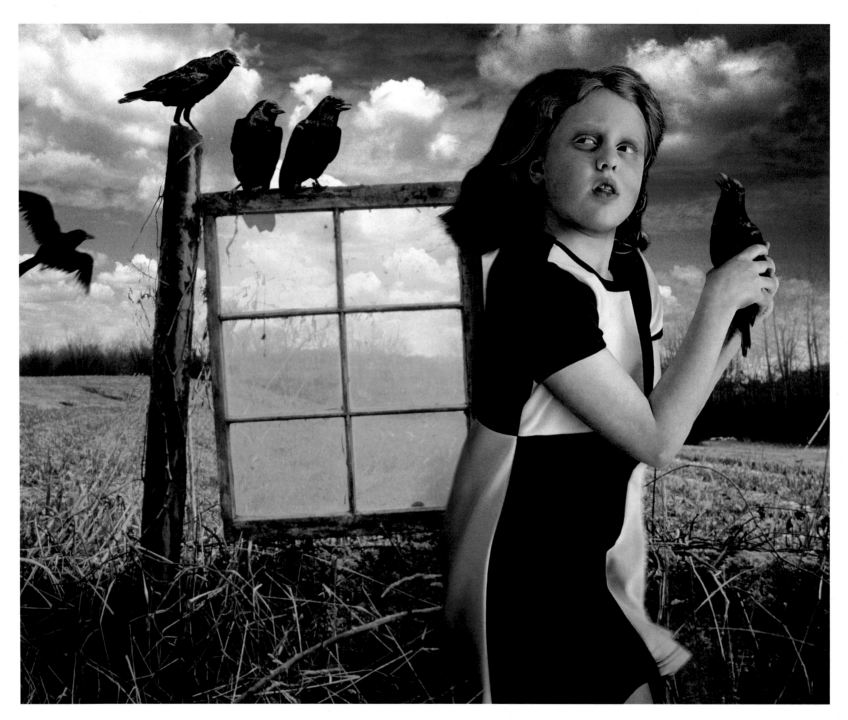

Stealing Crow

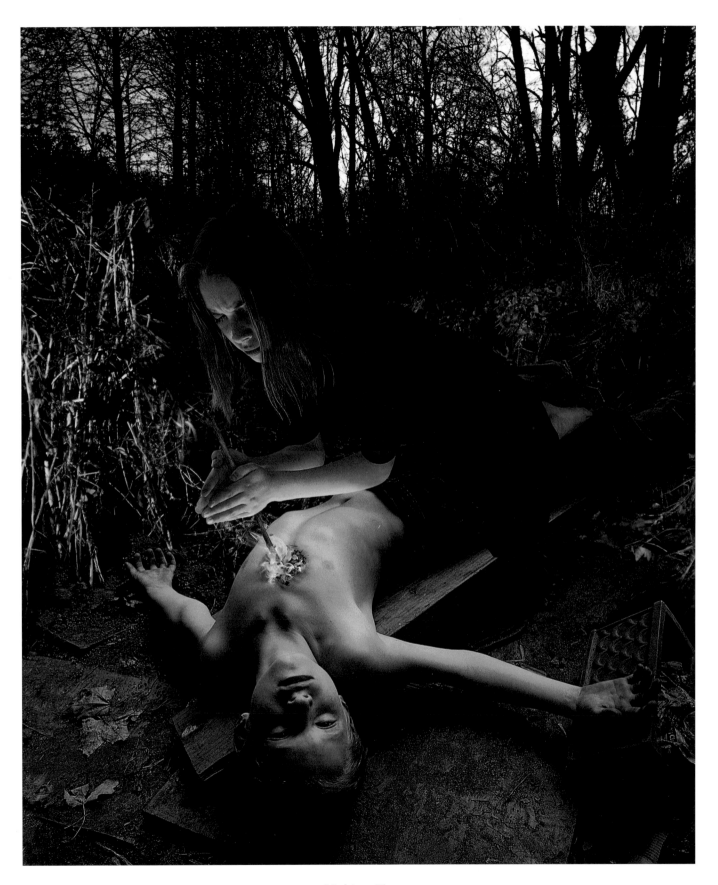

Making Fire

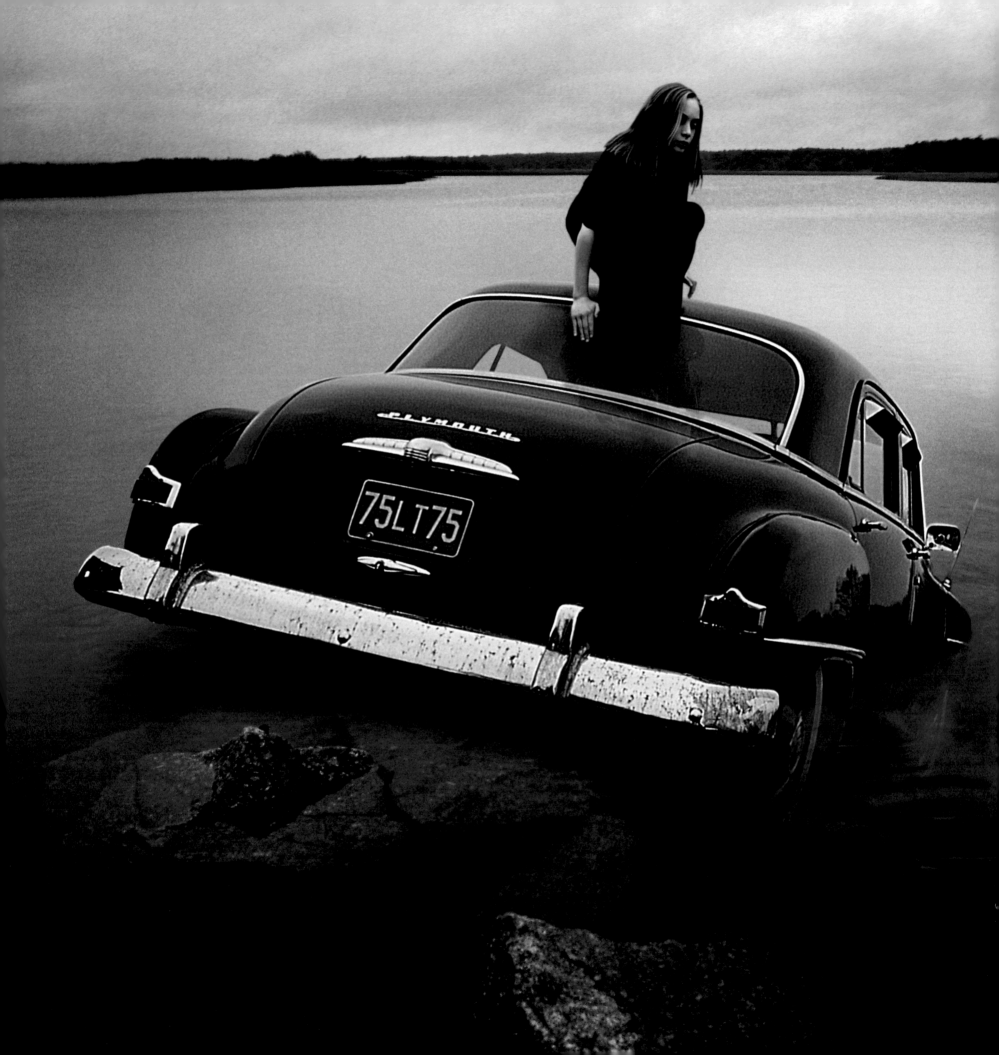

Plymouth Rock

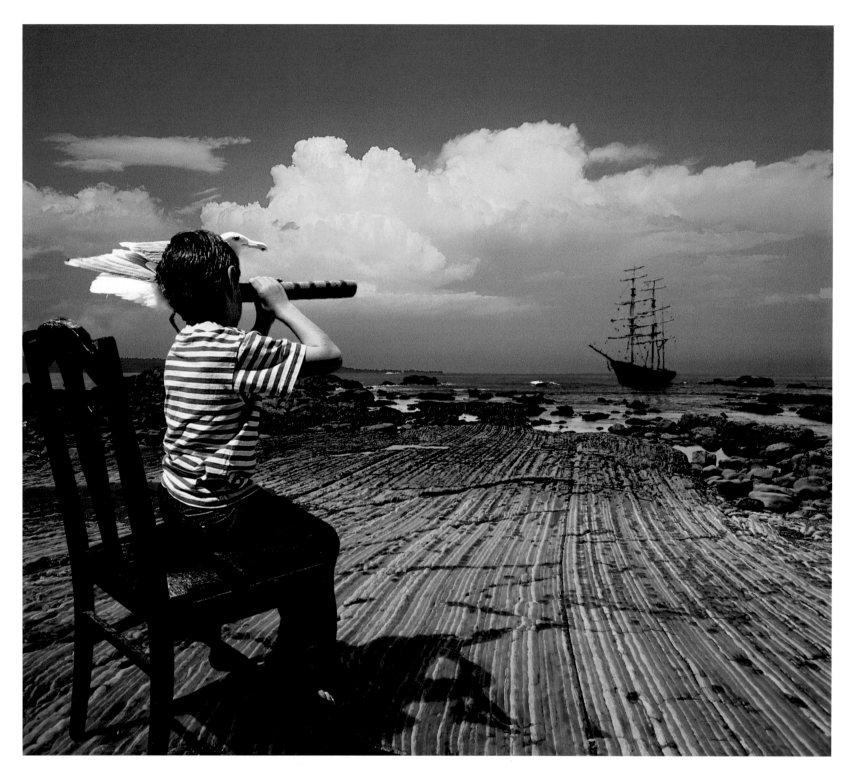

Visions Of Blackbeard

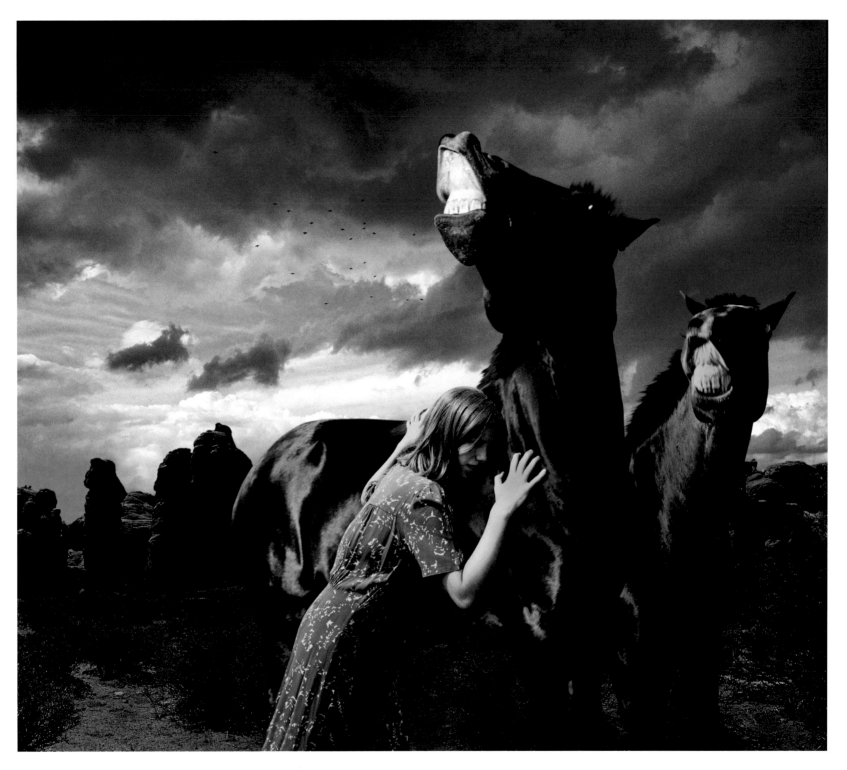

Horse Talk

Charmers

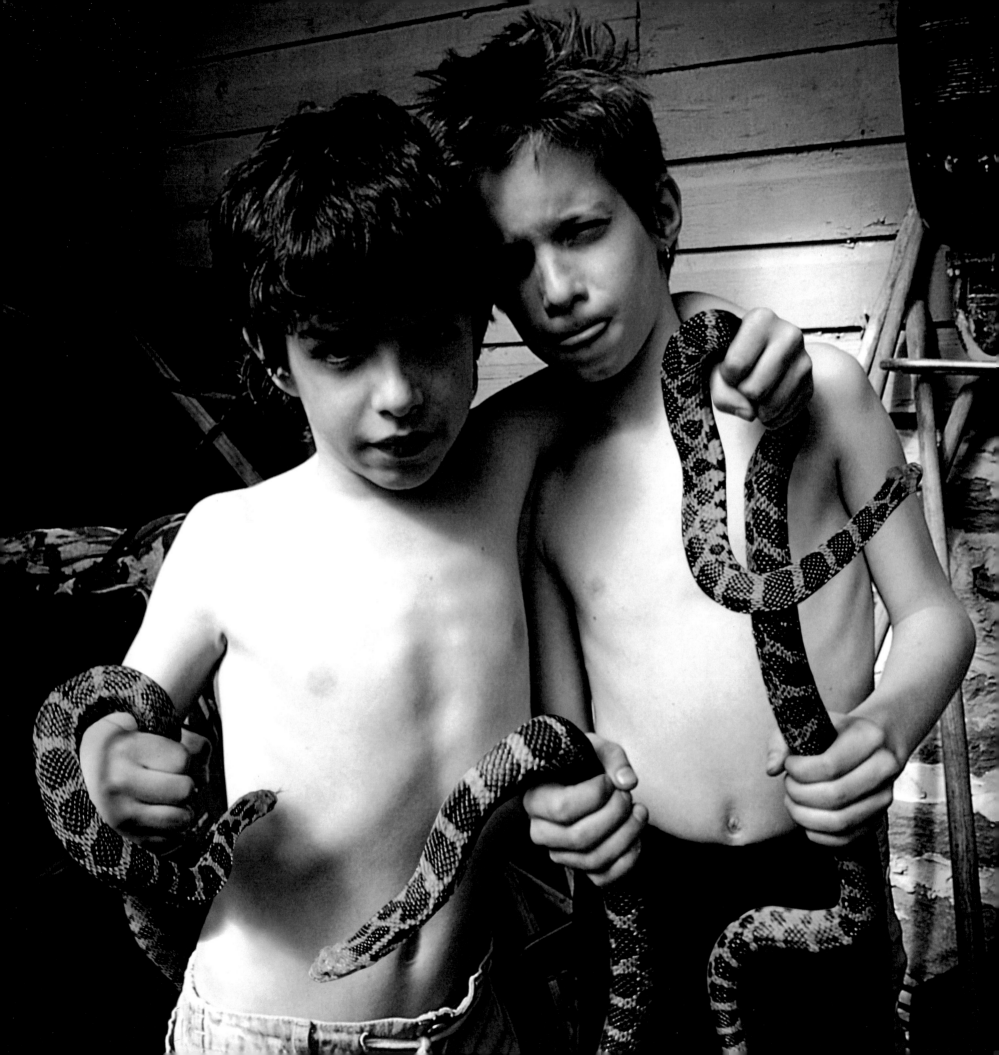

Rite Of Passage

2005–2007

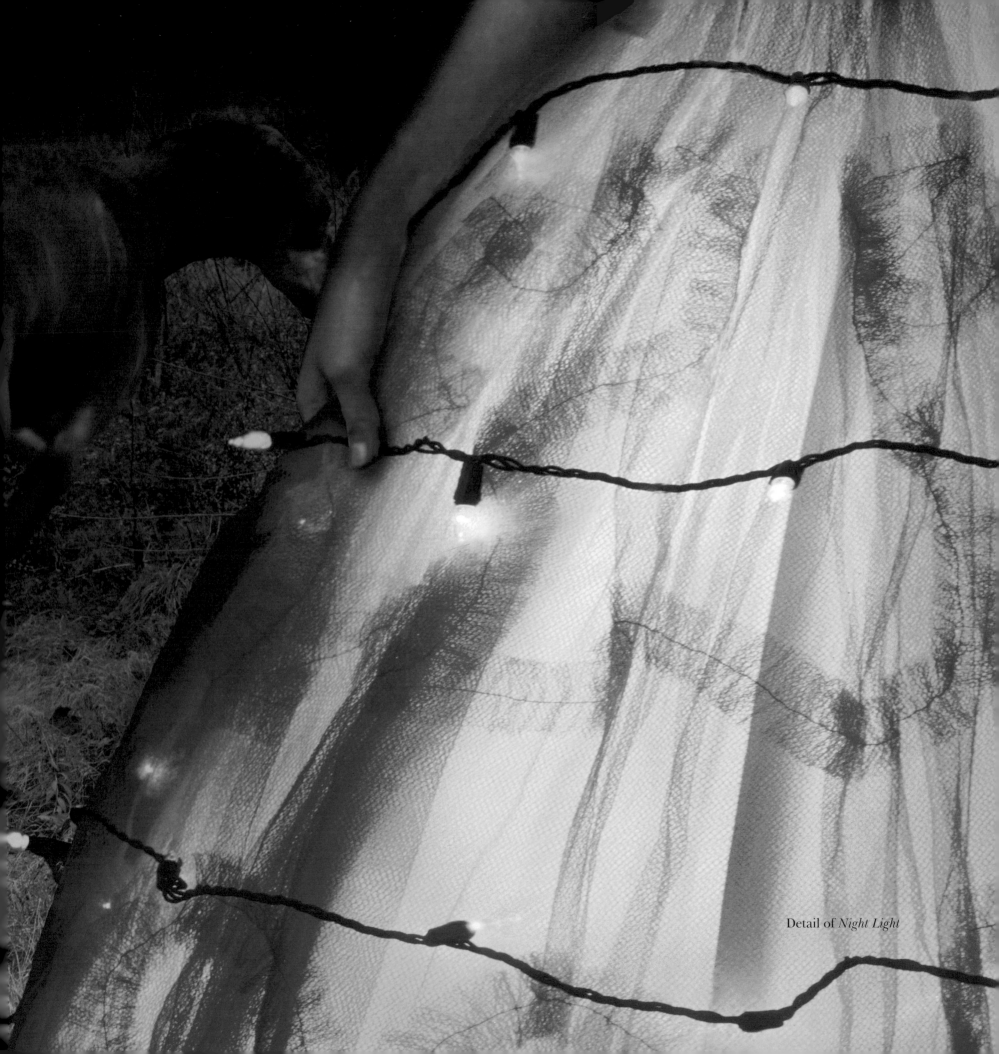

Detail of *Night Light*

Rite Of Passage

With time, adolescents begin to abandon the natural,

untamed state of childhood for the artificial pretenses of adulthood.

After my own daughter's arrival at the complexities of her

sixteenth milestone, this juxtaposition captured

my attention.

In composing a variety of stark, woodland settings

in contrast with a billowy dress or other man-made articles,

I explore the dichotomy between what is natural and what is fabricated.

Why do people costumed in formal dress seem so omnipotent

on the street, yet so vulnerable in the wild? Each of these photomontages

explores a place where unexpected circumstances collide.

. . .

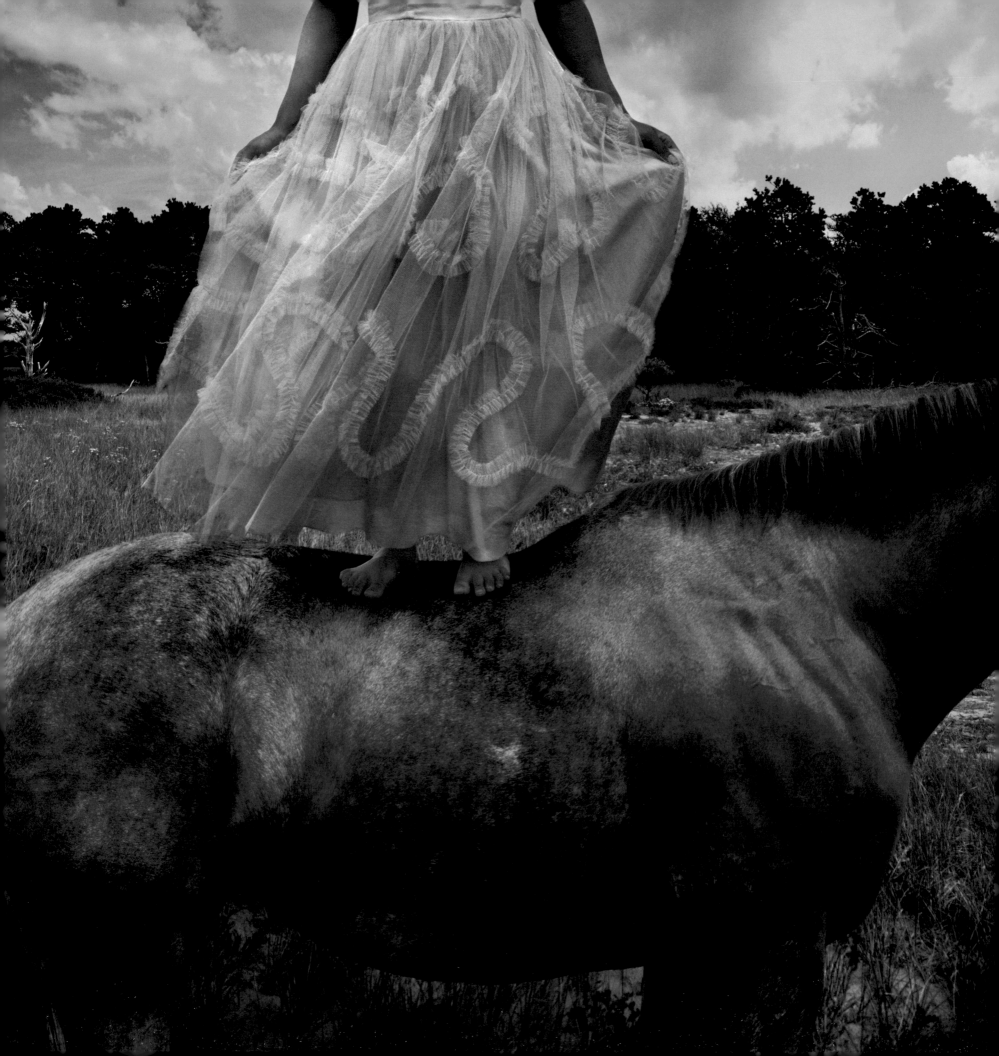

Prom Gown #2

Spring's Landfall

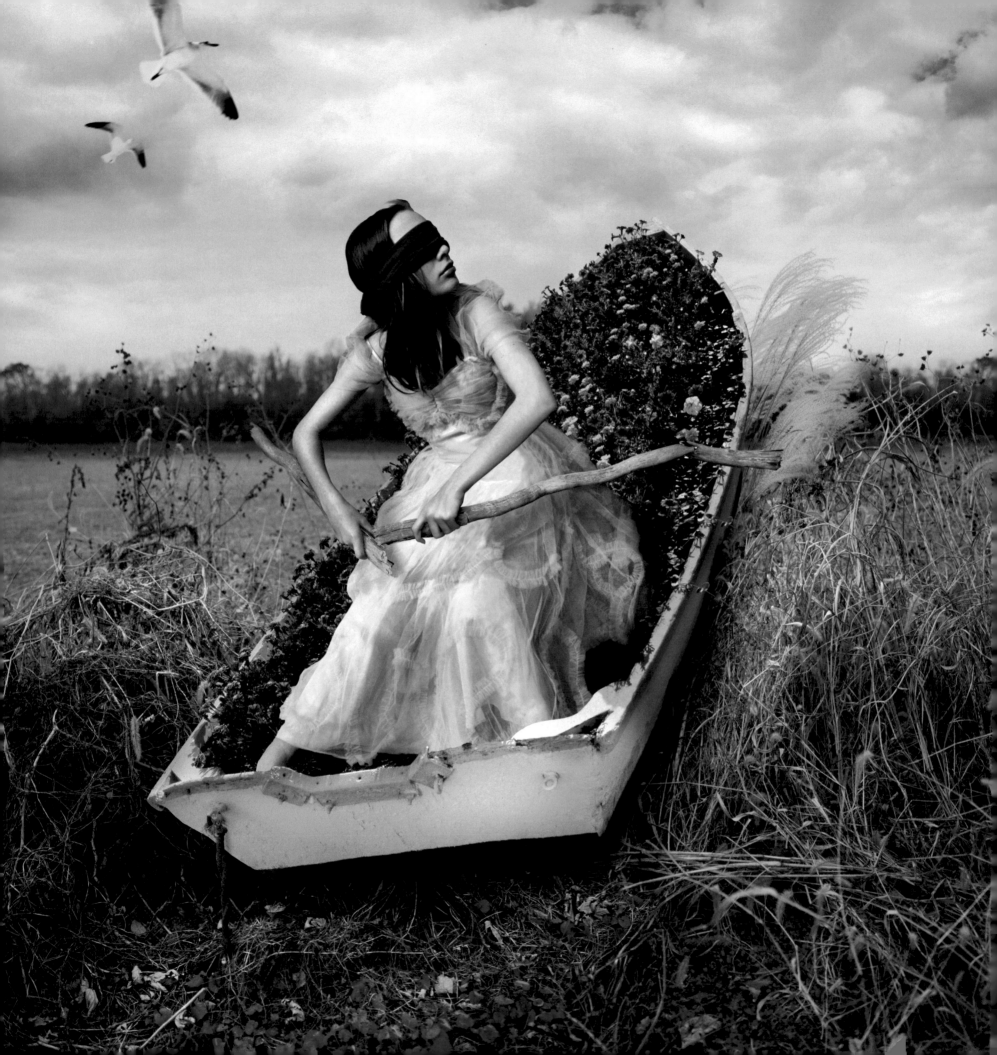

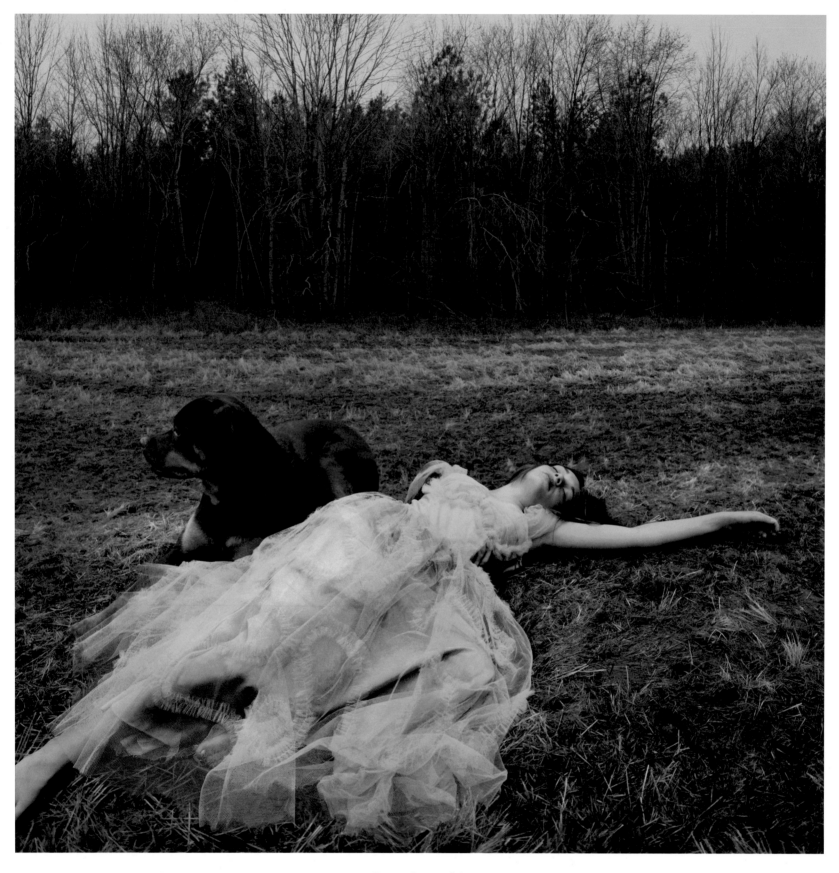

Prom Gown #1

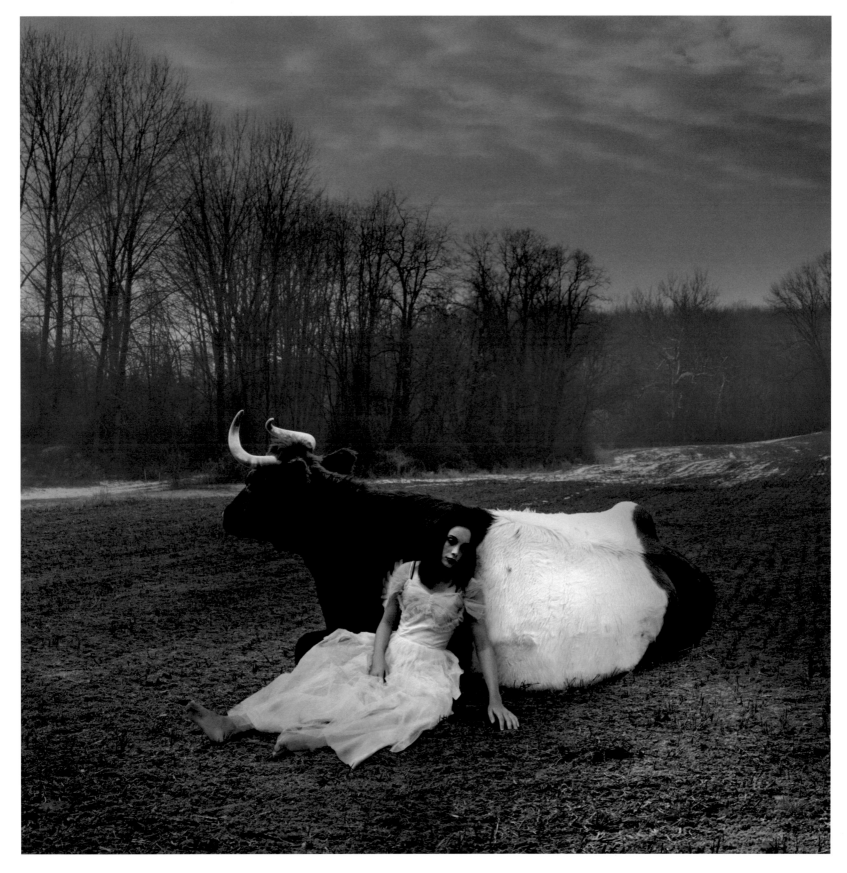

Cow Girl

Prom Gown #3

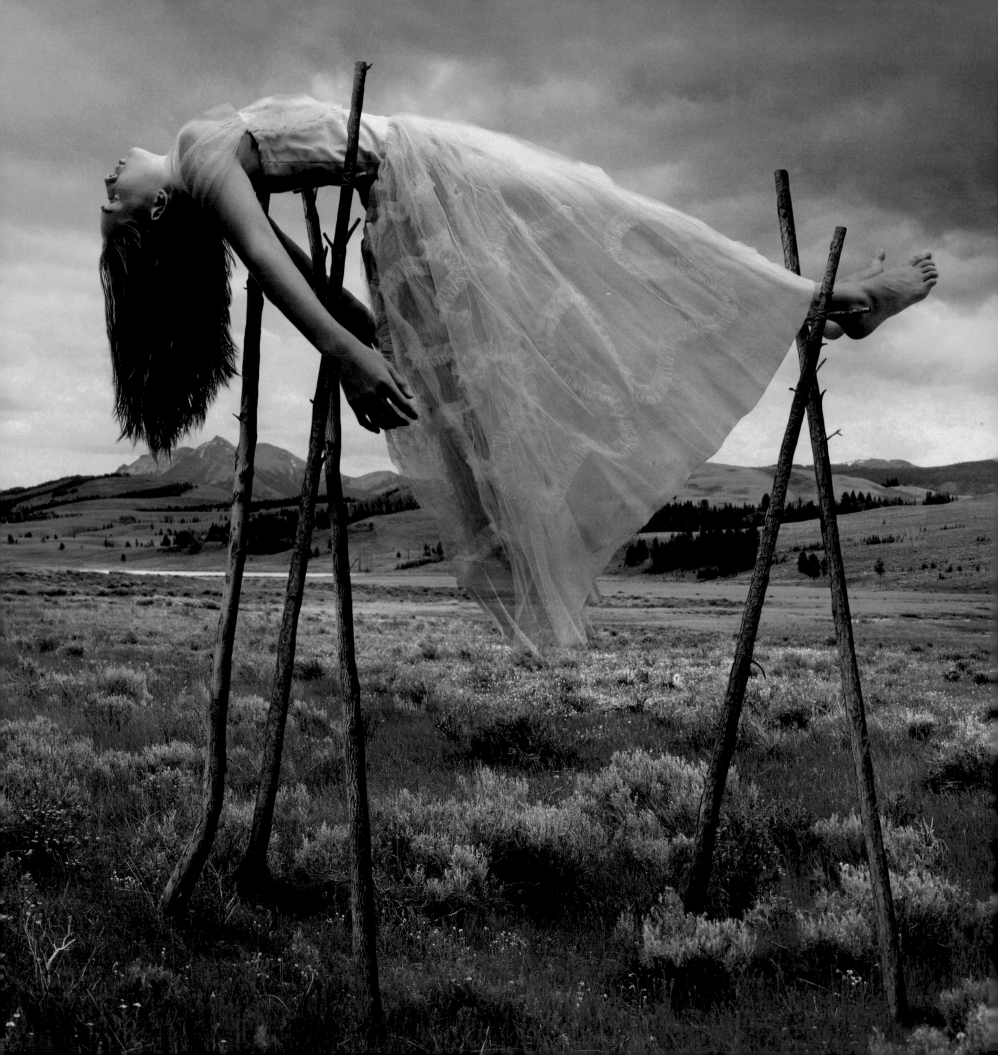

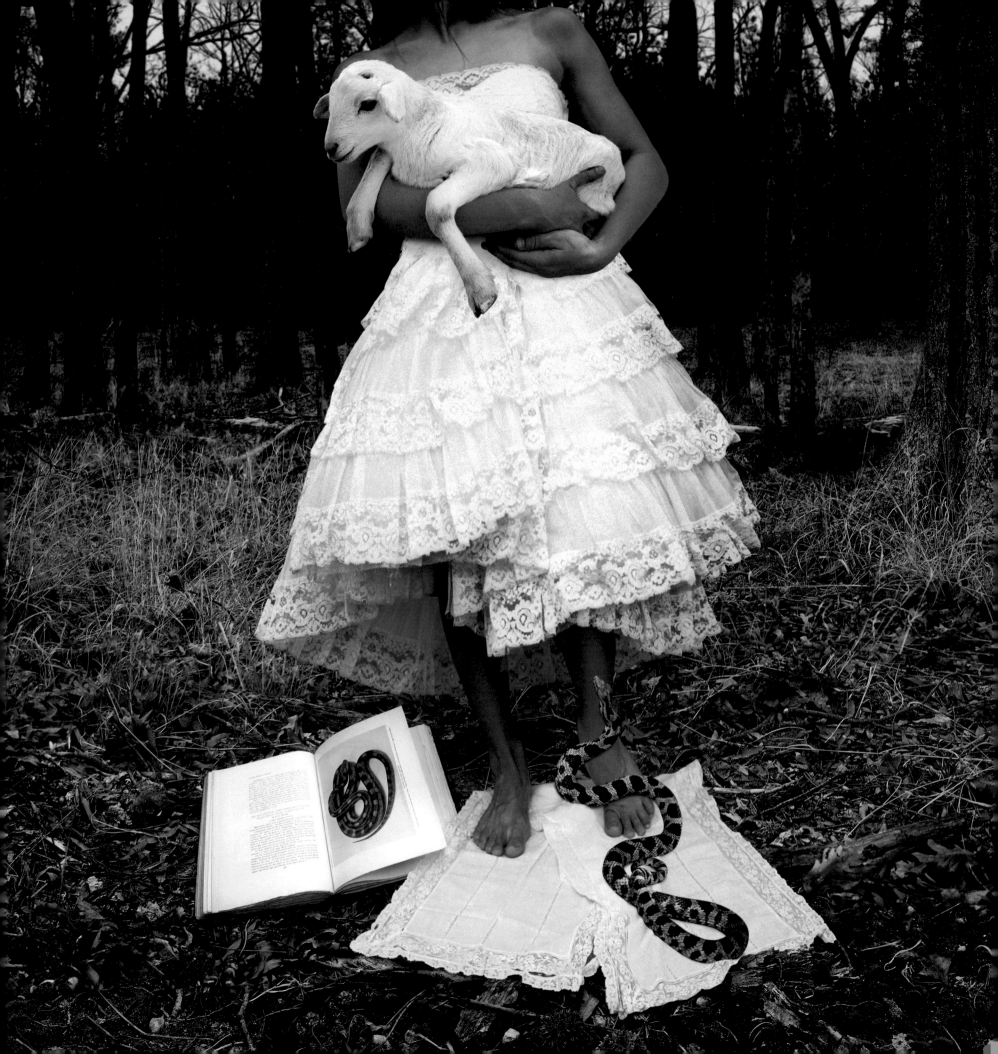

Once Bitten, Twice Shy

Night Light

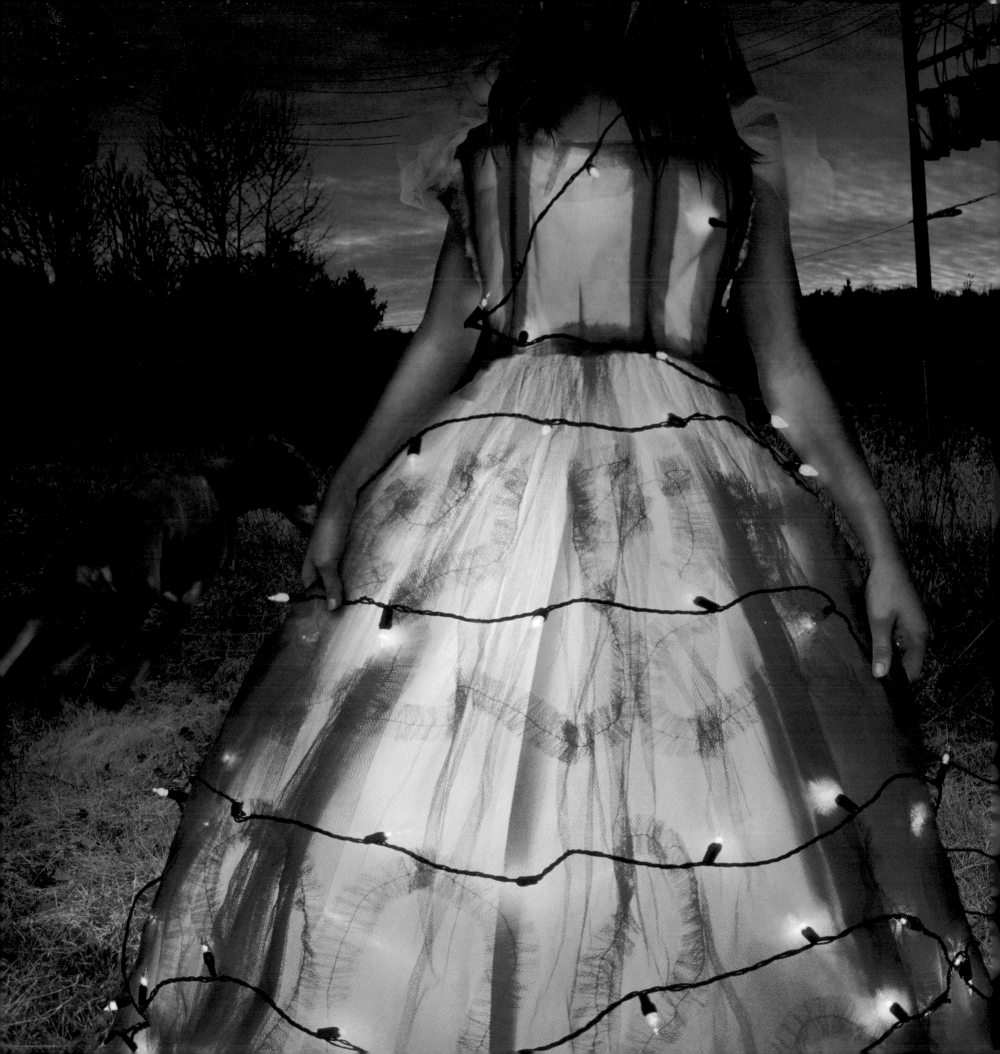

With The Pack

Following spread: *Foggy River*

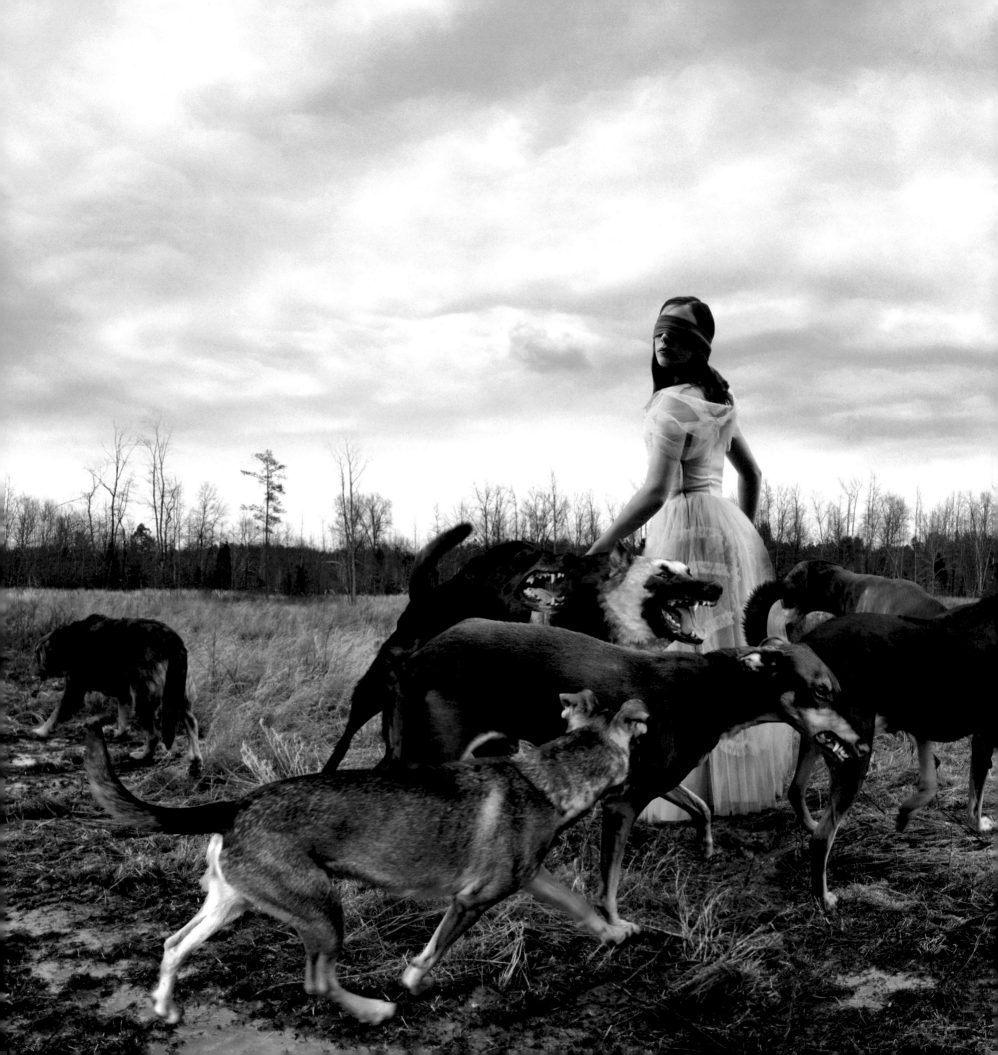

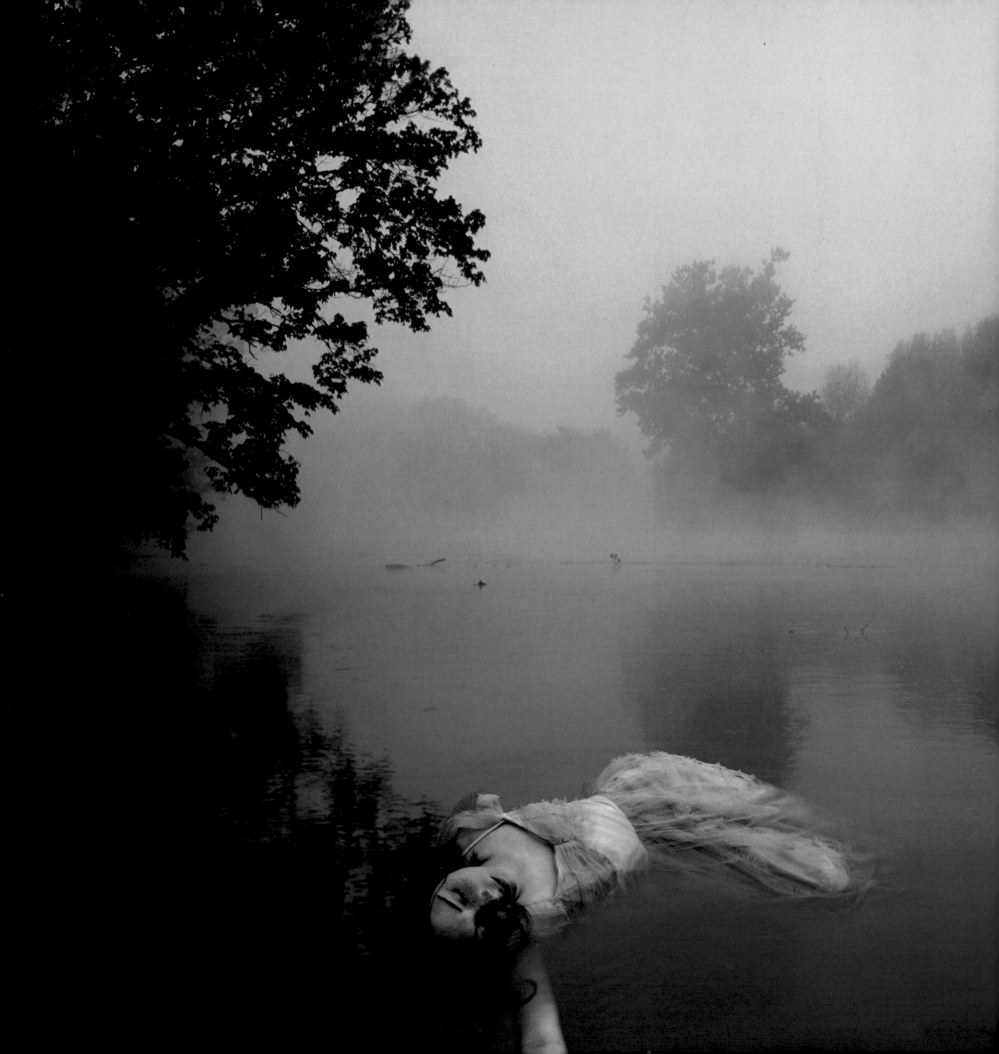

Roses And Gown

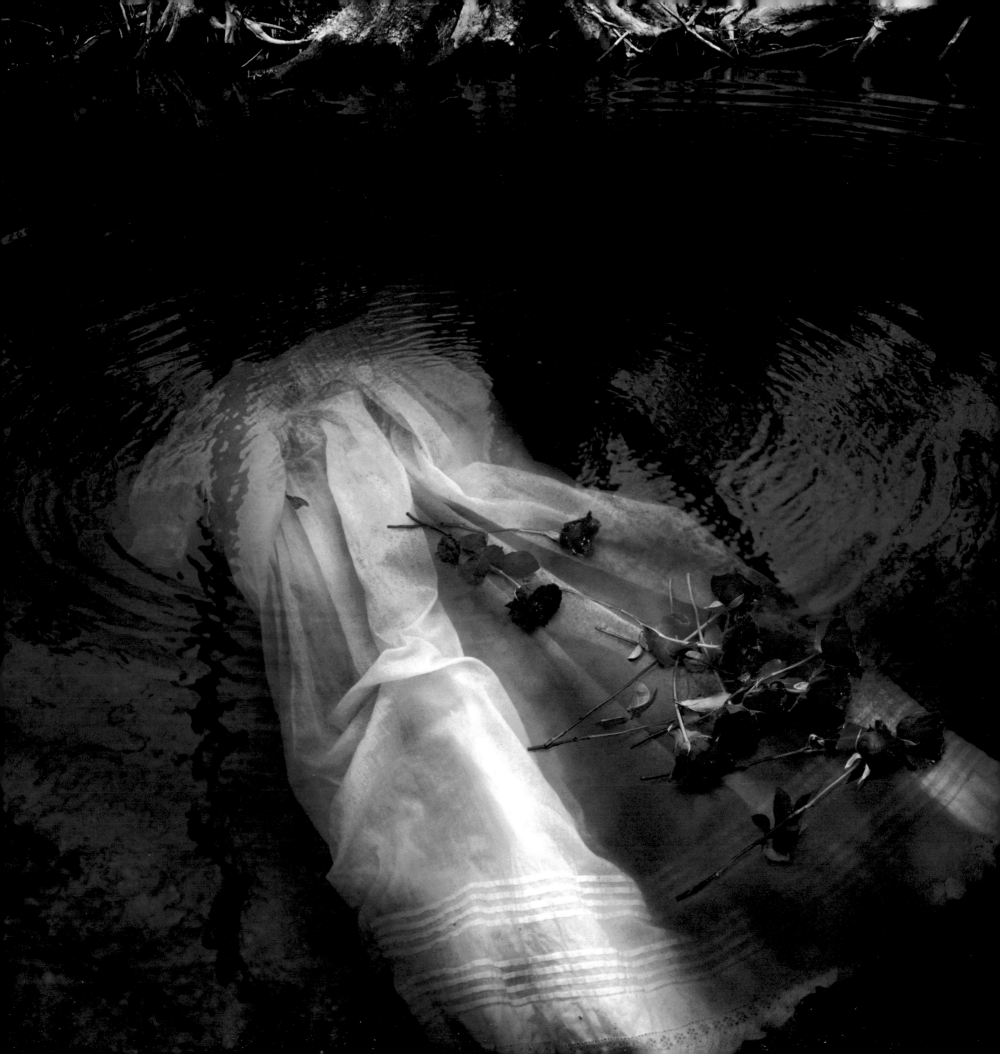

Entropic Kingdom

2008–2009

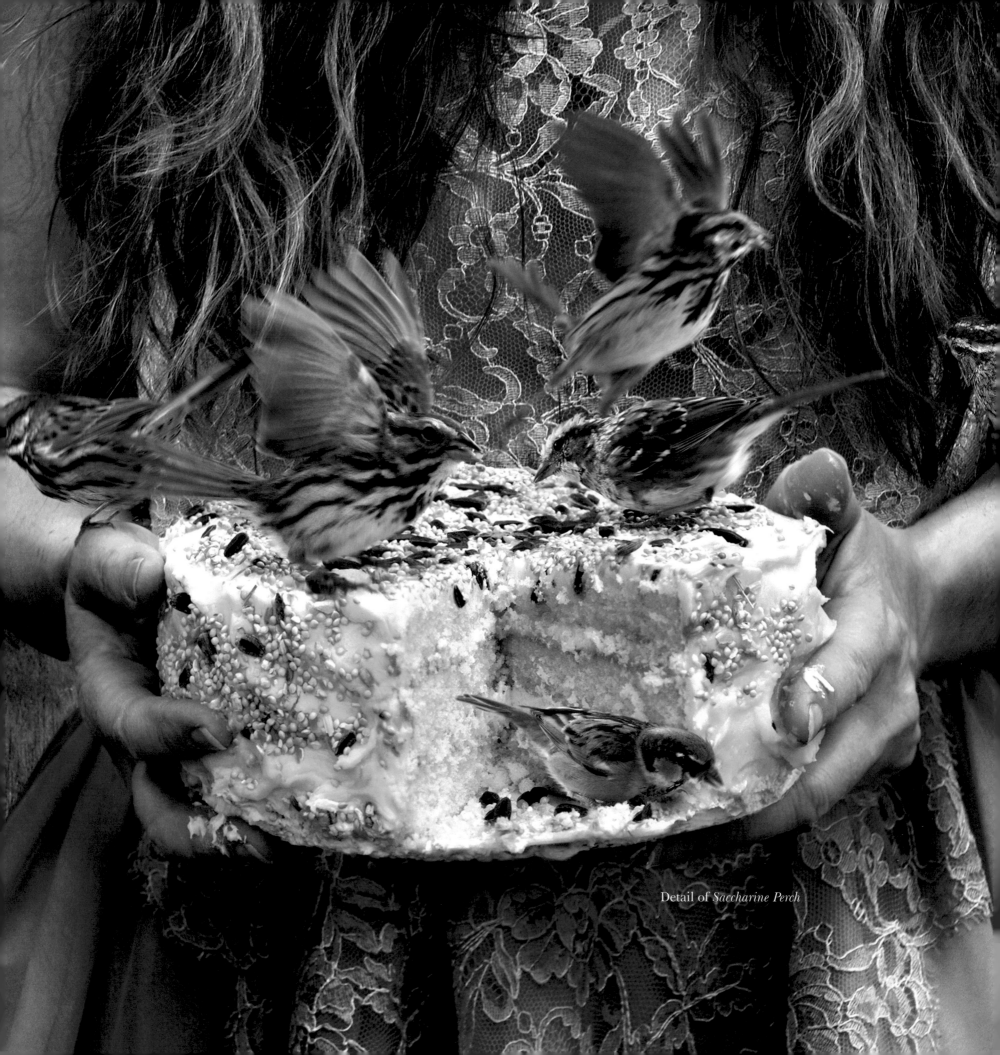

Detail of *Saccharine Perch*

Entropic Kingdom

The animal kingdom and mankind engage in an ongoing
dance of co-existence which results in a predictable tension. This tension
has escalated with man's increasing disregard for the fragility of the environment
and abdication of his responsibility to care for the earth. One particular
issue is global warming, which has had a significant impact on all living things. Climate
changes will minimally upset and perhaps ultimately destroy ecosystems.
As a result, mammals already compete for survival in smaller and smaller
spaces, while temperature changes alter migration patterns of fish, birds, and insects.
I feel strongly that the cumulative impact of negative environmental
changes cannot be ignored.

Having grown up on a Pennsylvania farm, I am inspired by Andrew Wyeth's
\rural landscapes, characterized by subtle, but powerful, emotion. I hope to strike a similar
emotional connection in the viewer by illustrating a disturbed world that has
been thrown out of balance as a result of climate changes created by man's blind
disregard in fulfilling immediate, self-serving needs. These photomontages
are composed of animals, children, and adults, all of which are potential
victims and at risk.

. . .

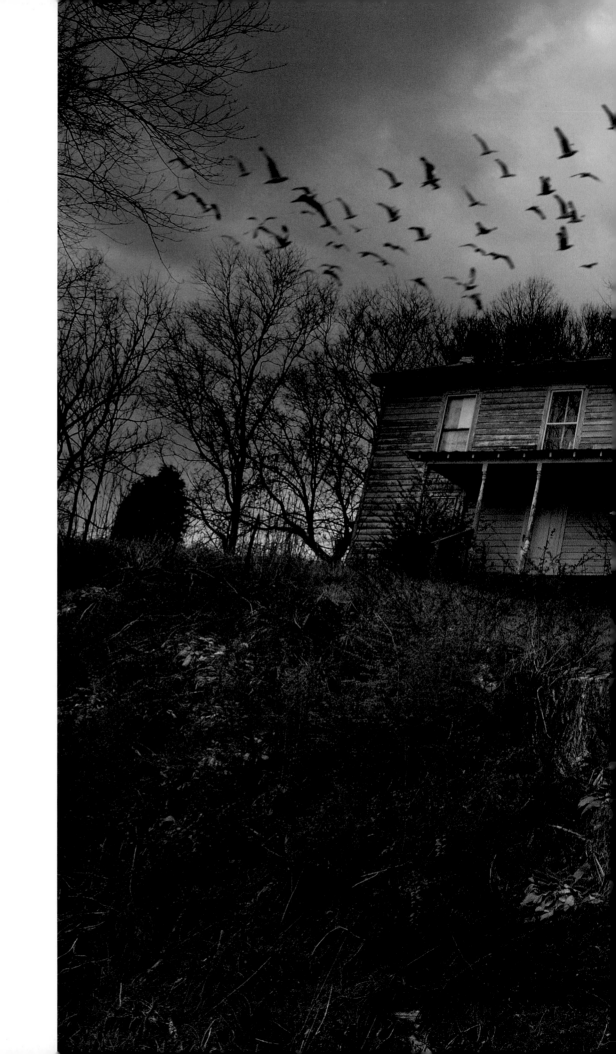

Winged Migration

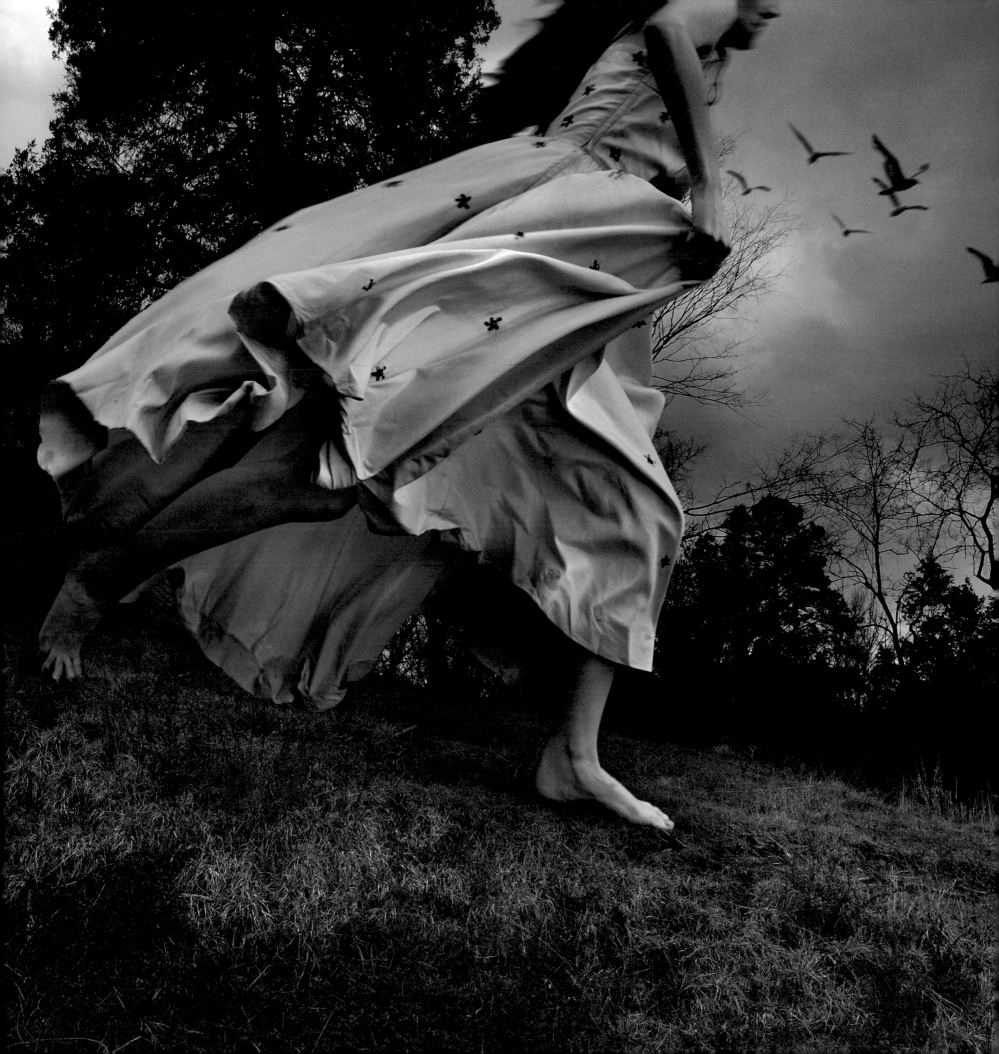

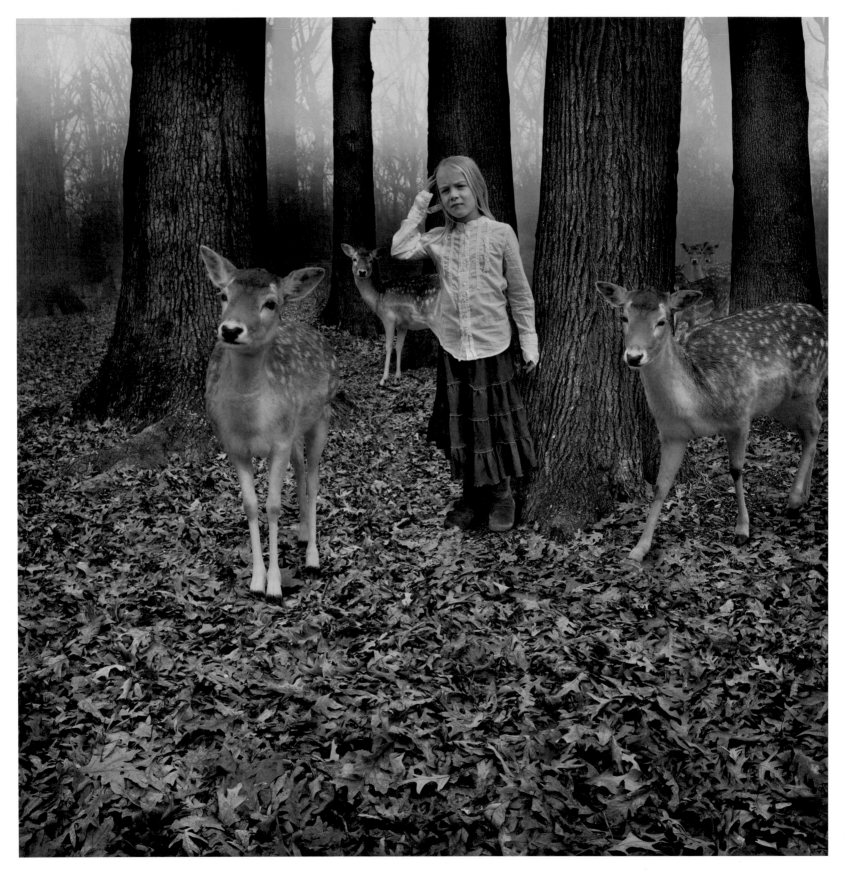

Too Delicate For Daylight

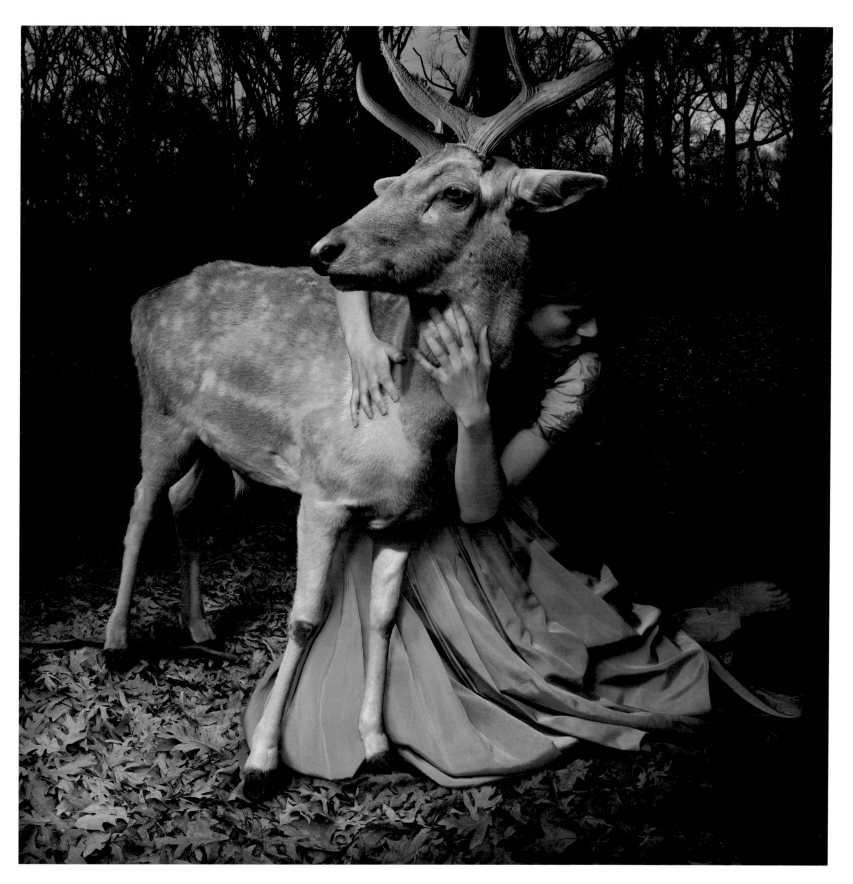

Camouflage

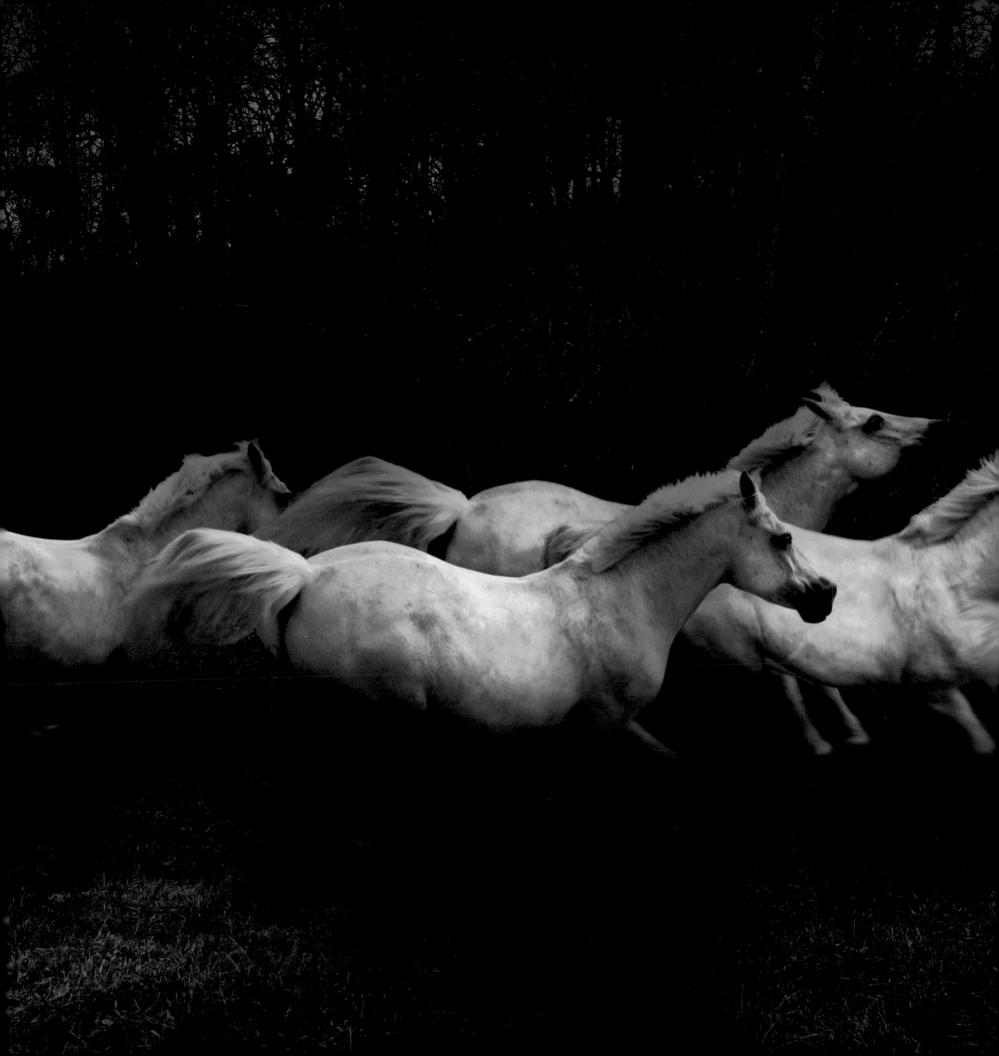

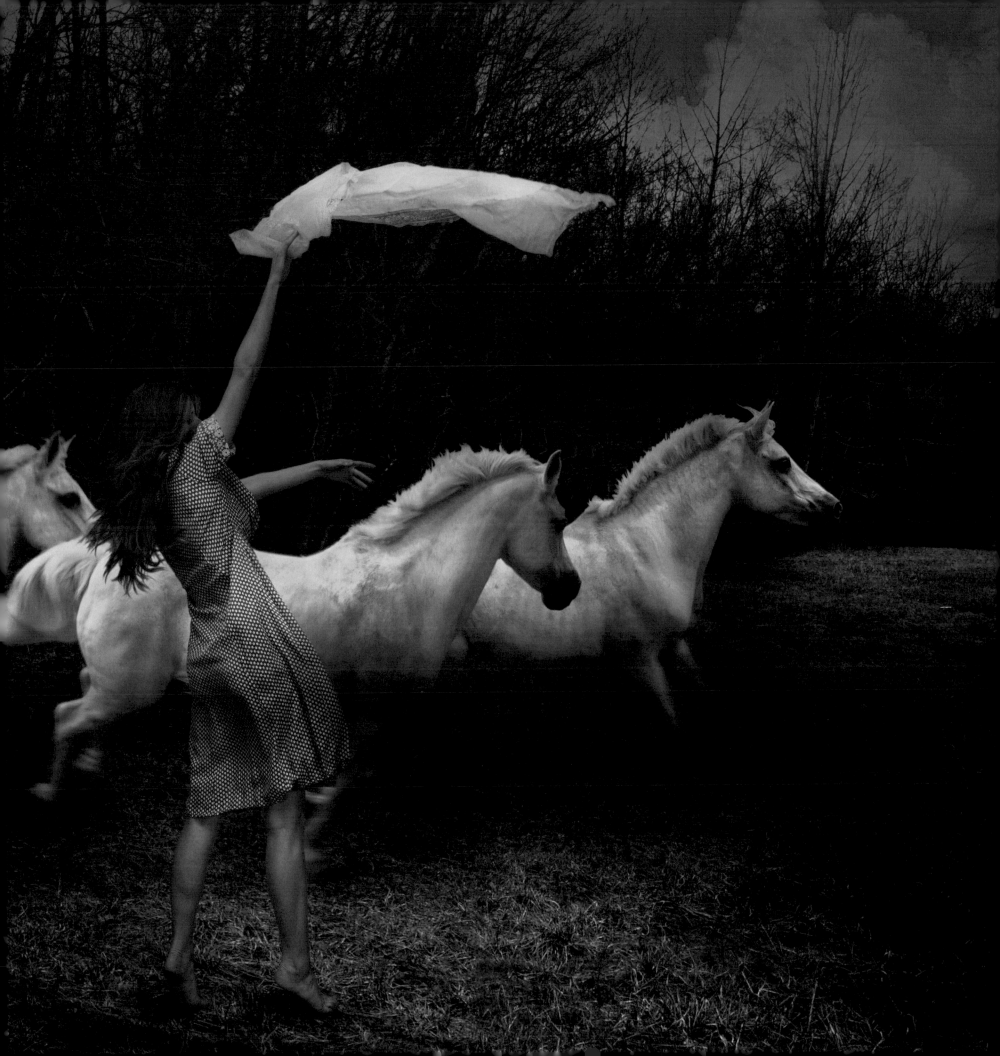

The Goatherd

Preceding spread: *Impending Storm*

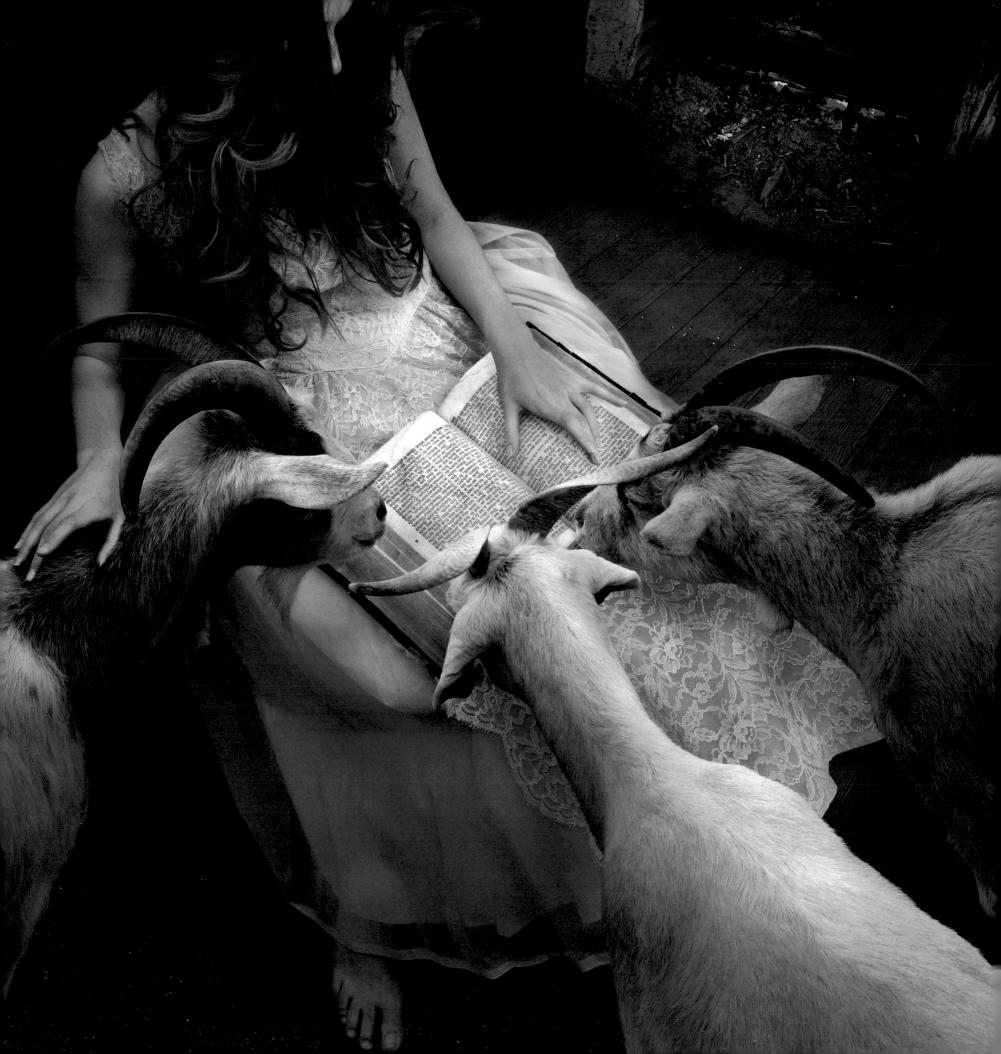

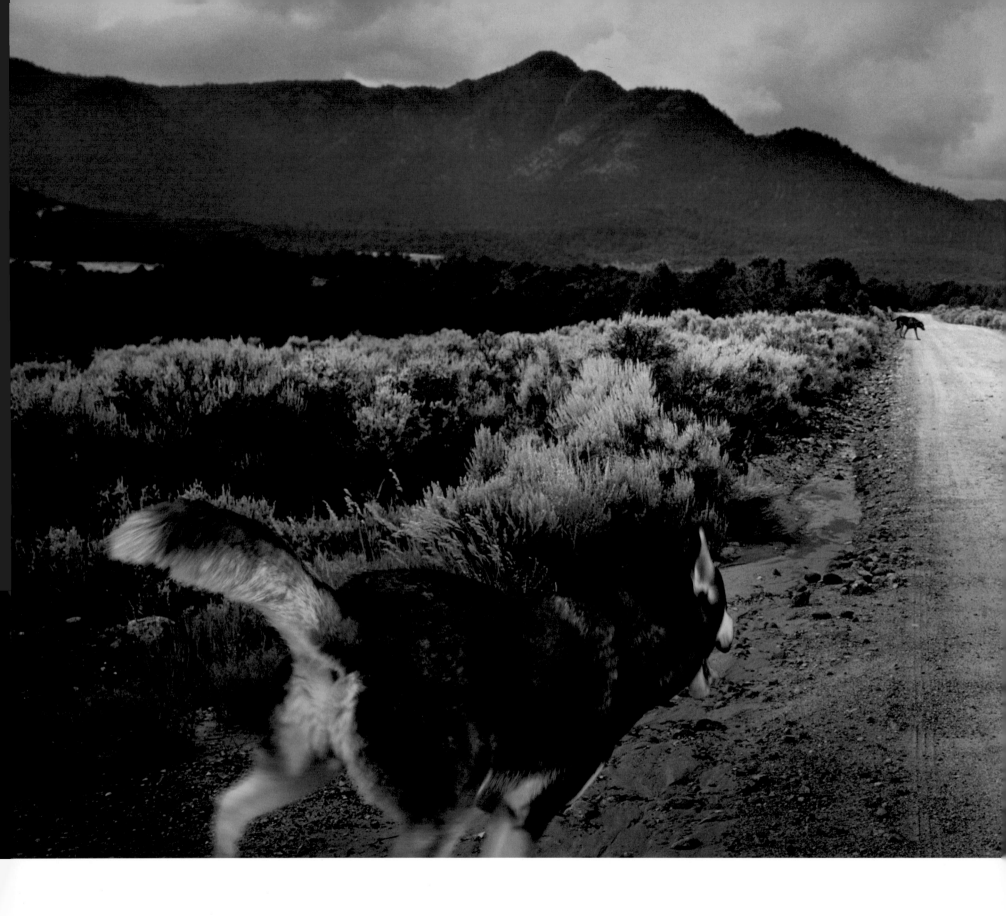

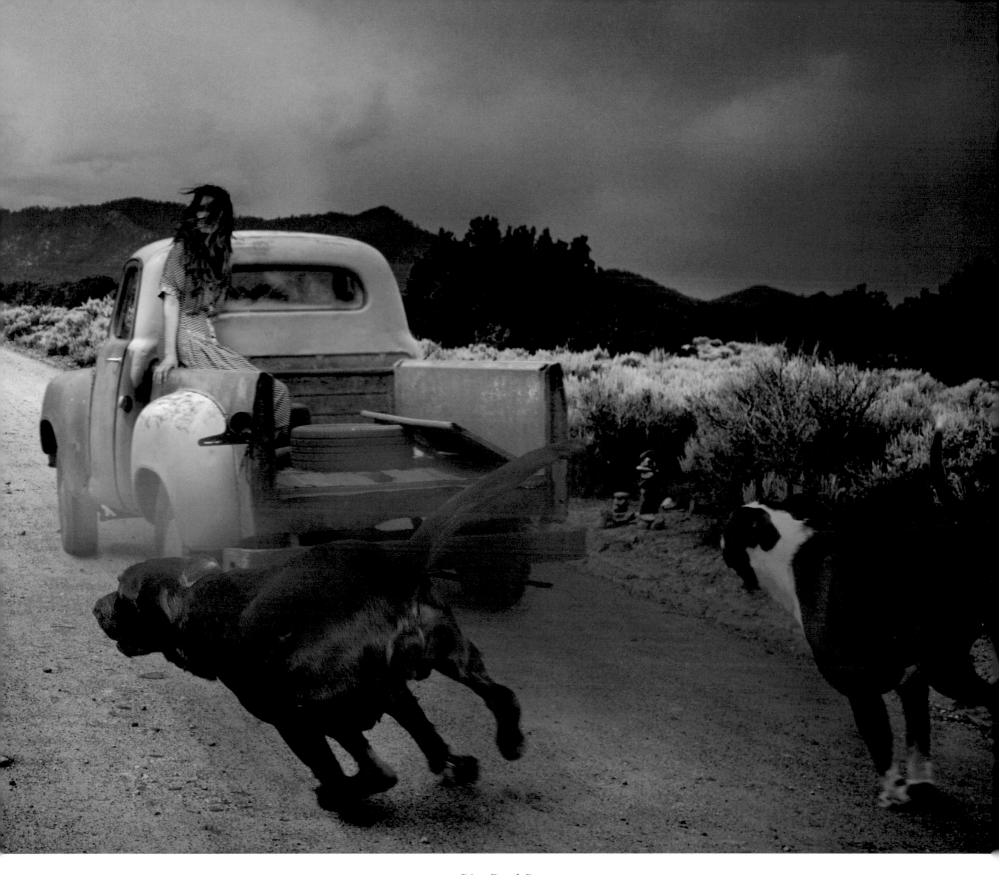

Dirt Road Dogs

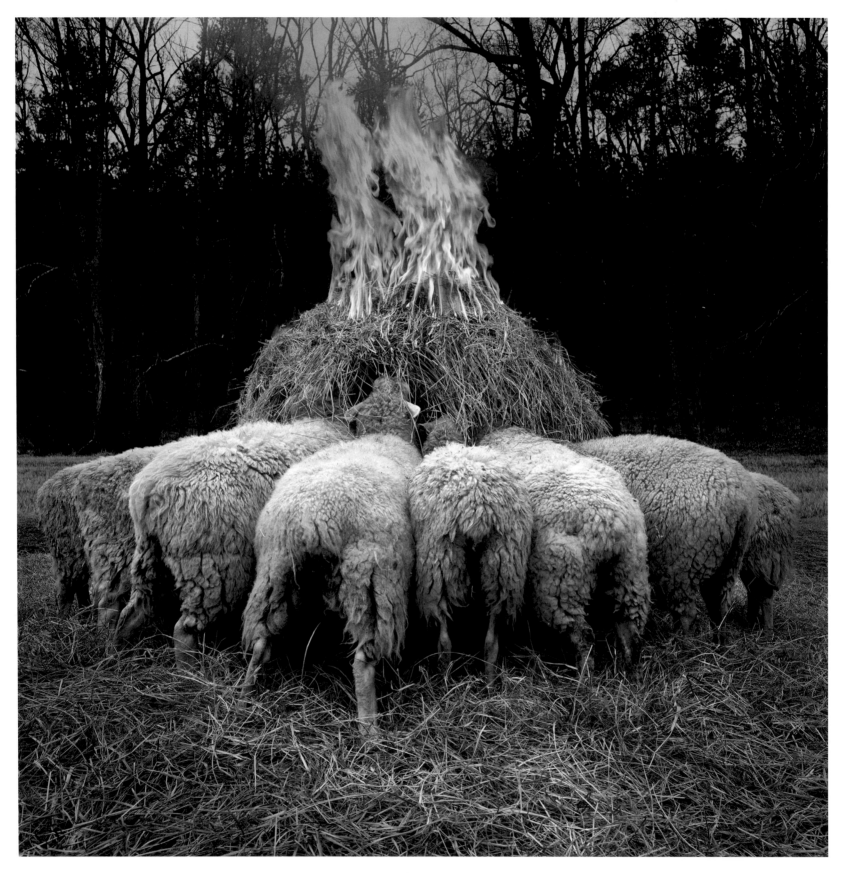

Feeding Time

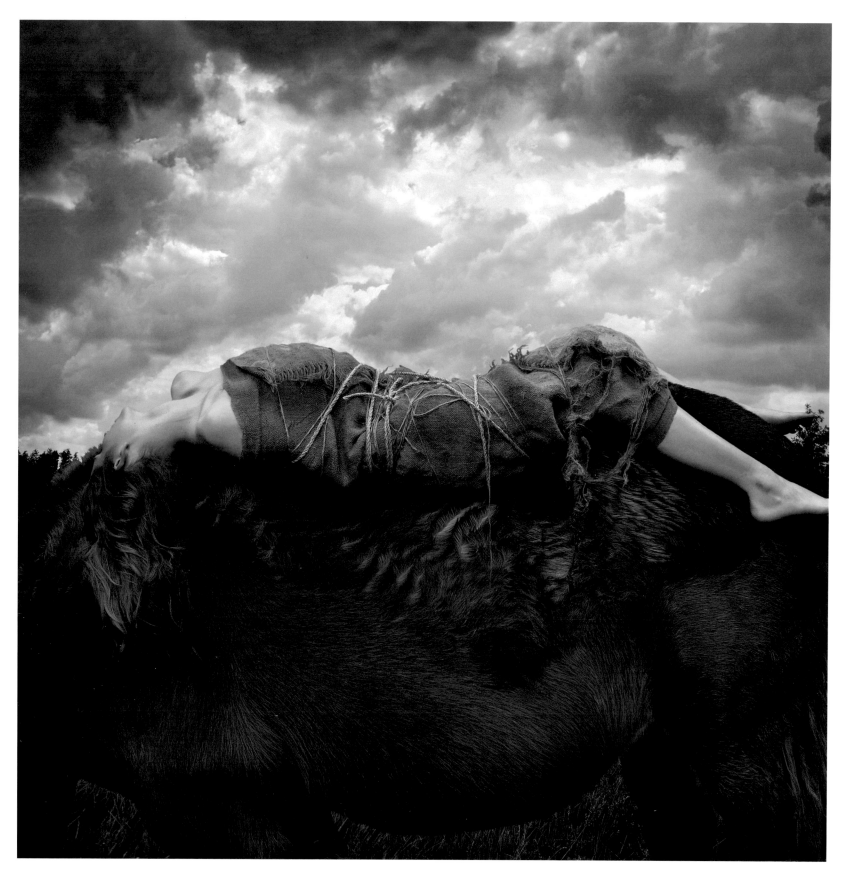

Storm Clouds

Saccharine Perch

Following spread: *Flying Big Blue*

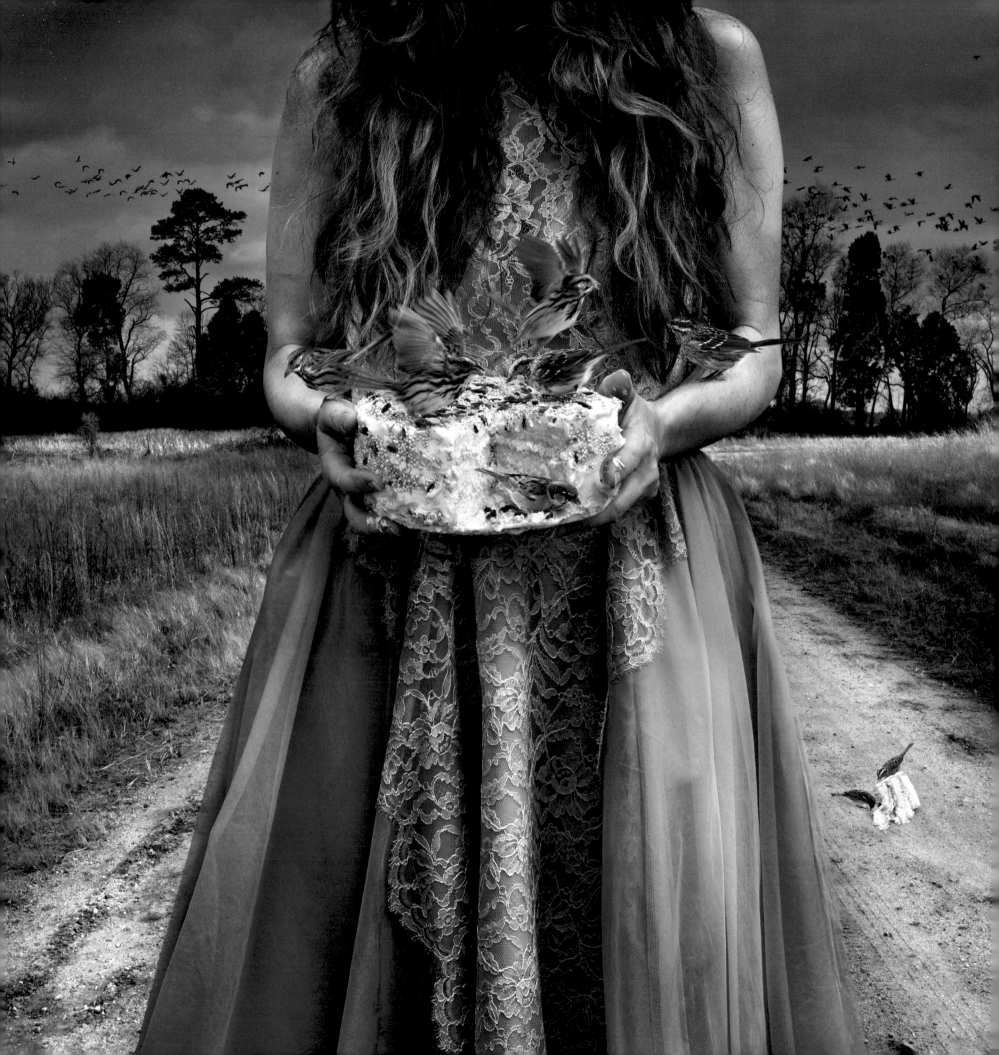

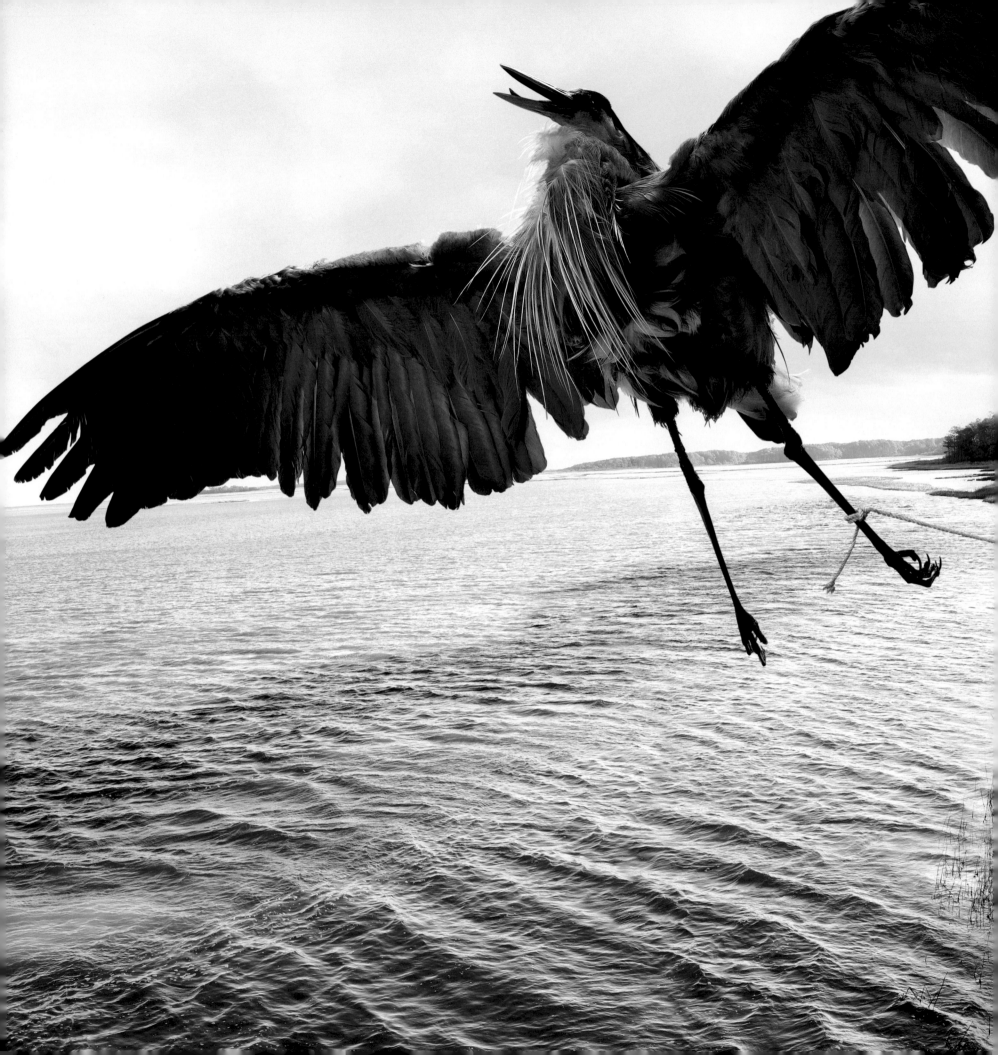

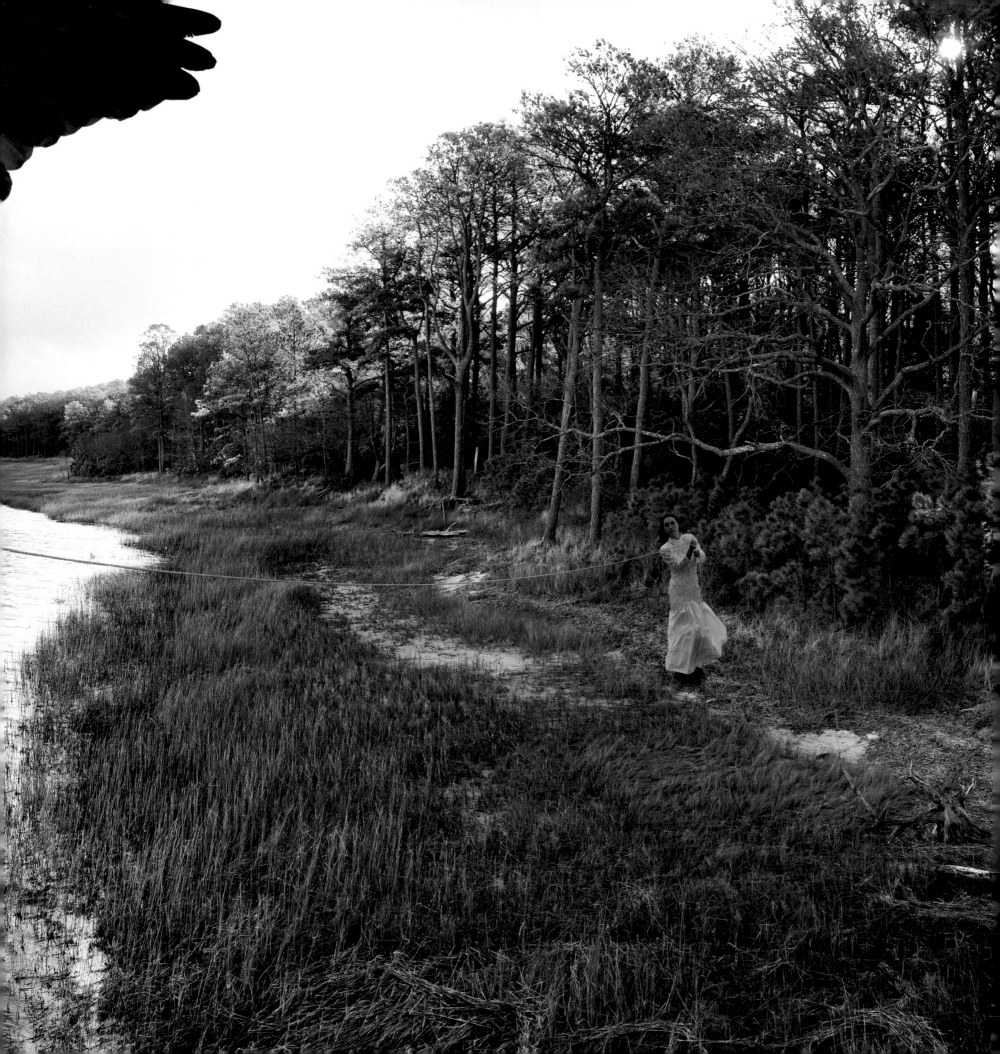

Marwari:
Indigenous Spirits

2009

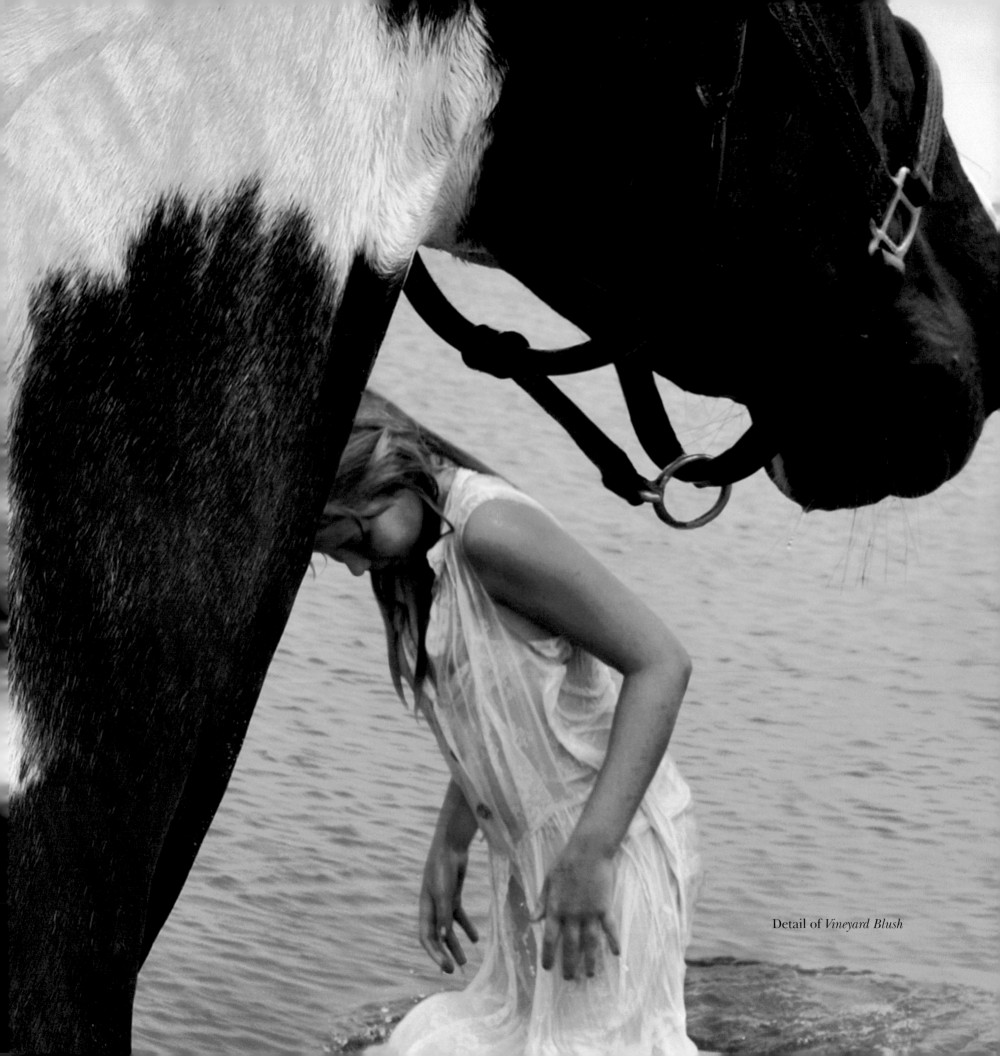

Detail of *Vineyard Blush*

Marwari:
Indigenous Spirits

In my eyes, horses represent that which is beautiful and
sacred in nature. In particular, the noble Marwari horses from India have
captured my attention after an inspirational encounter with them.
Known for their loyalty and bravery, the Marwari were considered divine
beings as far back as the twelfth century. Victimized by difficult
economic times, poor horse management, and global warming, the Marwari
horse population was almost decimated late in the twentieth century.
Fortunately, efforts currently are being made to preserve
the Marwari breed.

Inspired by the ancient Rajput art and the legend of the stallion
Chetak, I hope to capture the elegance and resilience of the Marwari horses.
In these photomontages I present dreamlike images of children at
play with the glorious Marwari. The Marwari horse series illustrates
both the struggle for survival and the hope for prosperity shared by
innocent children and animals.

• • •

Marwari Stallion #1

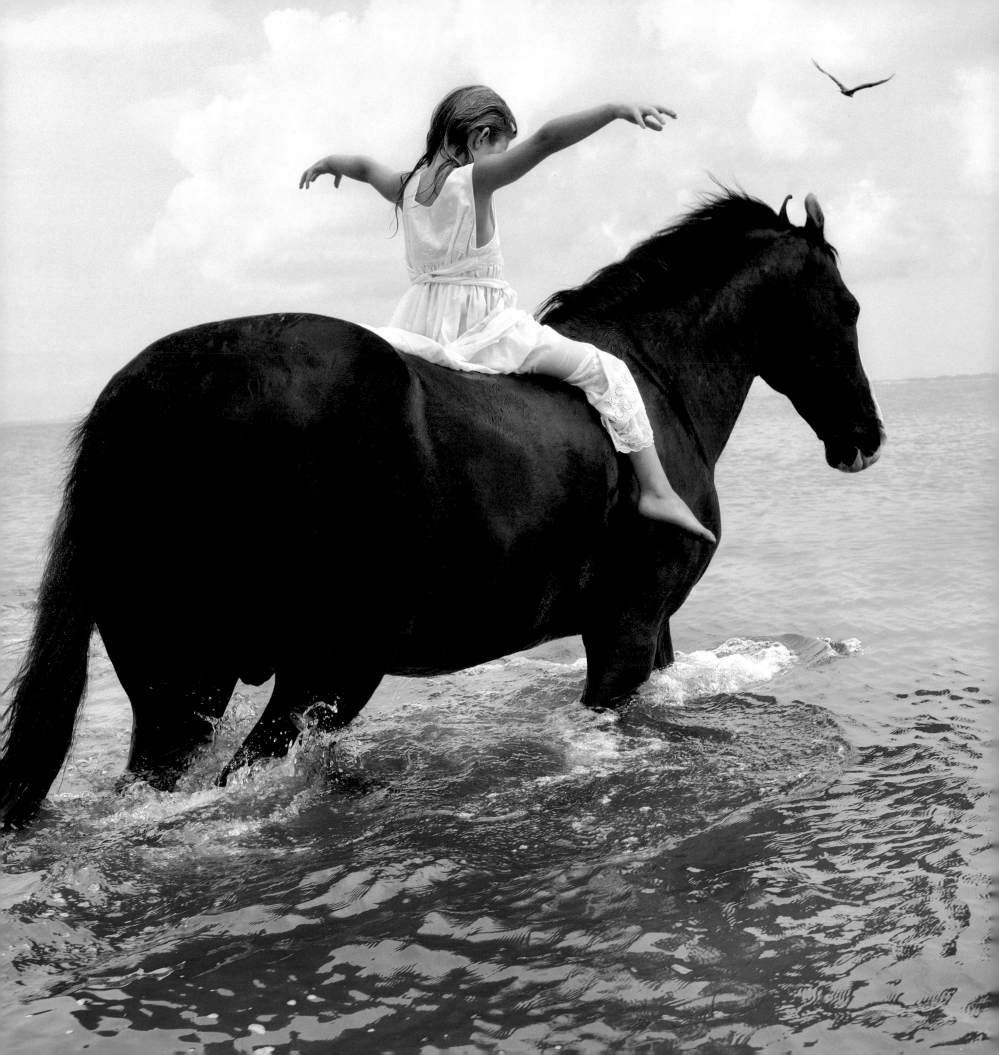

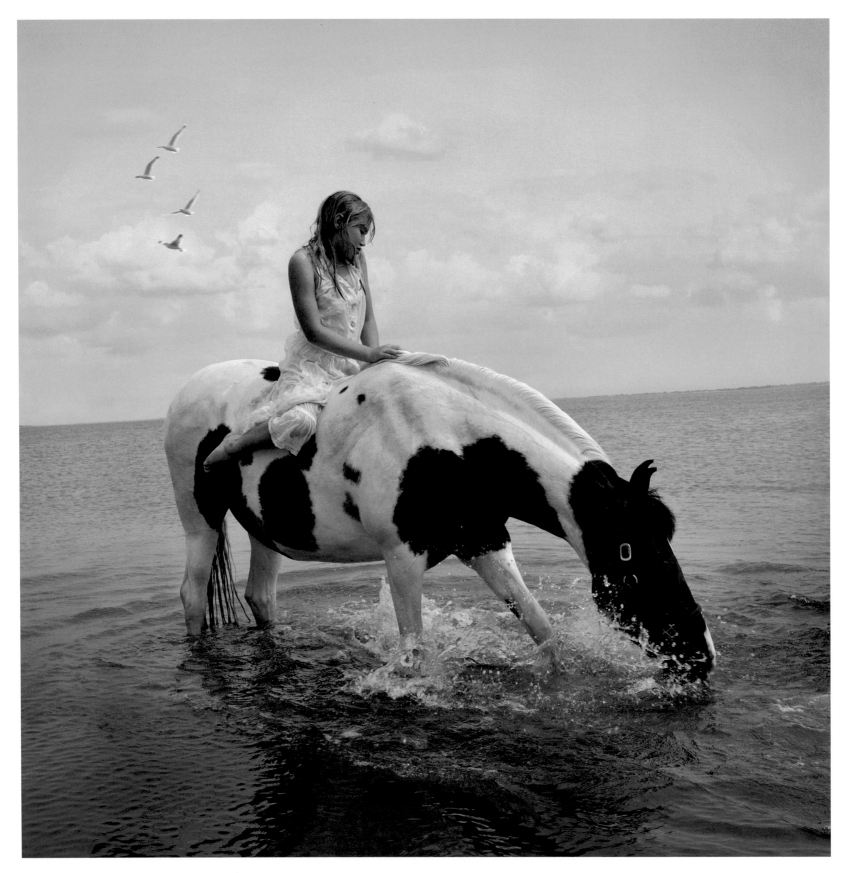

Mare Liberum

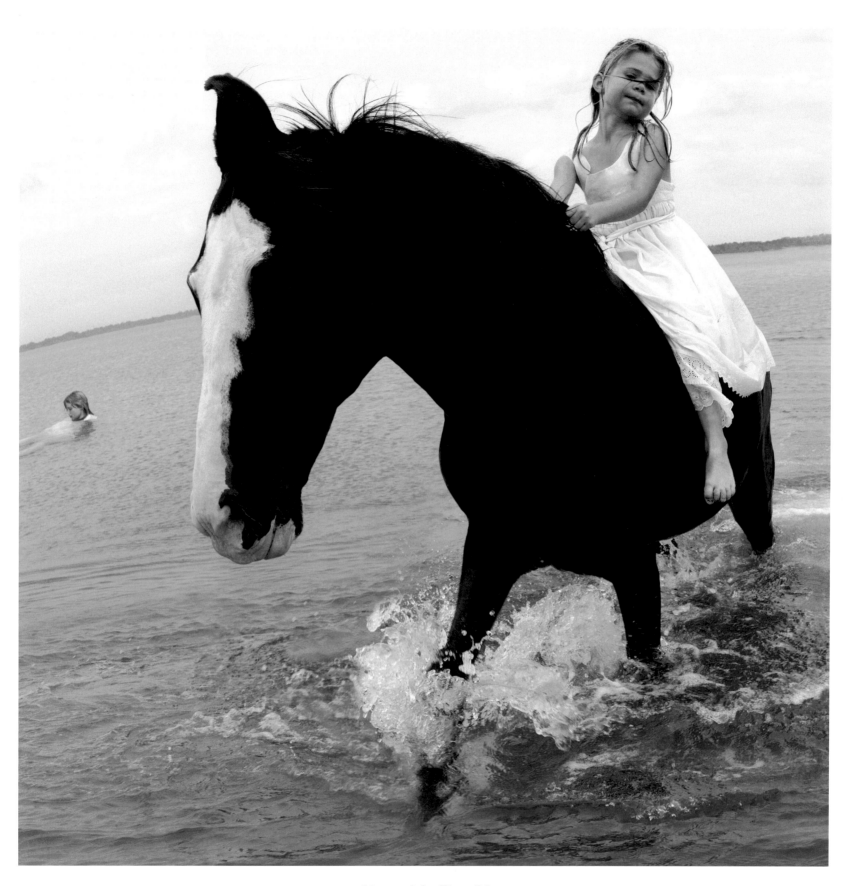

Marwari Stallion #2

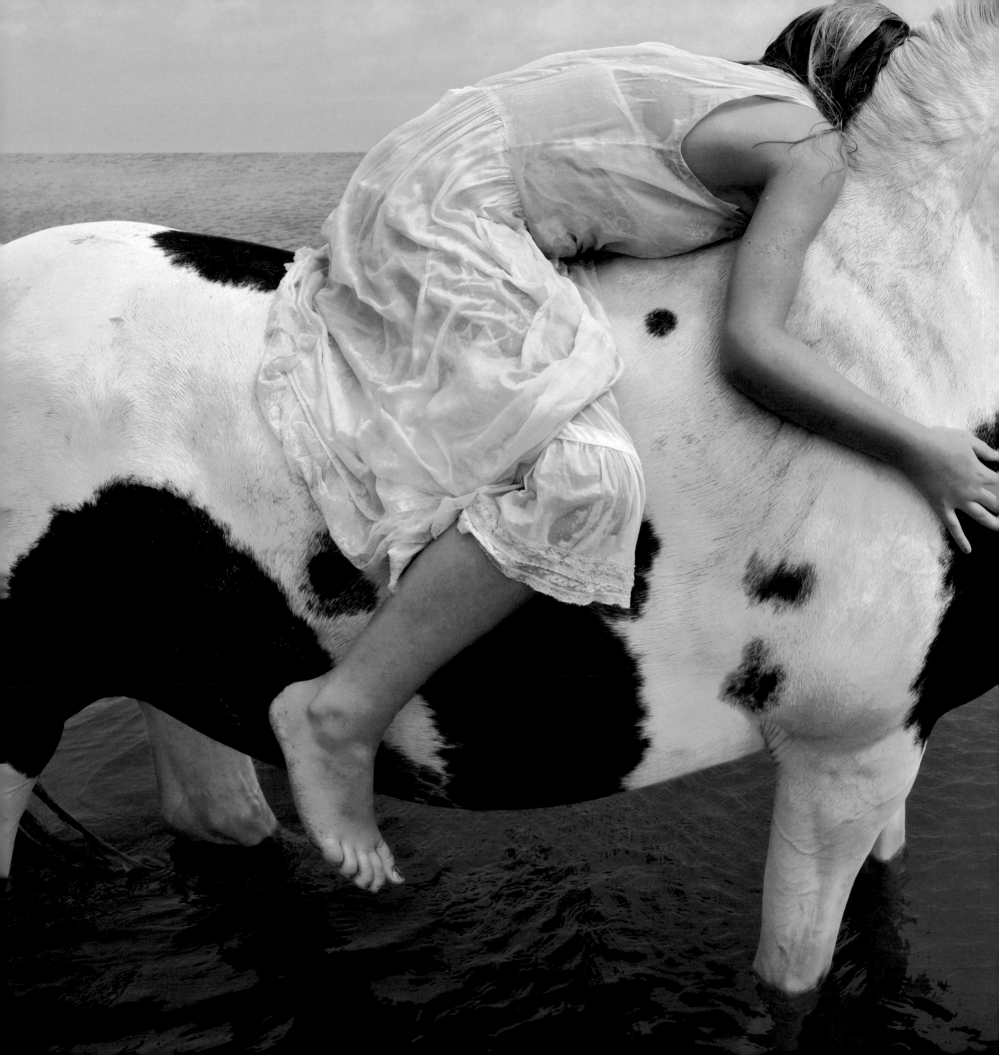

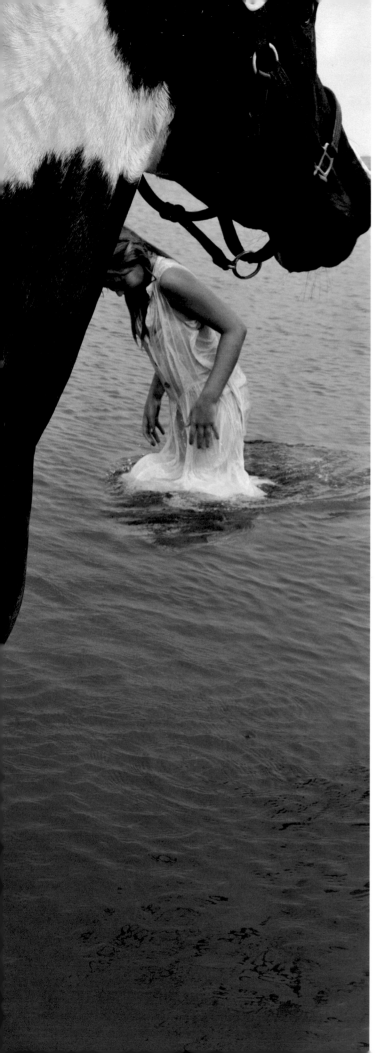

Vineyard Blush

Marwari Stallion #3

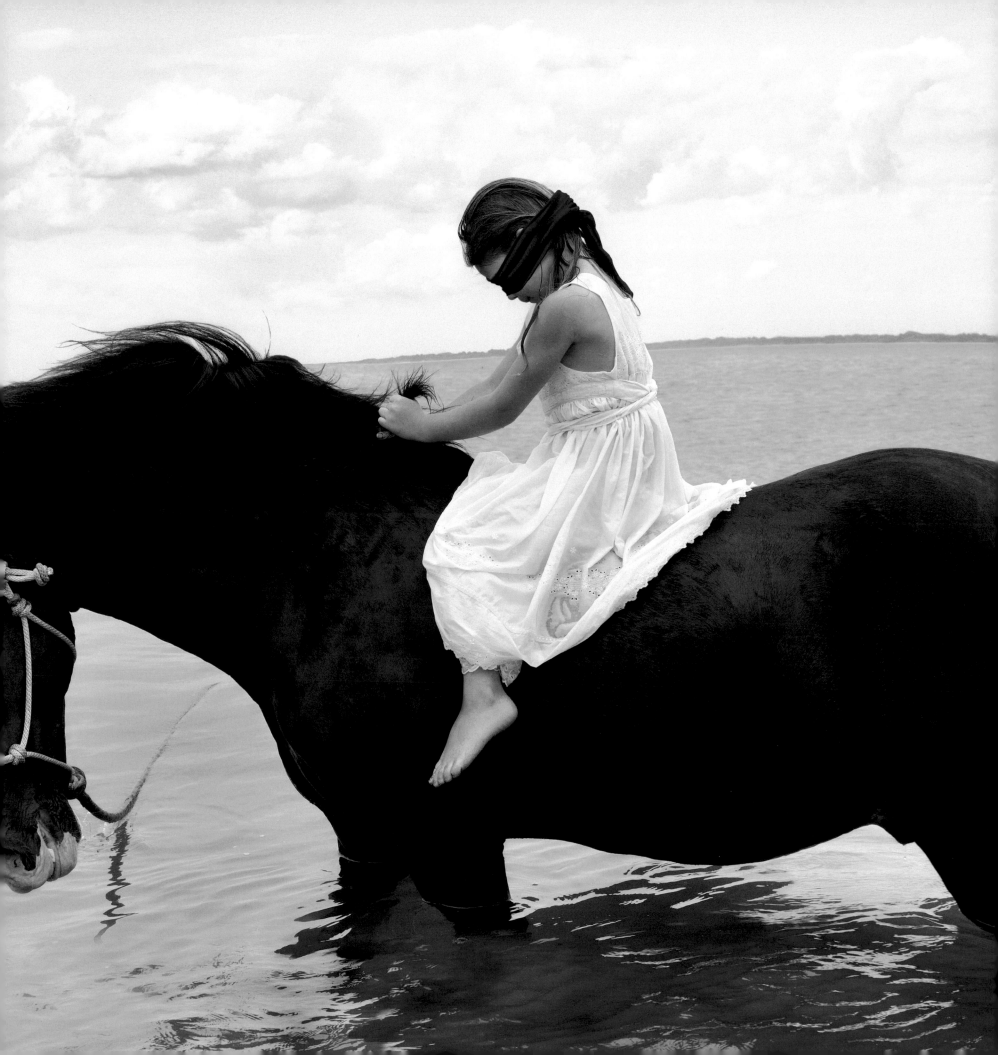

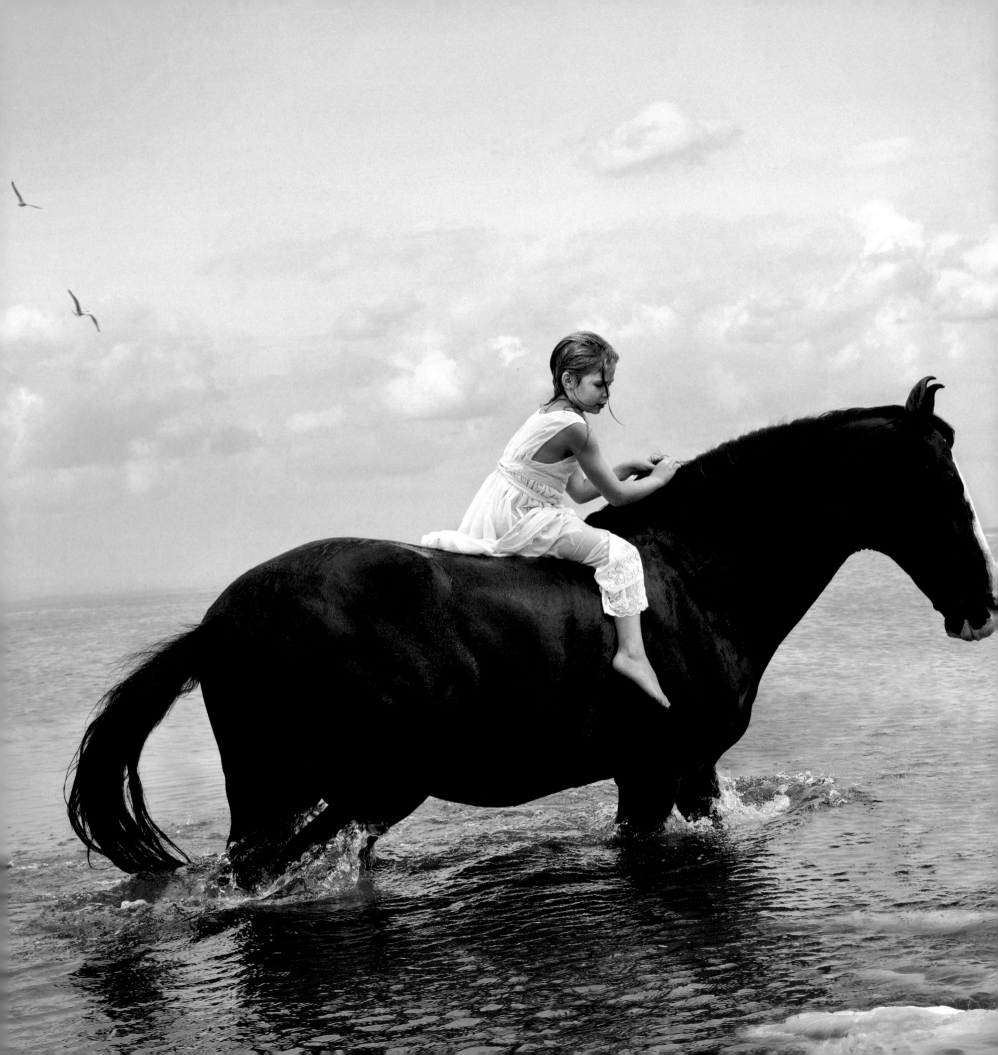

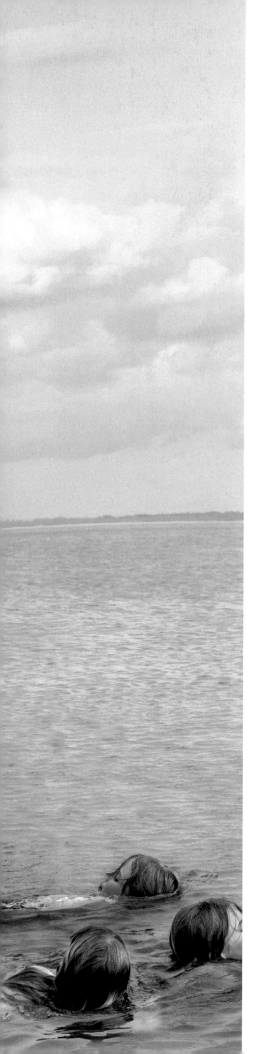

Maritime Sentry

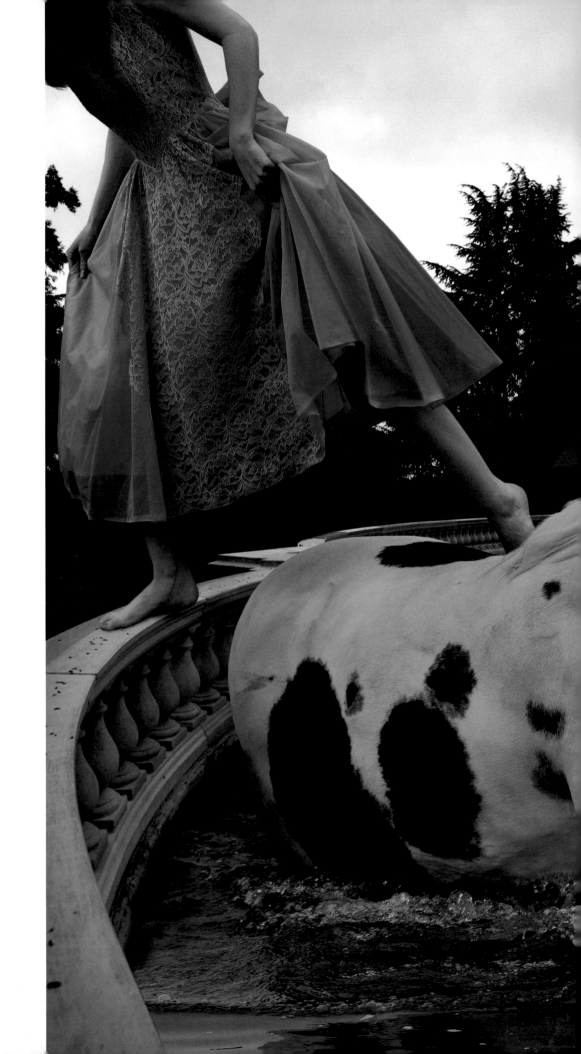

Unbridled Waltz

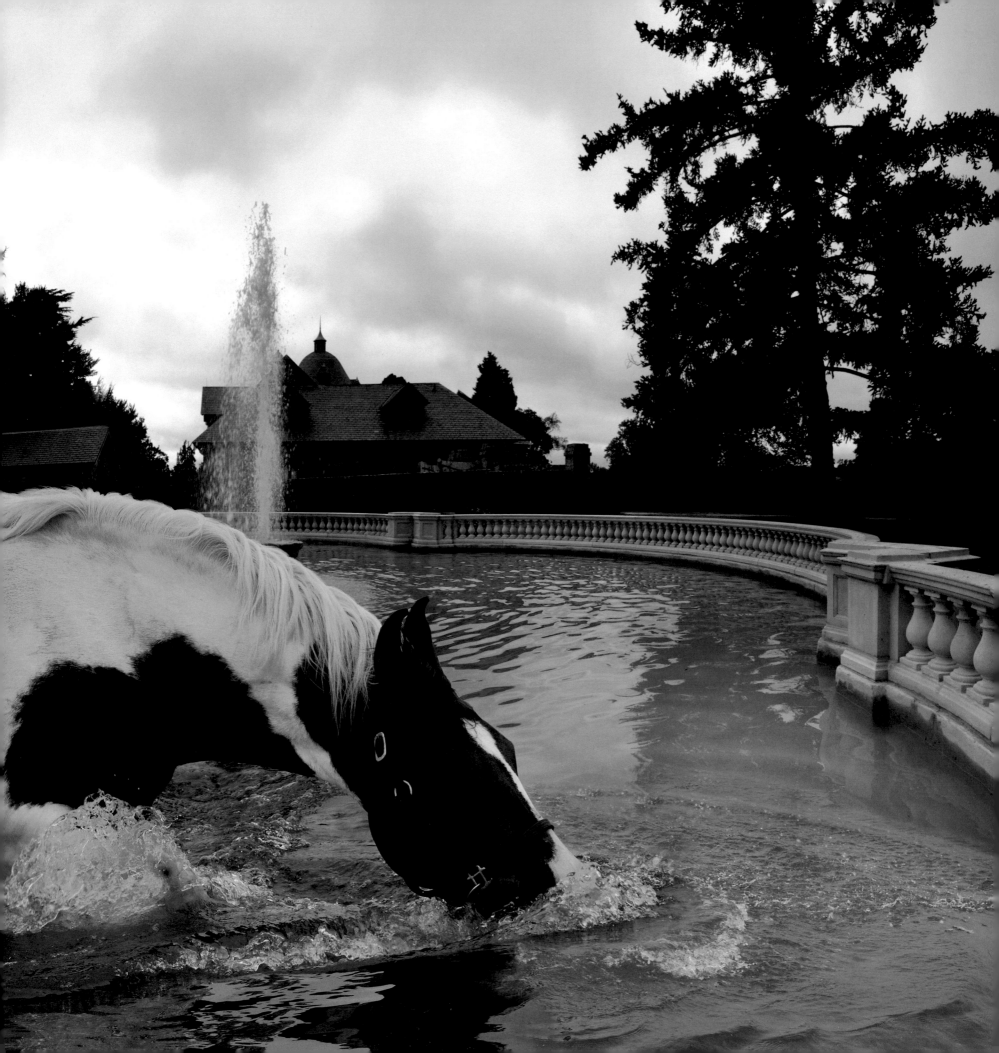

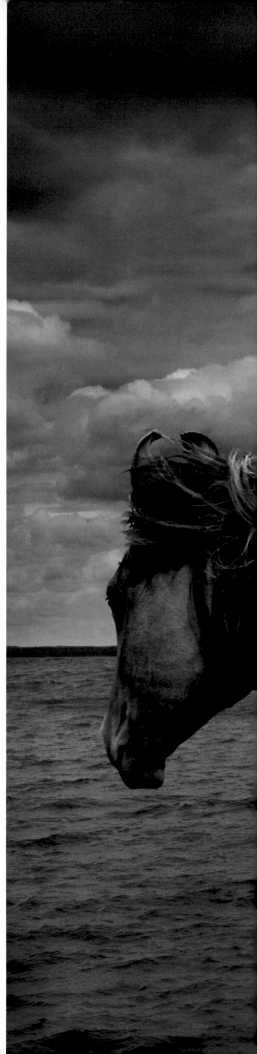

Deliverance

Following spread: *When Girls Dream*

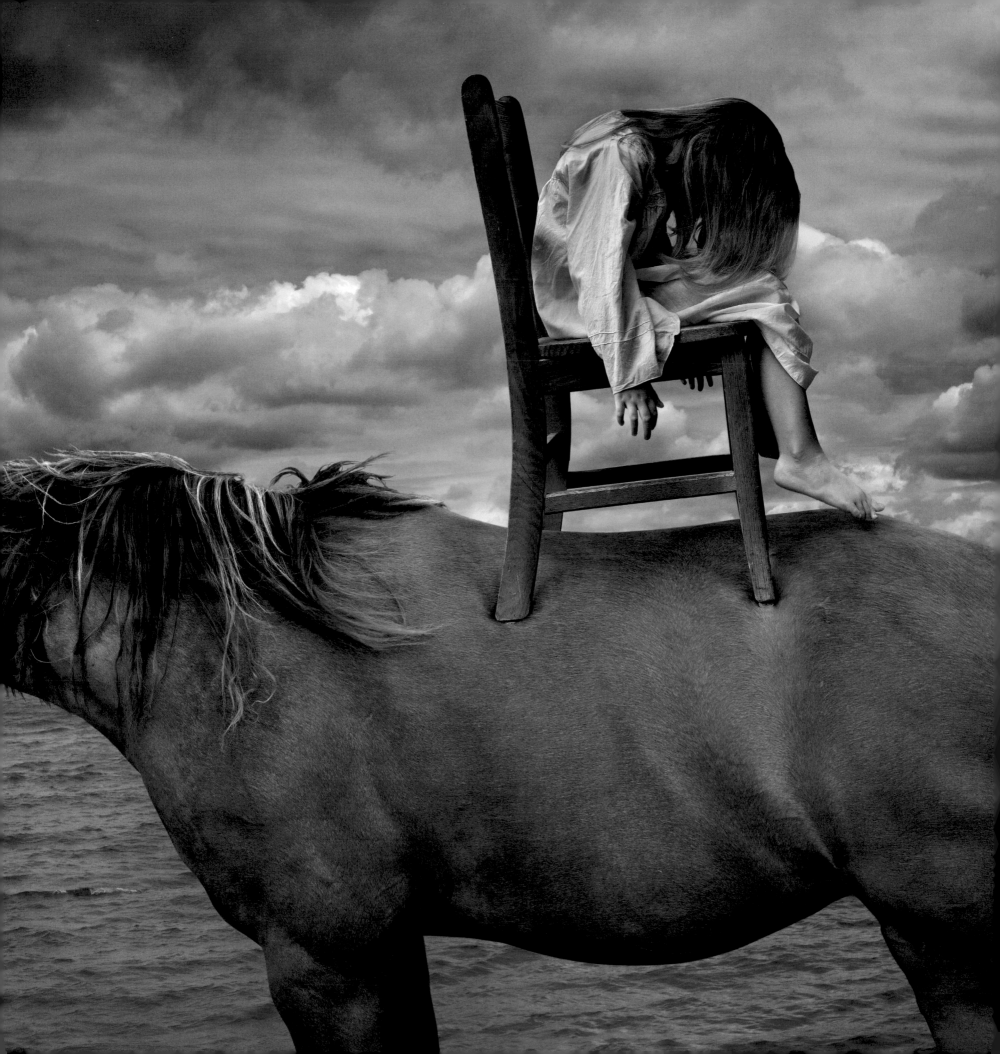

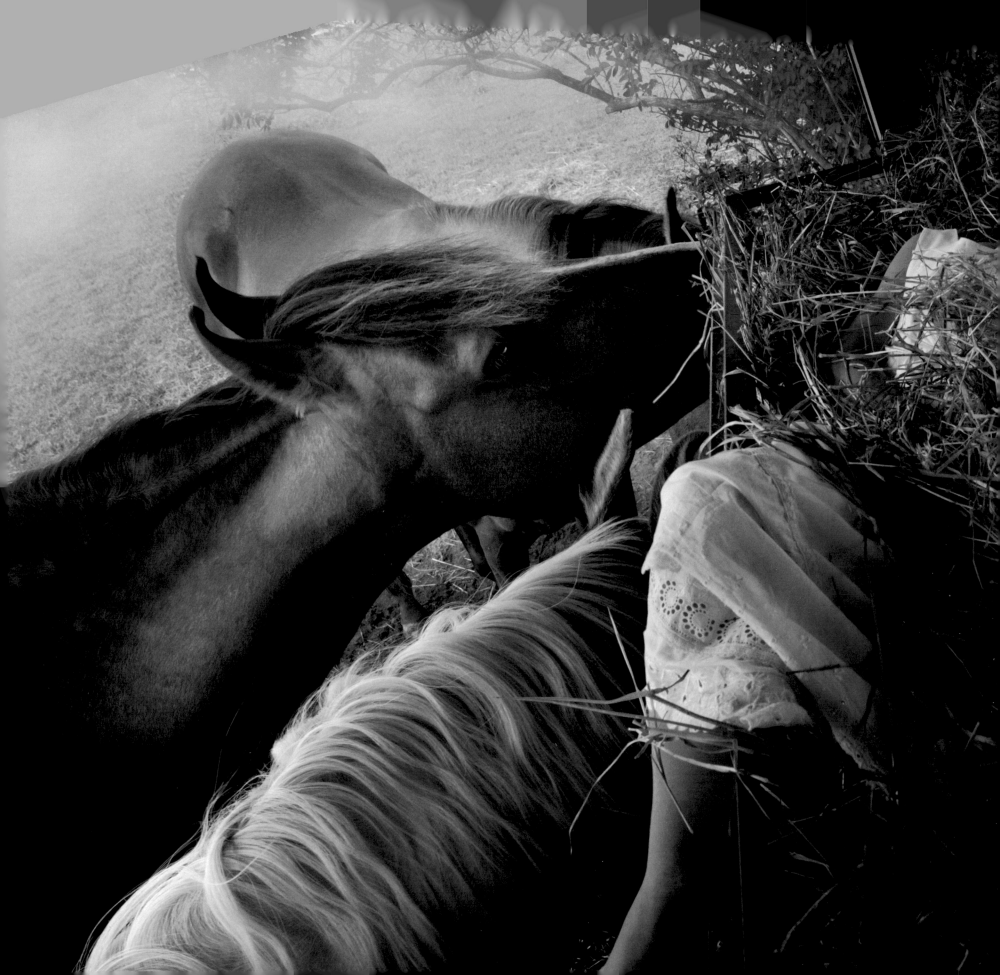

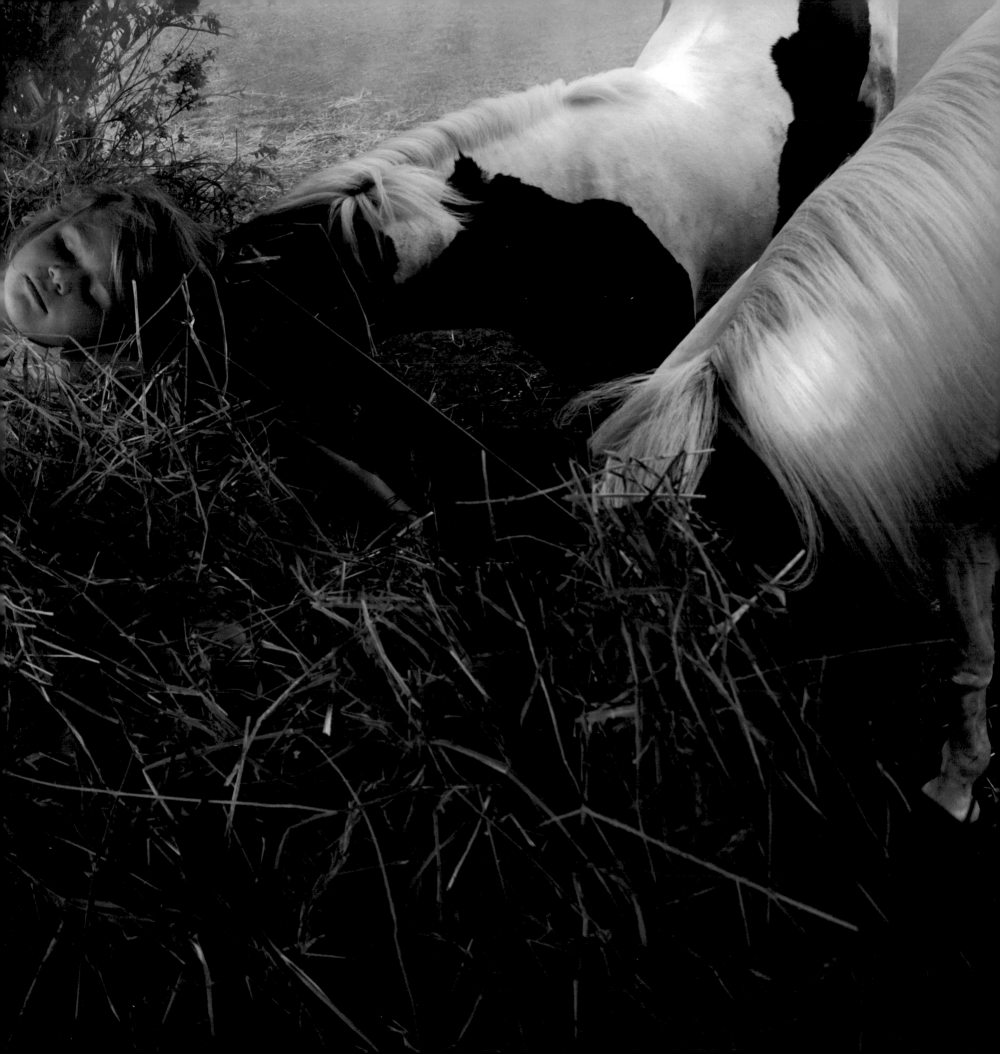

Dreaming In Reverse

2010

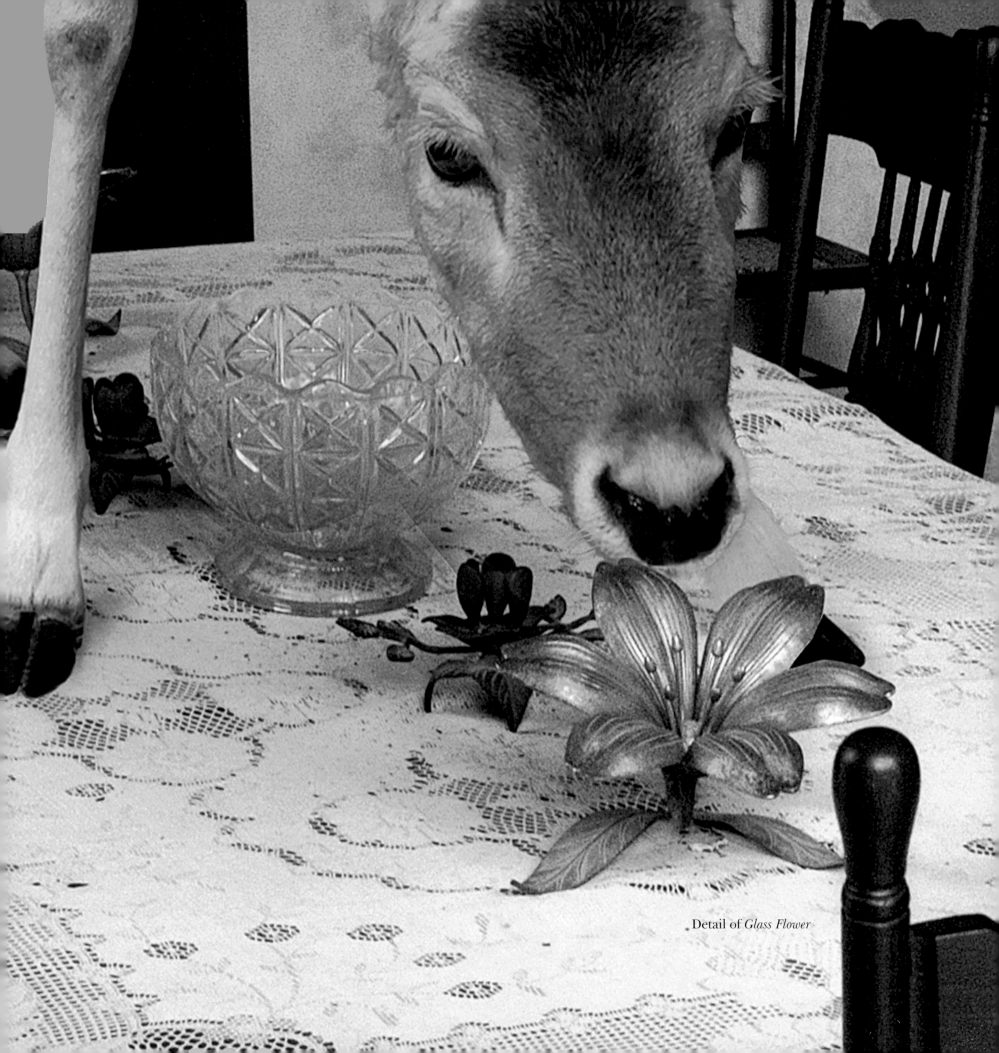

Detail of *Glass Flower*

Dreaming In Reverse

Twenty-five years ago I traveled freely throughout the Mexican
countryside where I relished a warm, welcoming, and slow-paced style
of living. I was heartened by the physical beauty of the landscape
and the simple, pure lifestyles shared by both the Hispanic and indigenous
people of Mexico. A sense of spirituality and magic were imbedded
in their religious practices, crafts, art, dance, and literature. Recently, I
returned to Mexico where I experienced a country teetering on the brink of
change created by increasing political and economic challenges,
and exacerbated by the trappings of global consumerism. The Mexican
people appeared handcuffed by demands largely outside of their
control and threatened by the potential loss of their
cultural richness.

Sensing that little time remains to photograph the beauty of Mexico,
I have created the series "Dreaming In Reverse" to express both my concern for
cultural loss, as well as my appreciation for the inherent loveliness of
Mexican life. Employing magic realism, an art genre used in the early twentieth
century in Mexico, I have created images of Mexico which seem true and believable,
but also perhaps improbable. These photomontages illustrate my dreams
for the Mexican people that they are able to retain the authenticity
of their culture.

. . .

Caging The Songbird

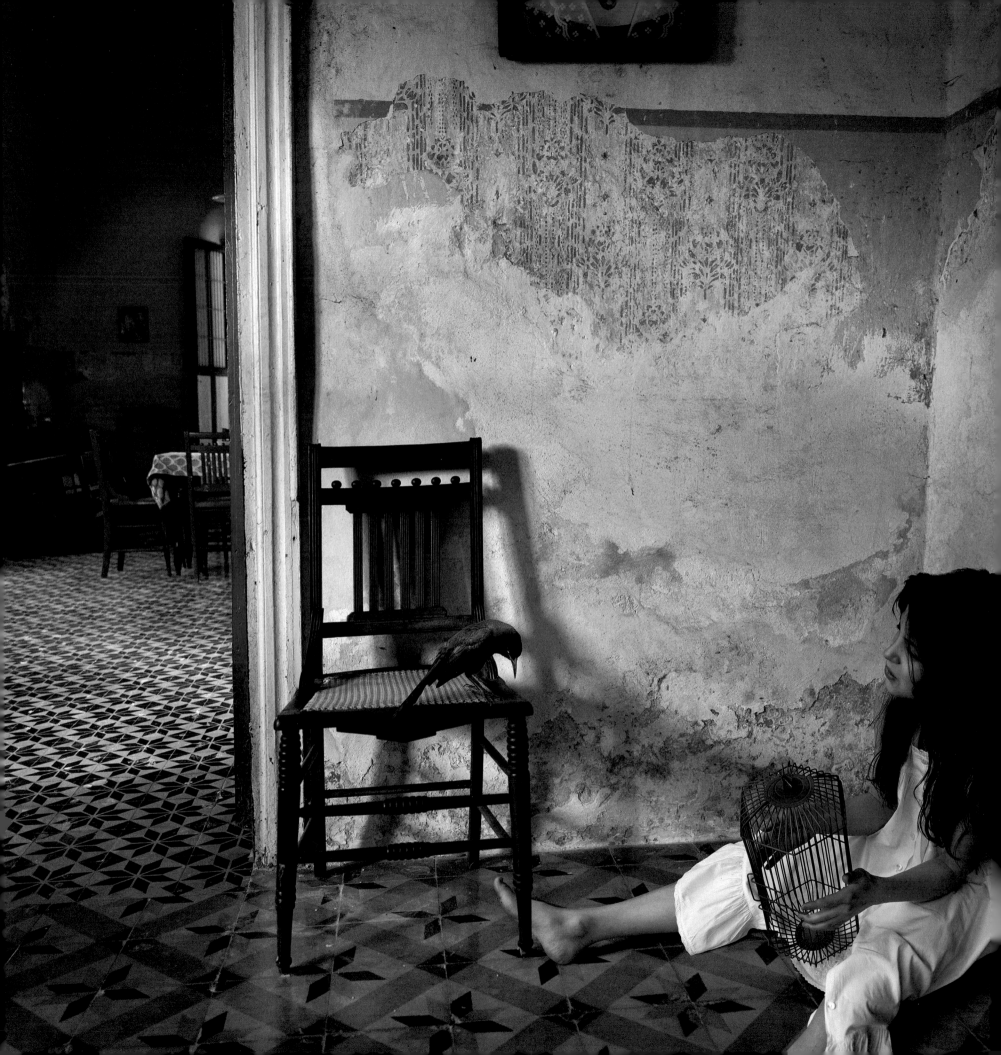

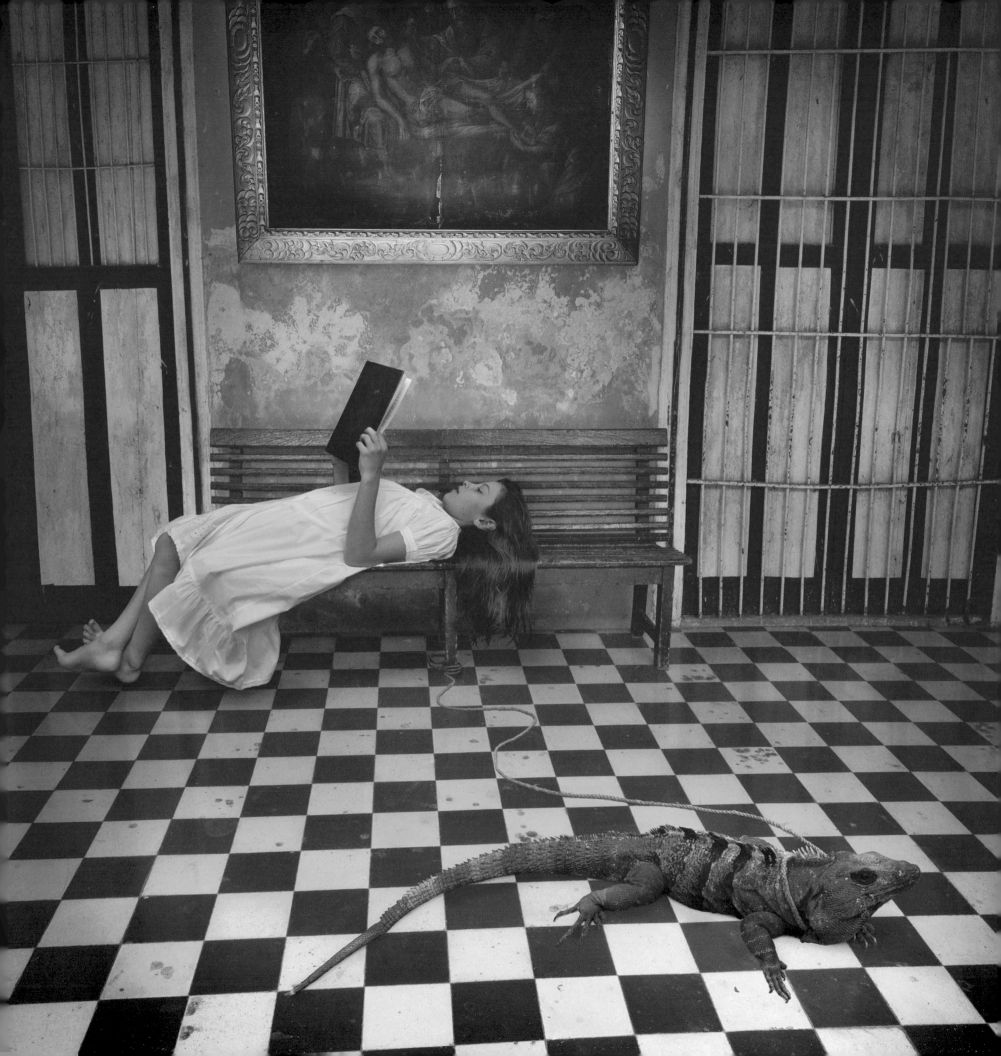

Afternoon With Octavio

Presumptuous Guests

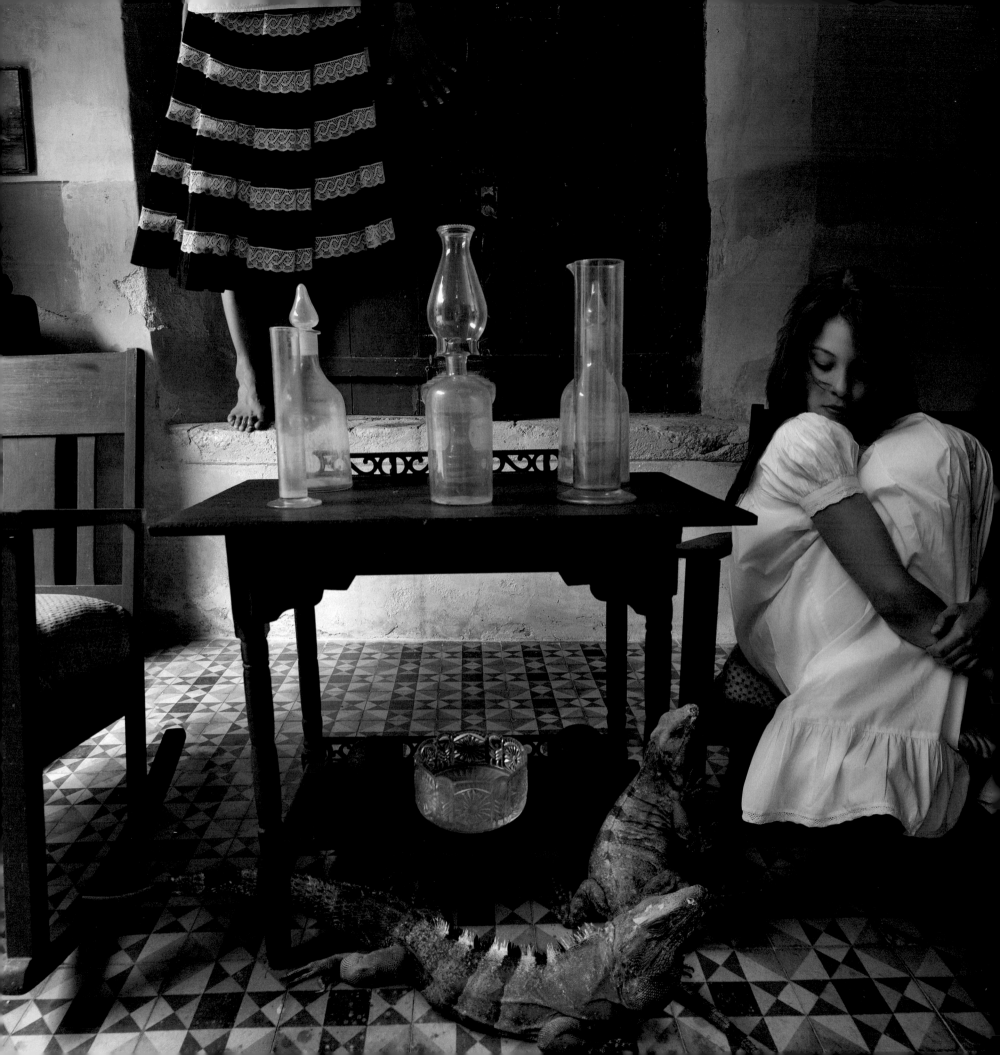

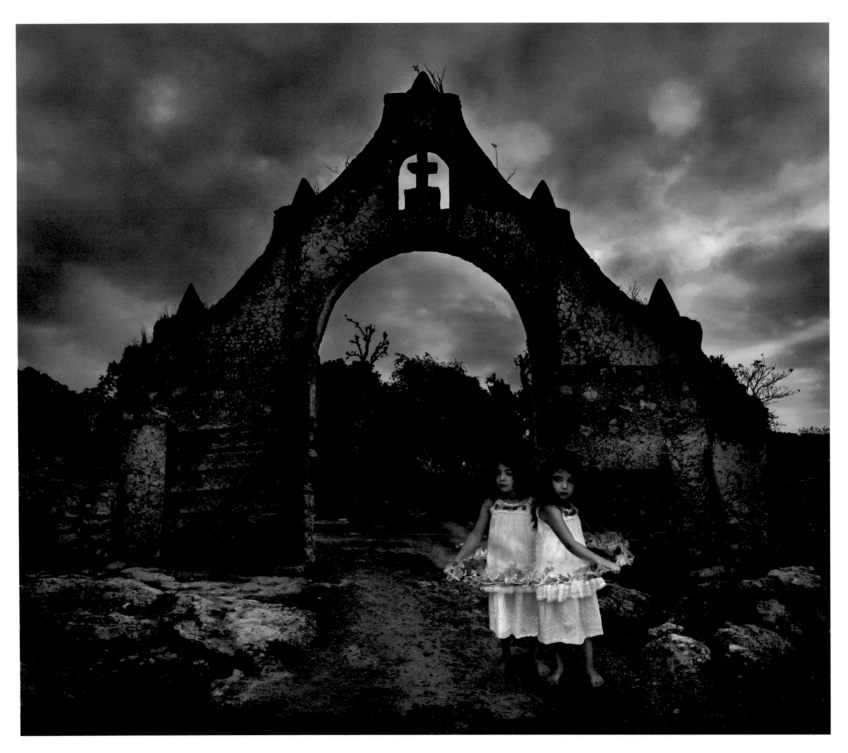

Ring Of Fire

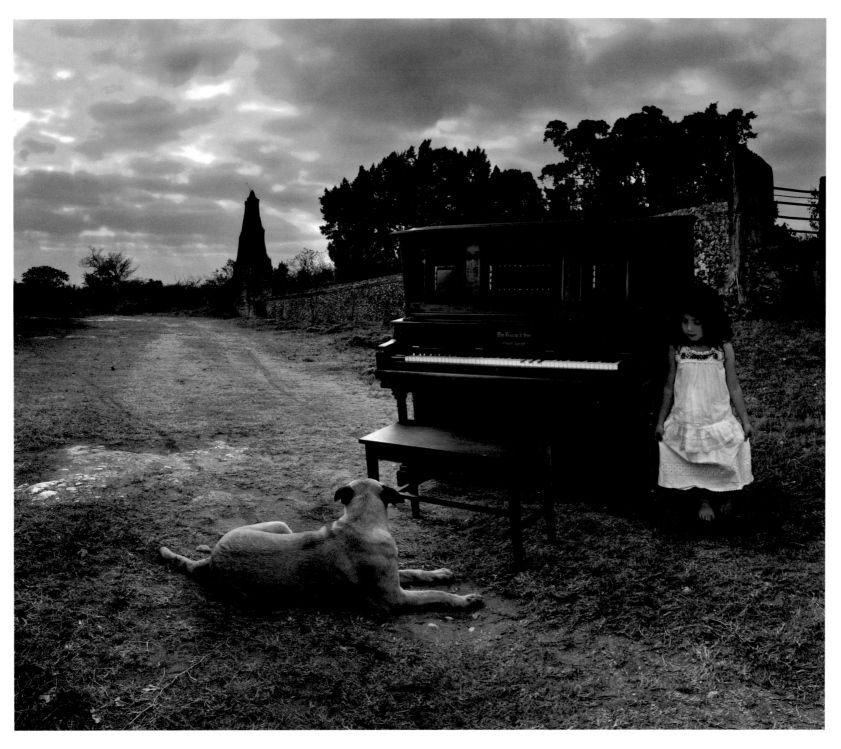

Stuck In The Key Of C

Glass Flower

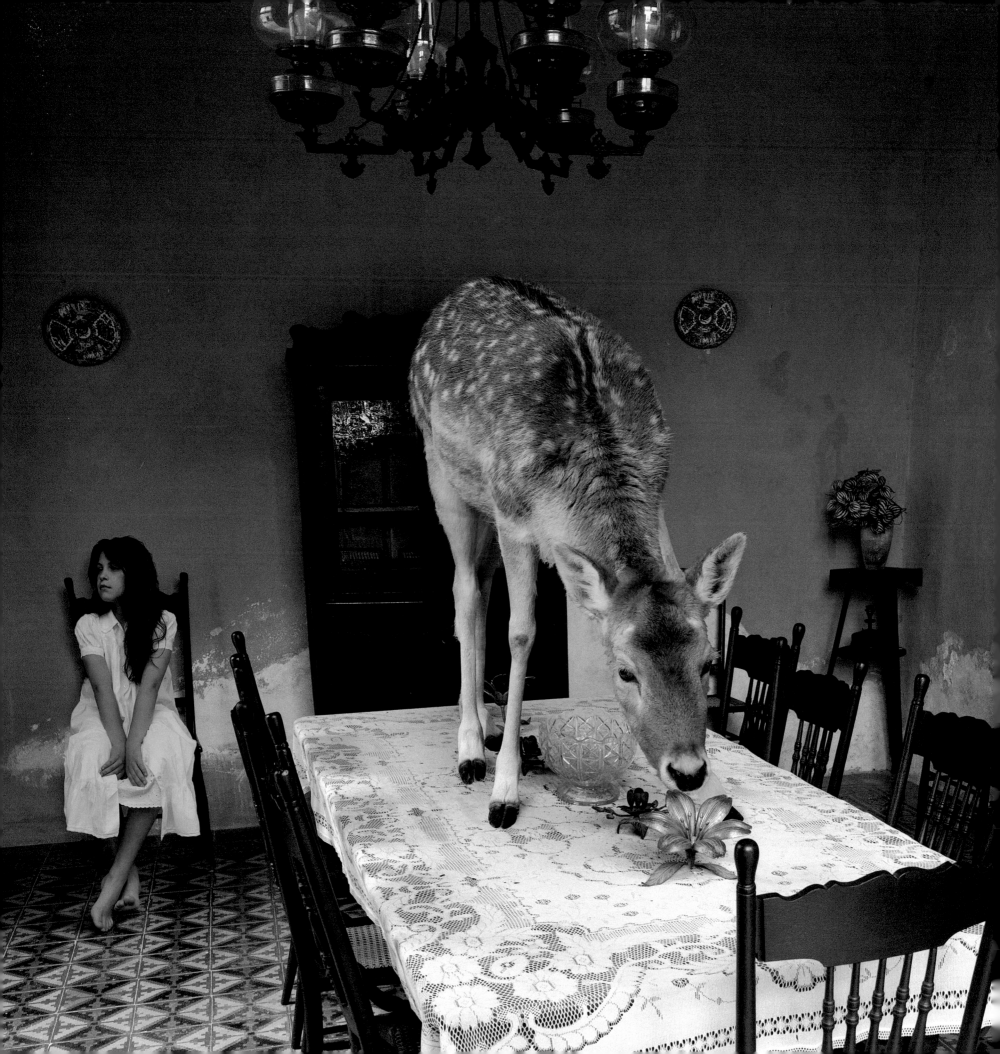

Cobblestone Commotion

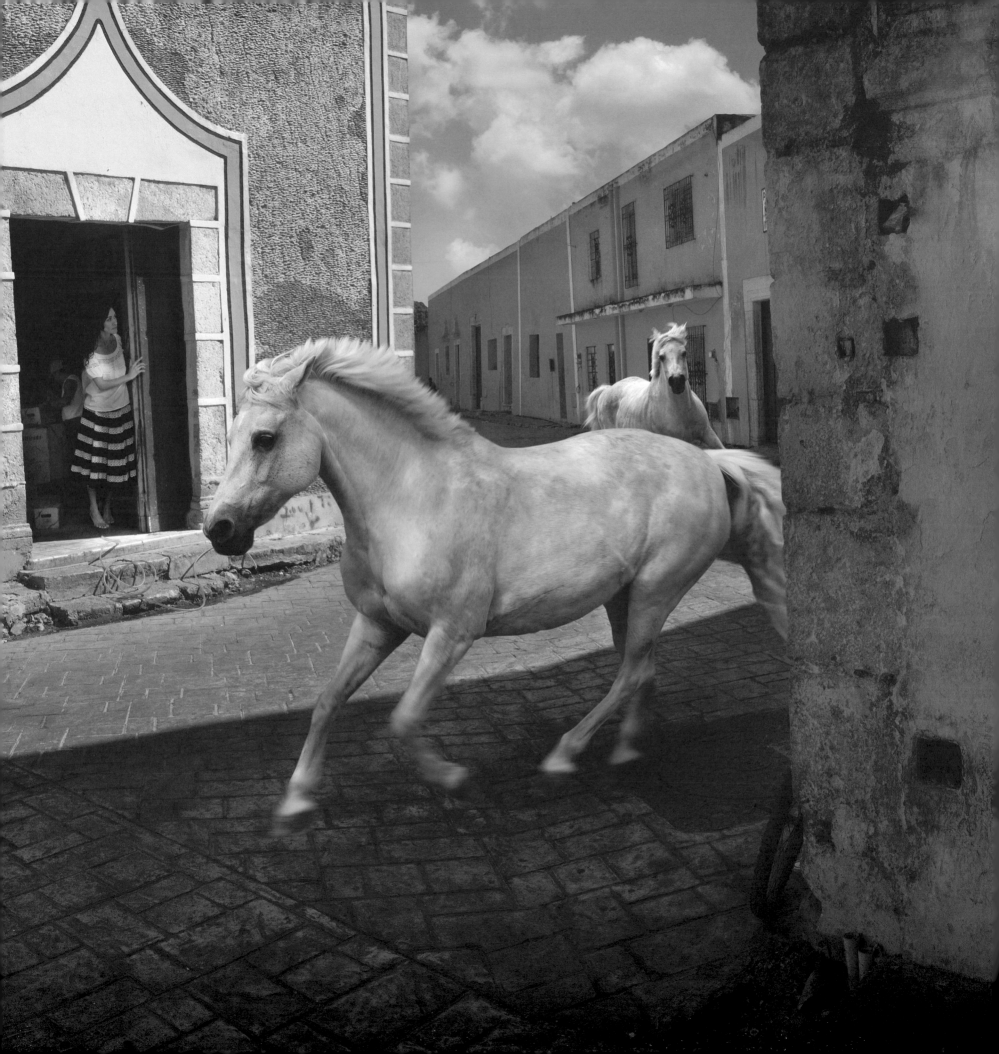

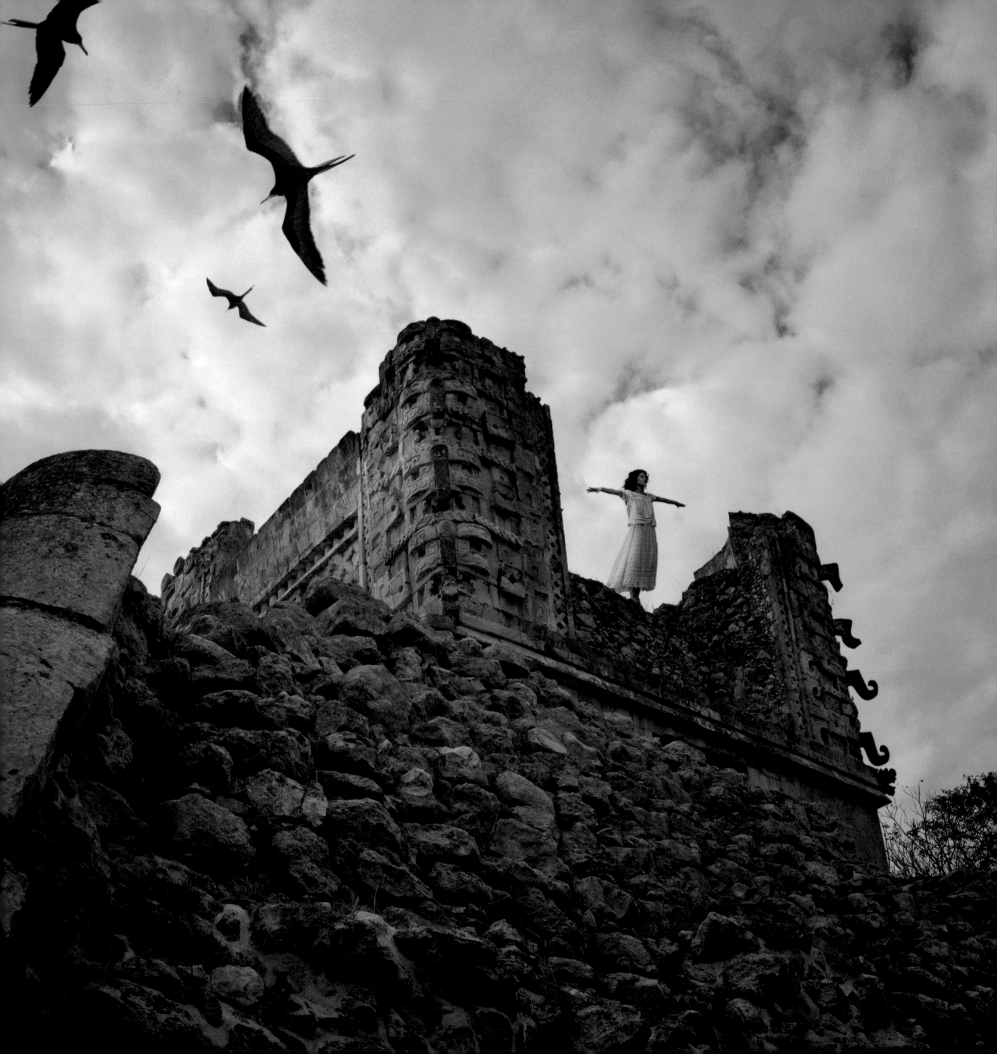

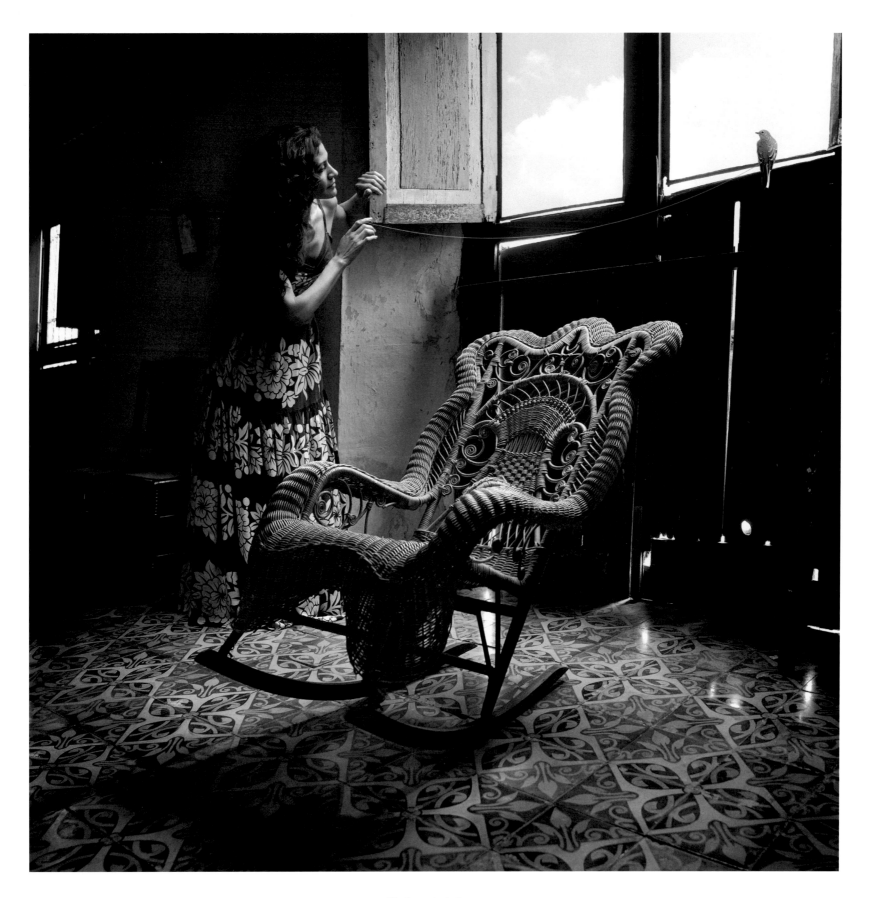

Tethered Aviator

Left: *Seabird Mimicry* Following spread: *La Torera*

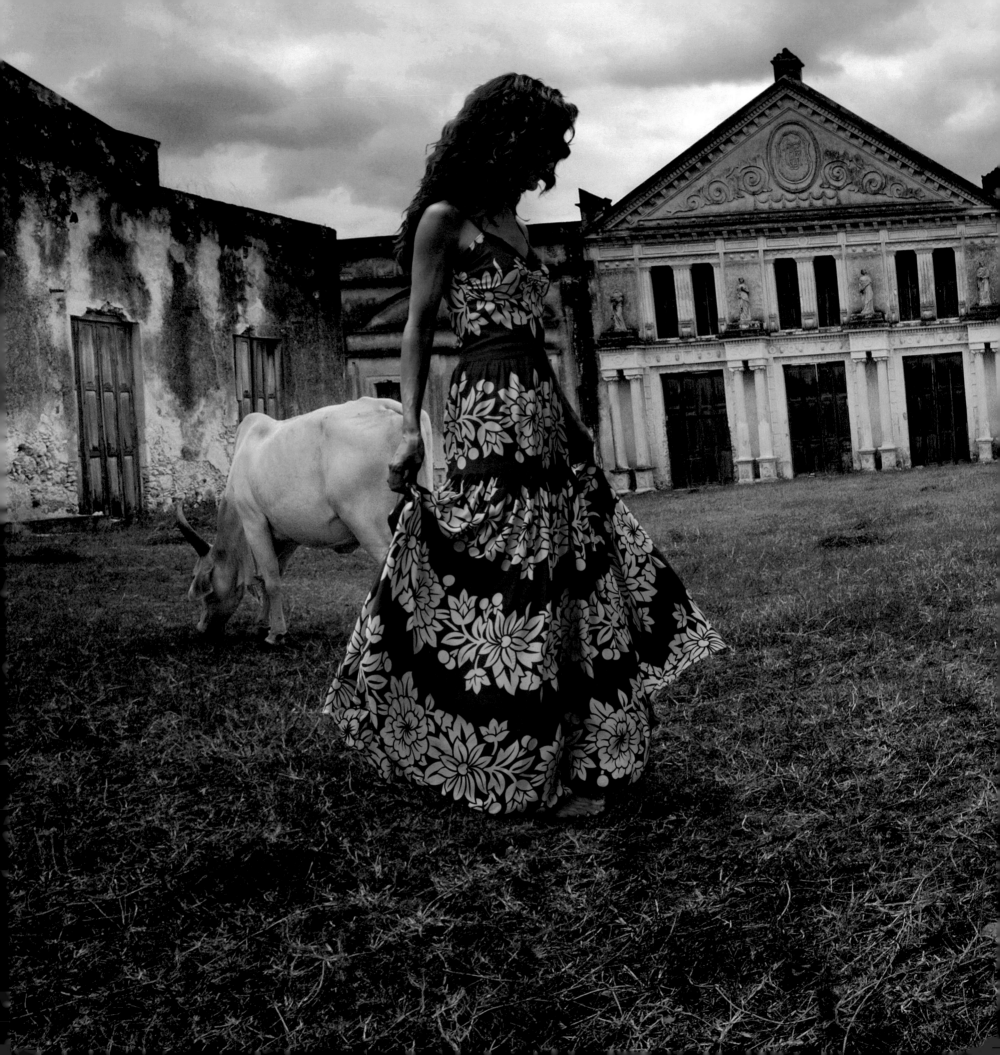

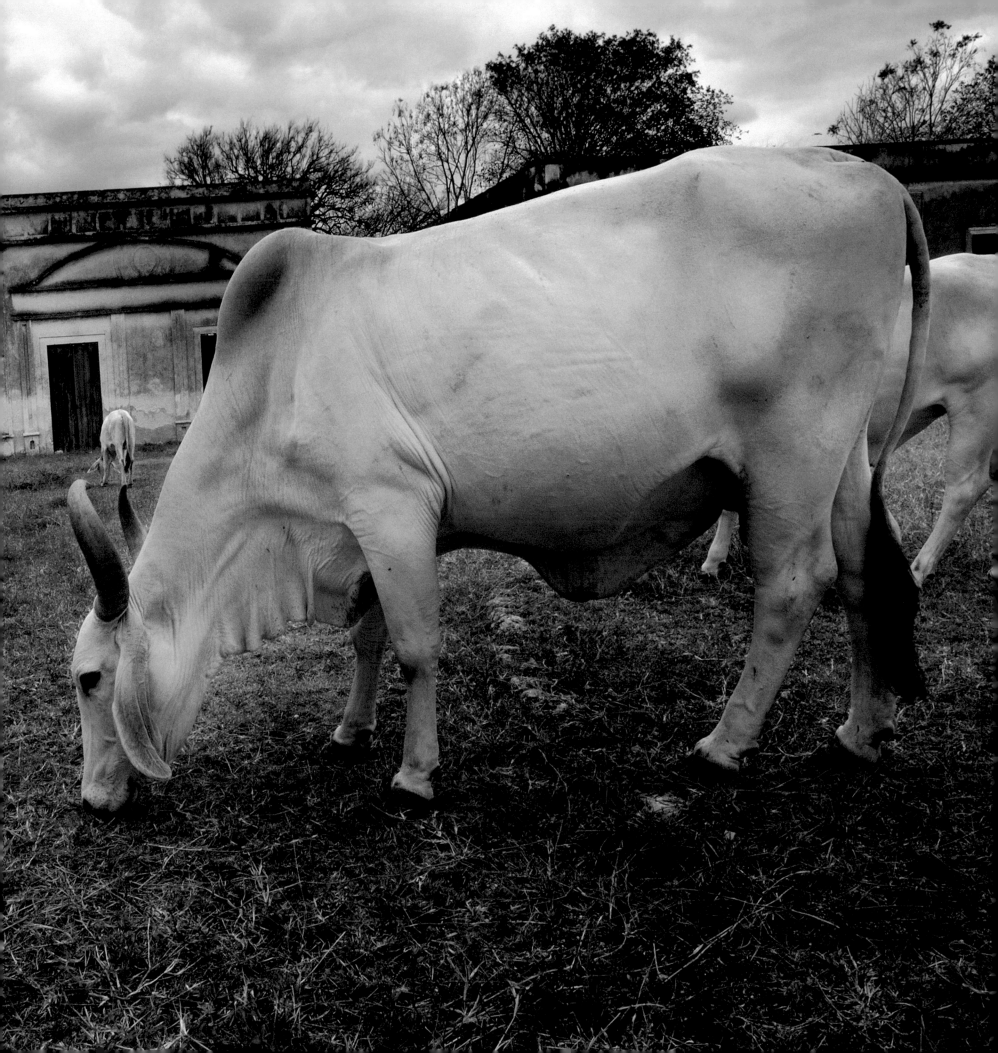

Illumination

2012

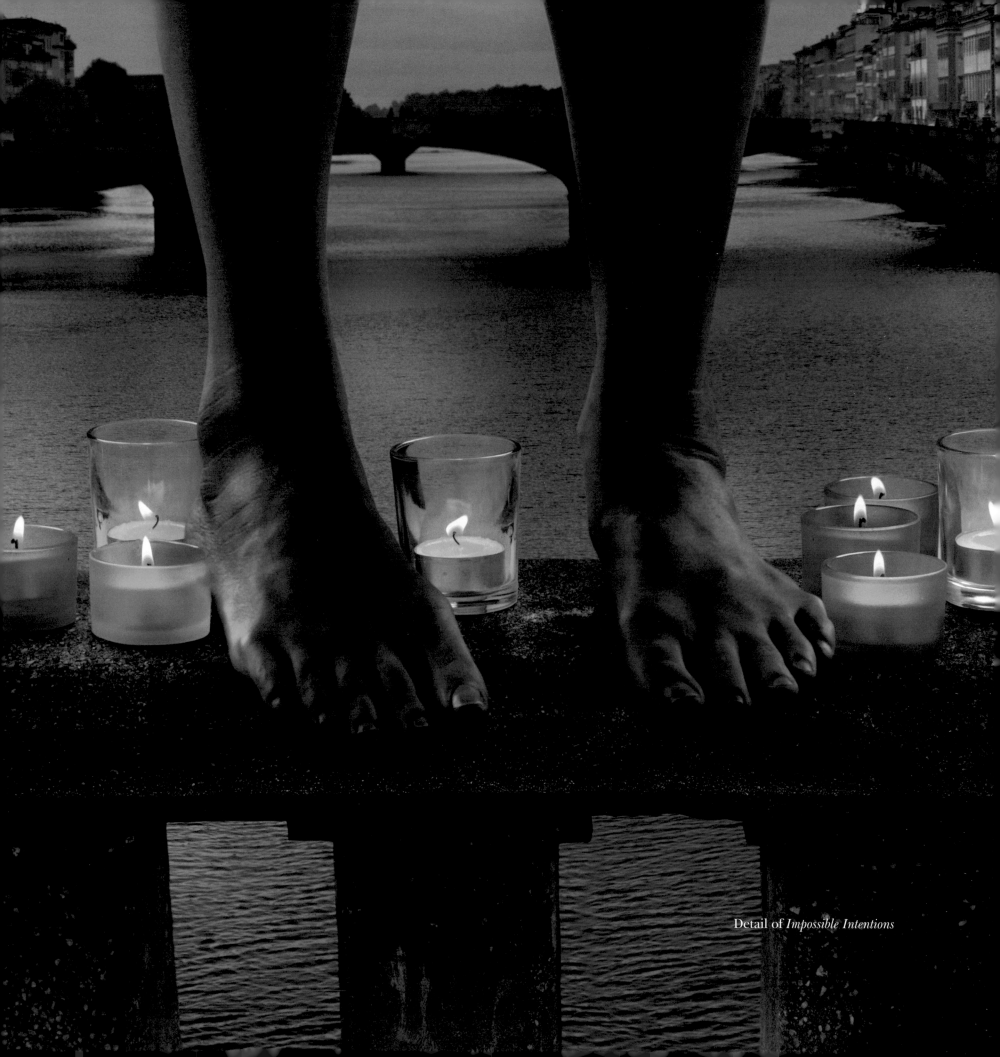

Detail of *Impossible Intentions*

Illumination

Renaissance artists affirmed the transformational nature
of light in their classical paintings. Taddeo Gaddi and Giotto di Bondone
of the Renaissance period painted breathtaking frescoes in which light
created dramatic effects. Artists, such as these masters, inspired me to create
photomontages that highlight the aesthetic power of light.

Following recent travels in Italy, I was awed by the metaphysical nature
of Tuscan light. The unique light accentuated the brilliance of the Renaissance
artistic and architectural masterpieces. I came away with the
understanding that light exposes possibilities and opens the mind to
seeing things differently. "Illumination", a series of photomontages,
illustrates stories about personal beliefs and seeing
things in a different light.

· · ·

A View From The Bridge

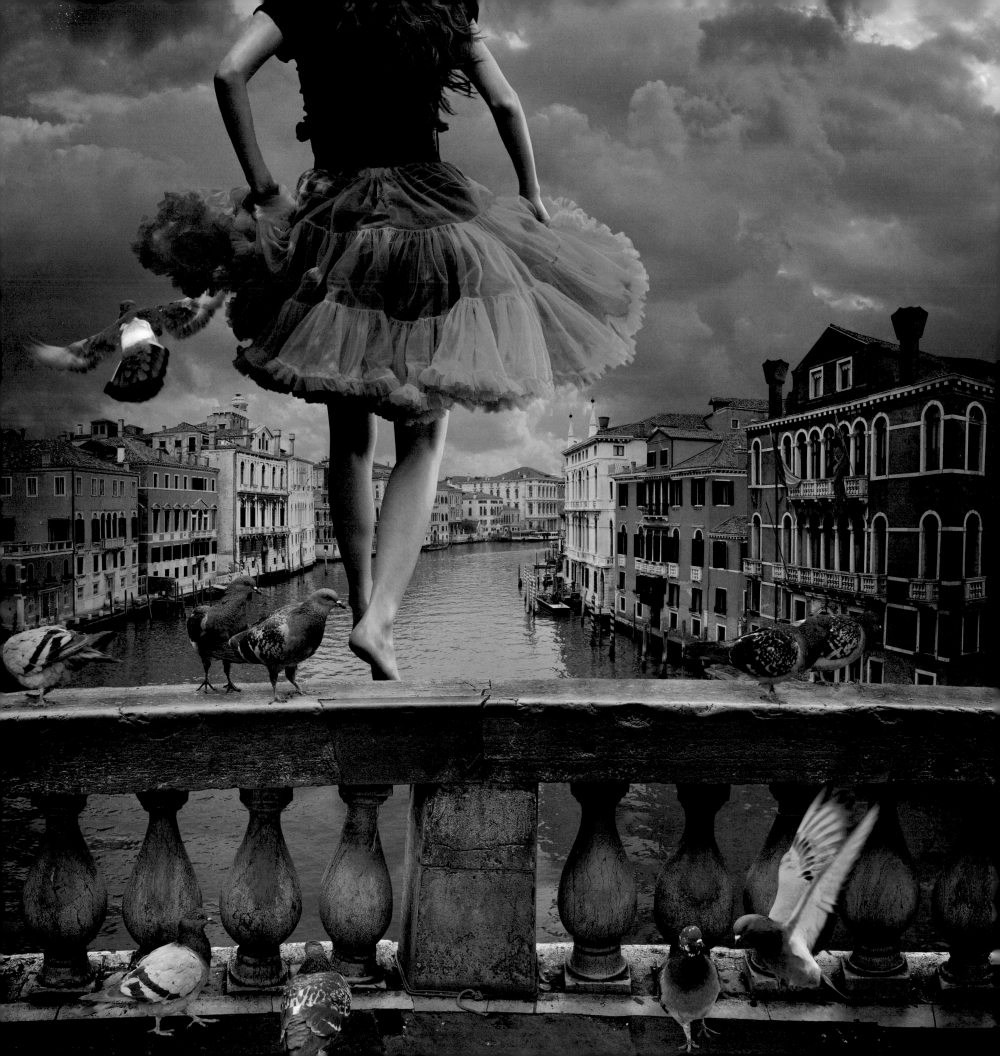

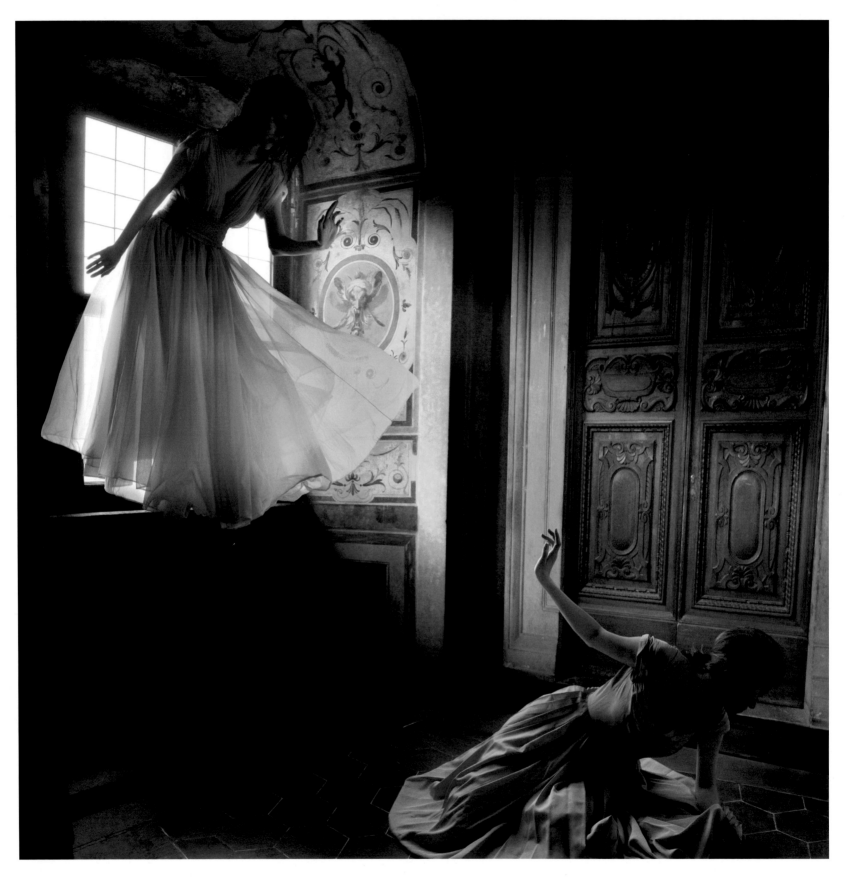

Annunciation

Right: *Impossible Intentions*

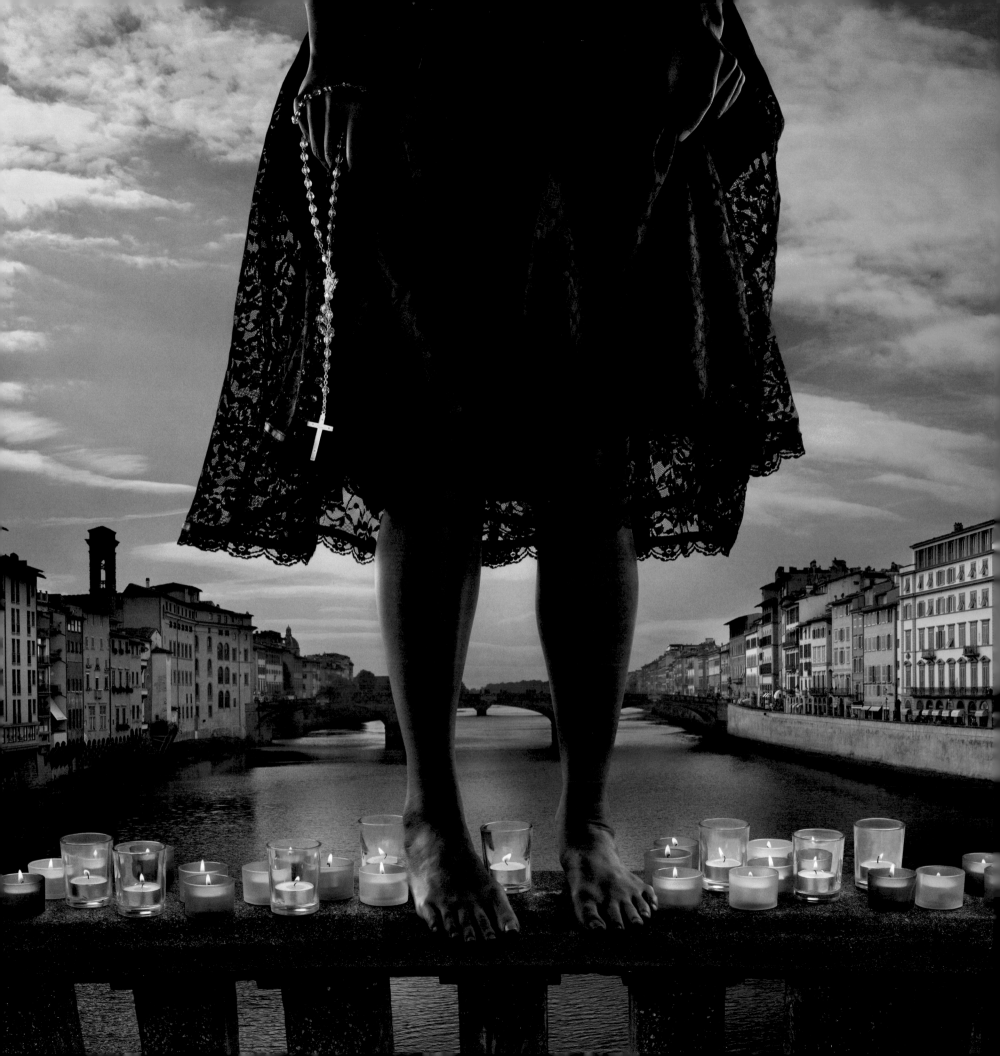

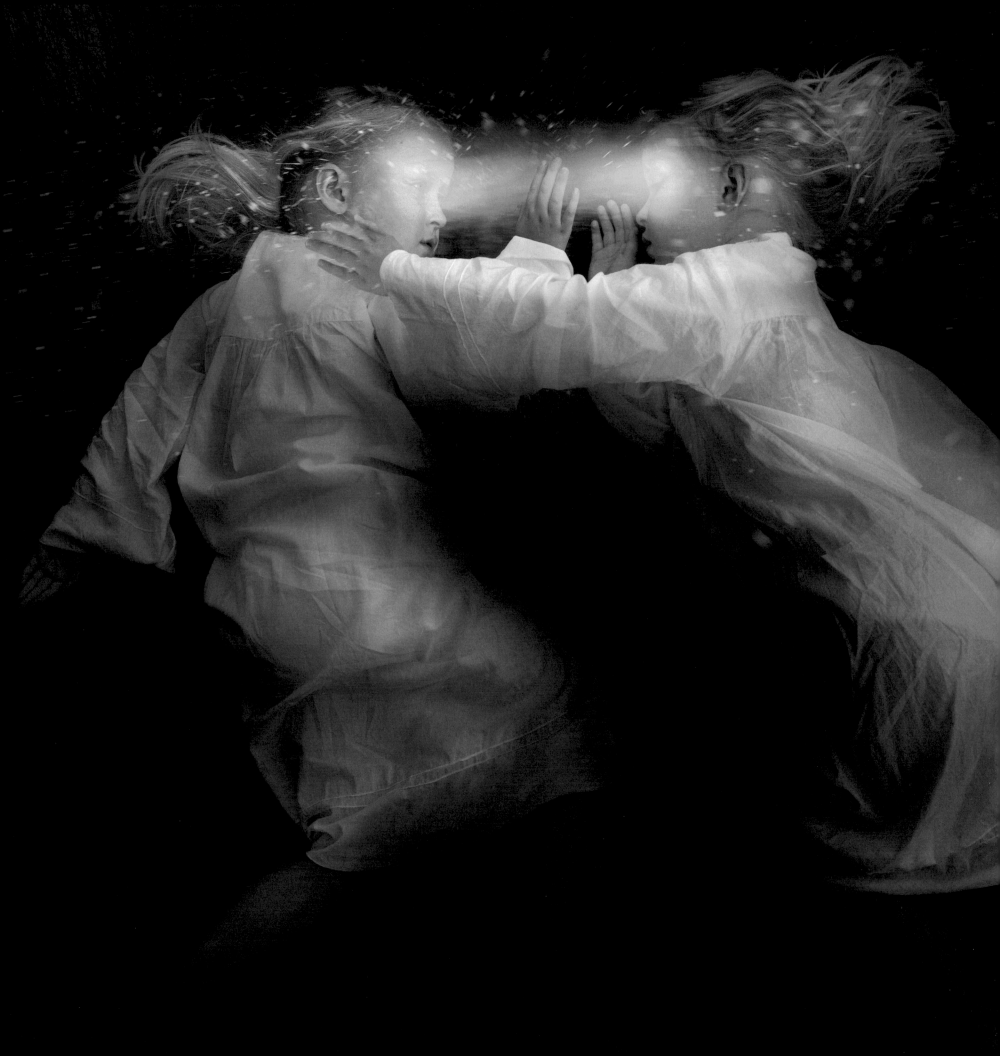

Illumination

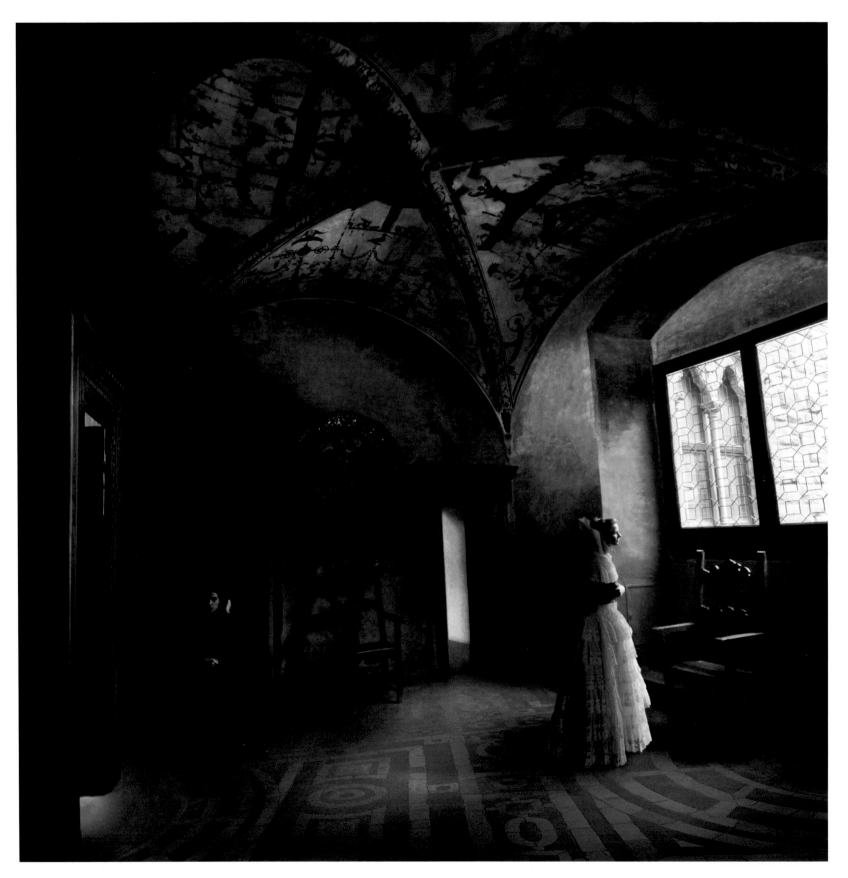

Medici Gold

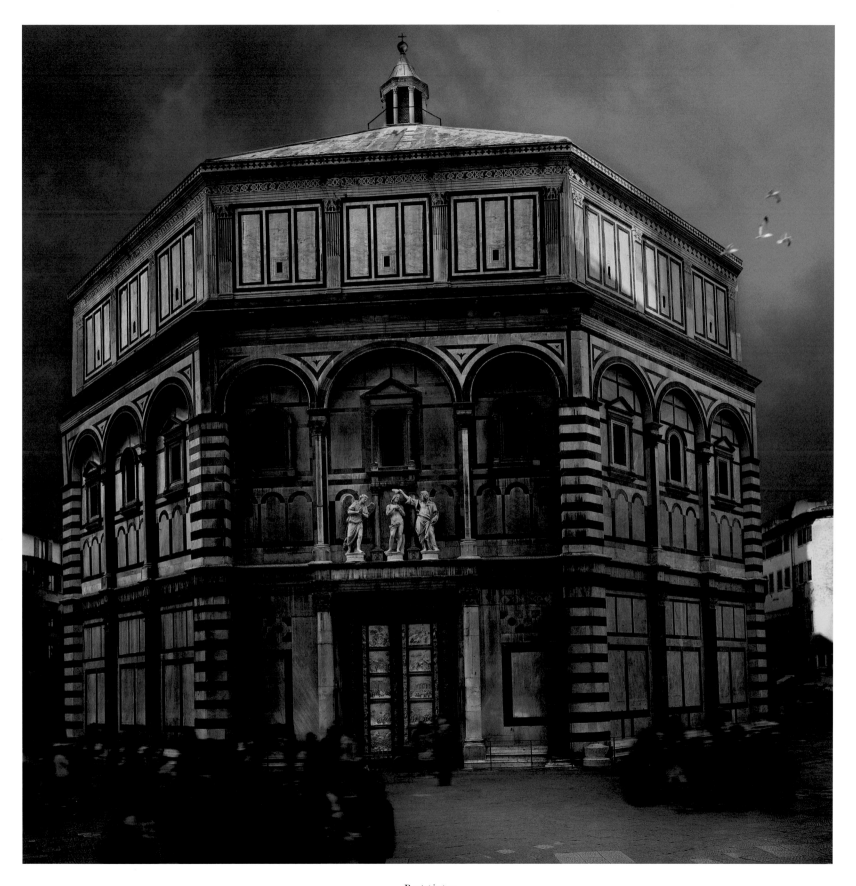

Baptistry

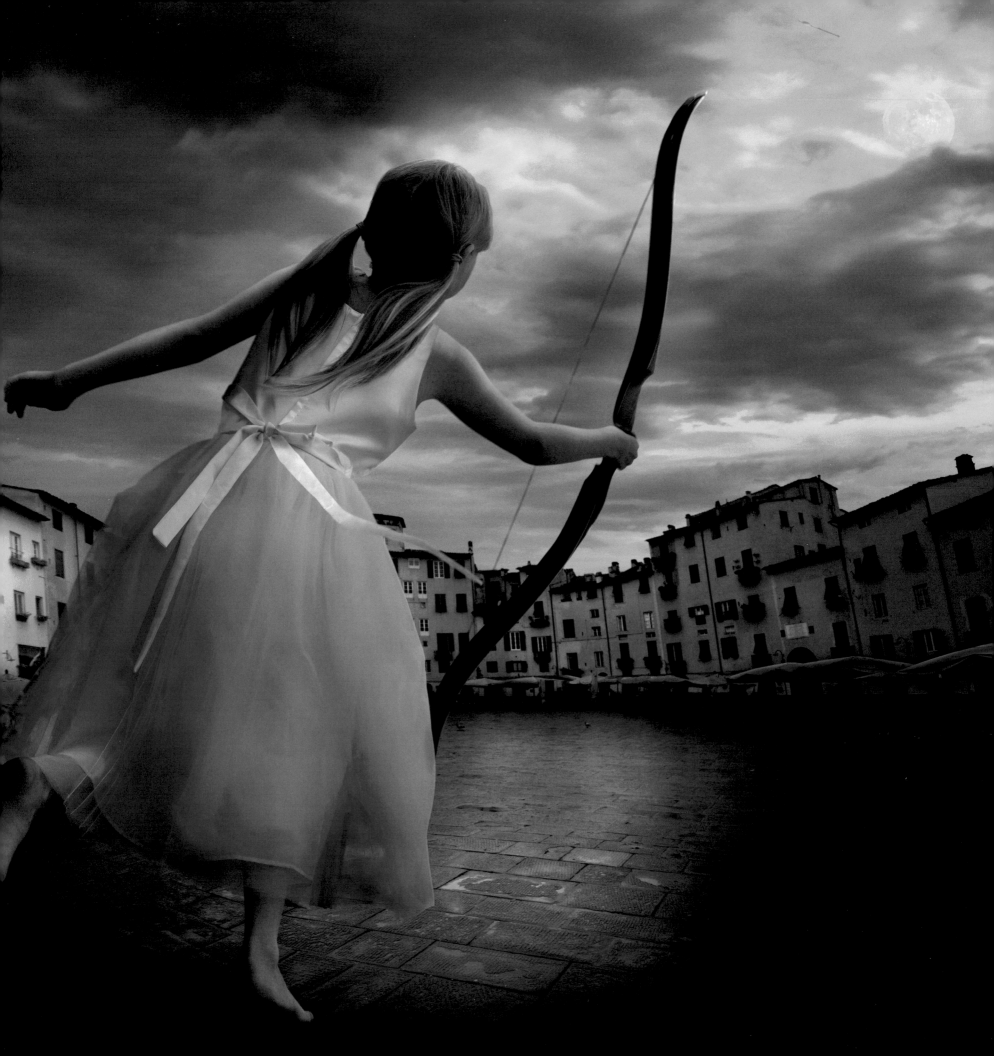

Lucca Luna

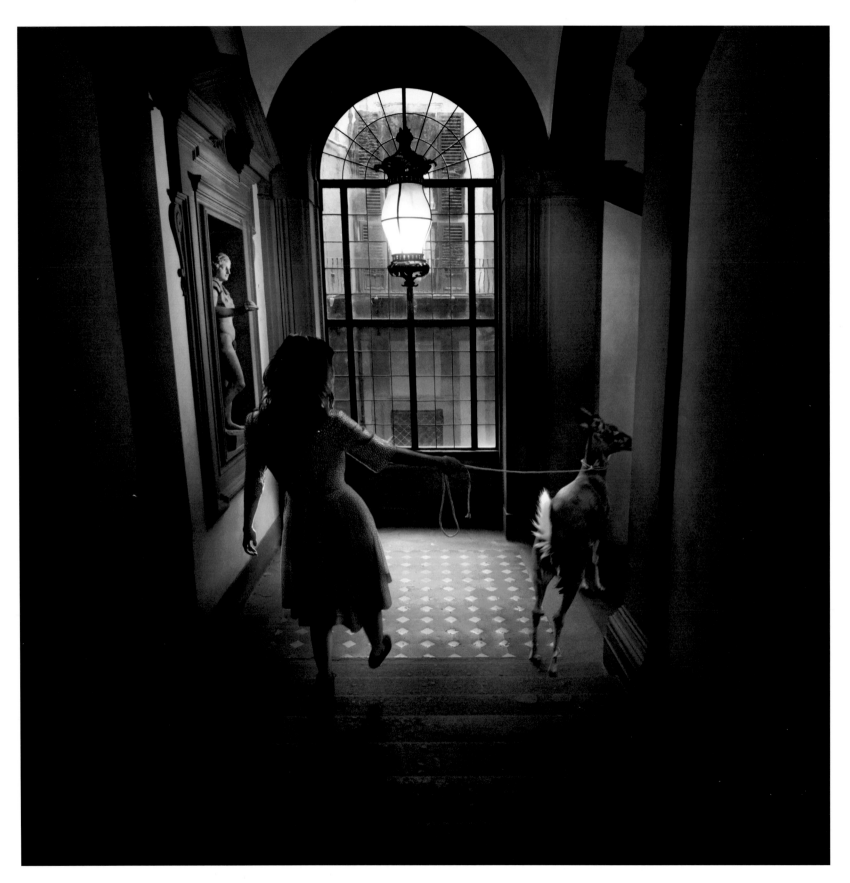

Walk On The Wild Side

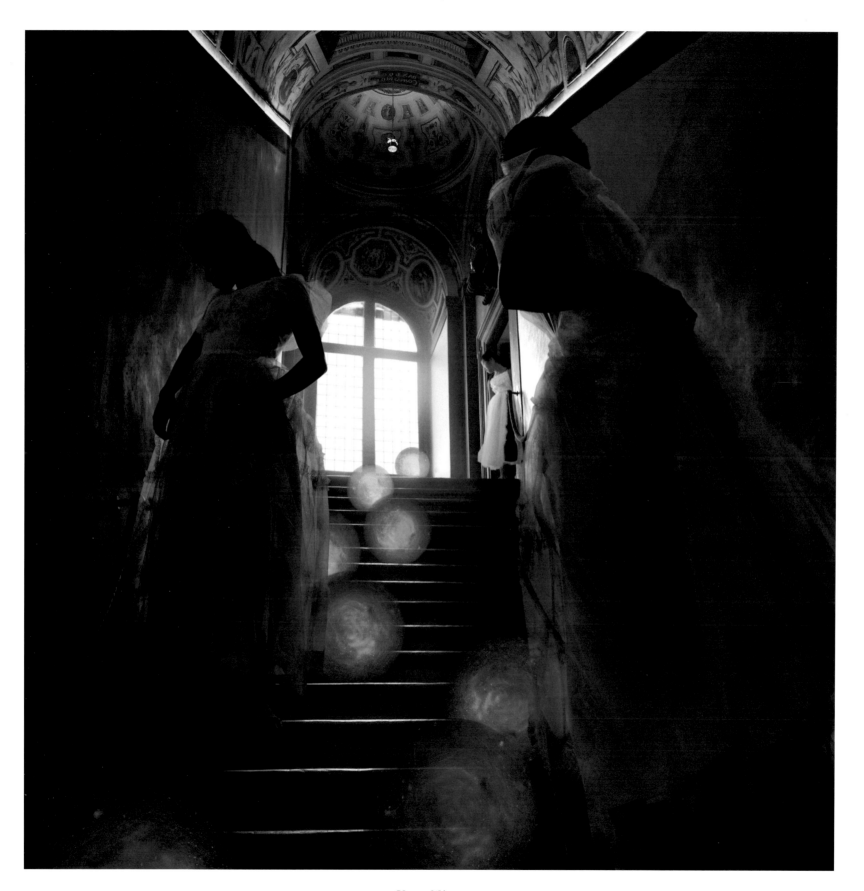

Ursa Minor

Pennants Over Pienza

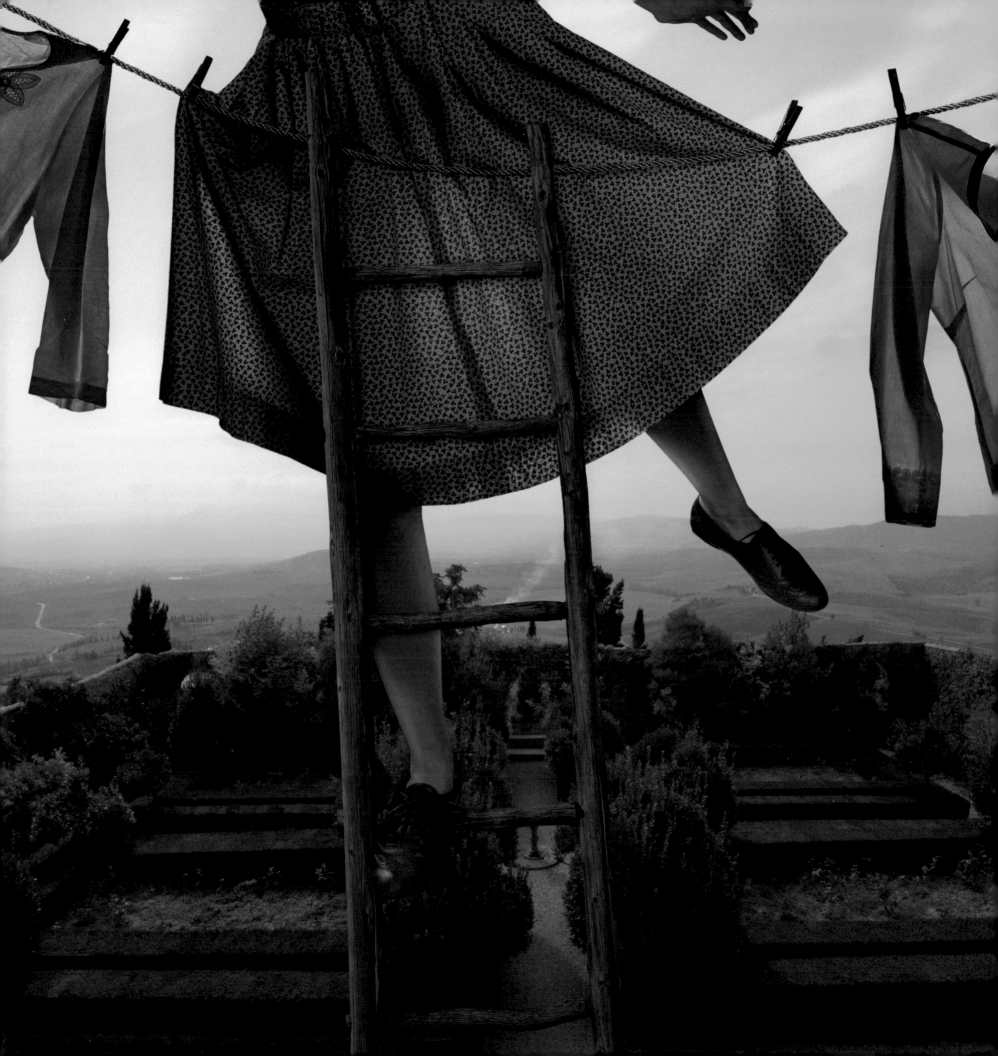

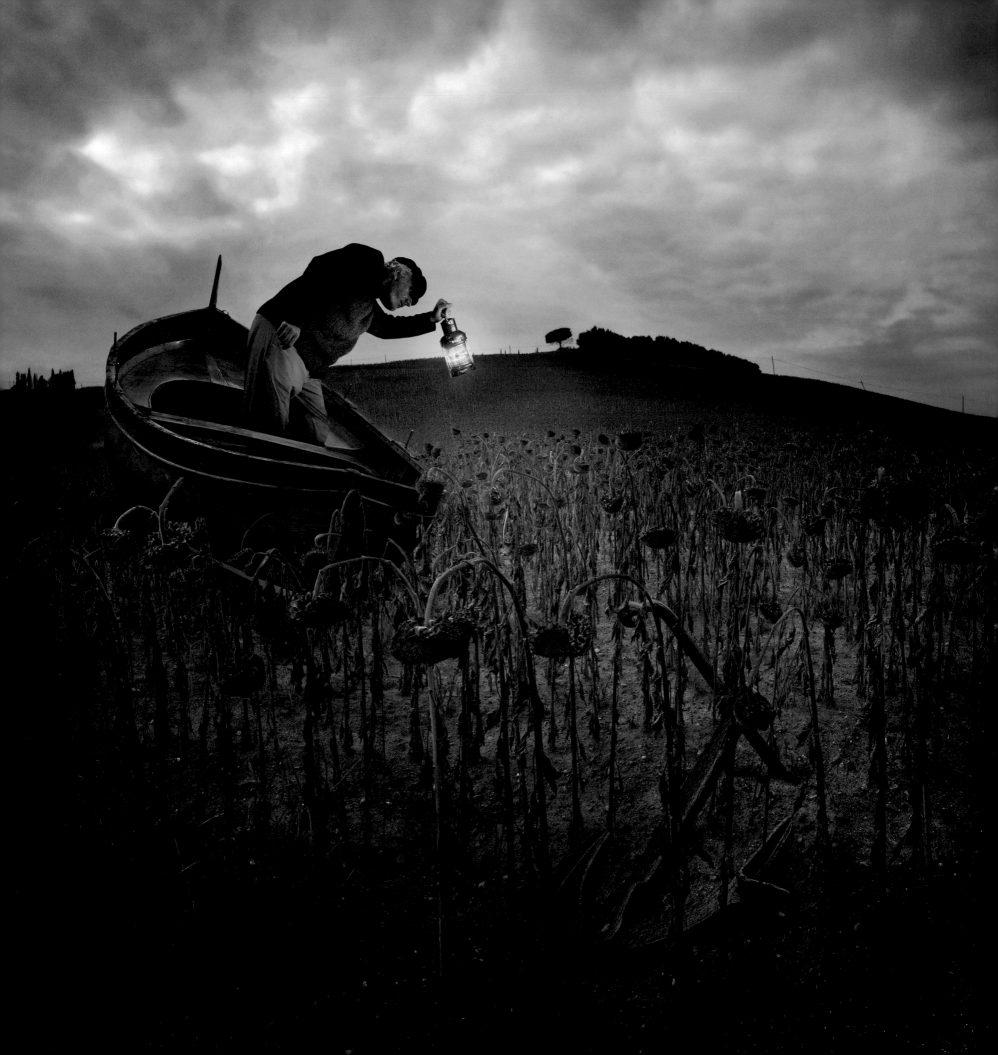

Autumn Moorage

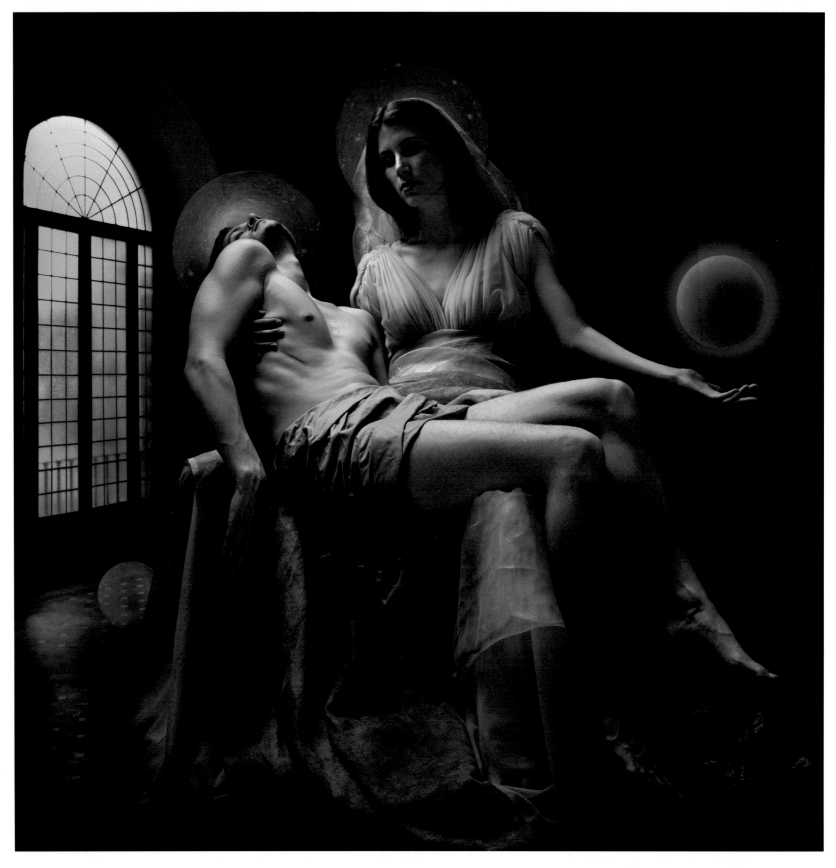

Pietà

Right: *Meant For Love*

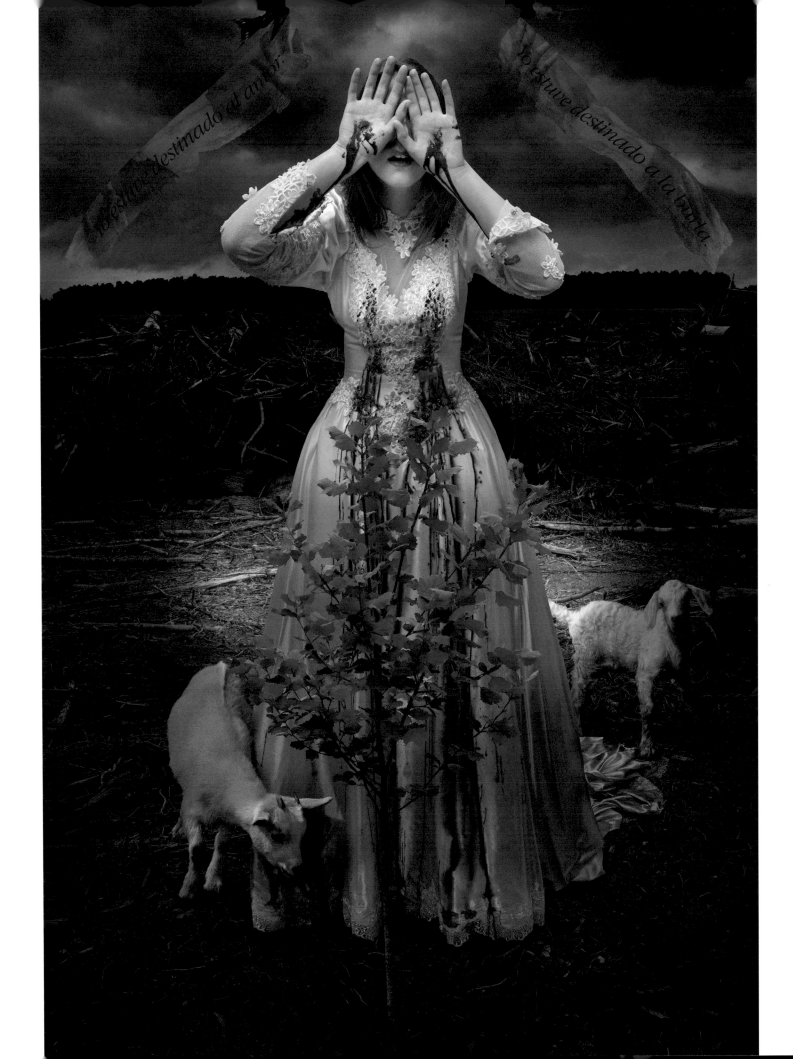

Vissi d'amore

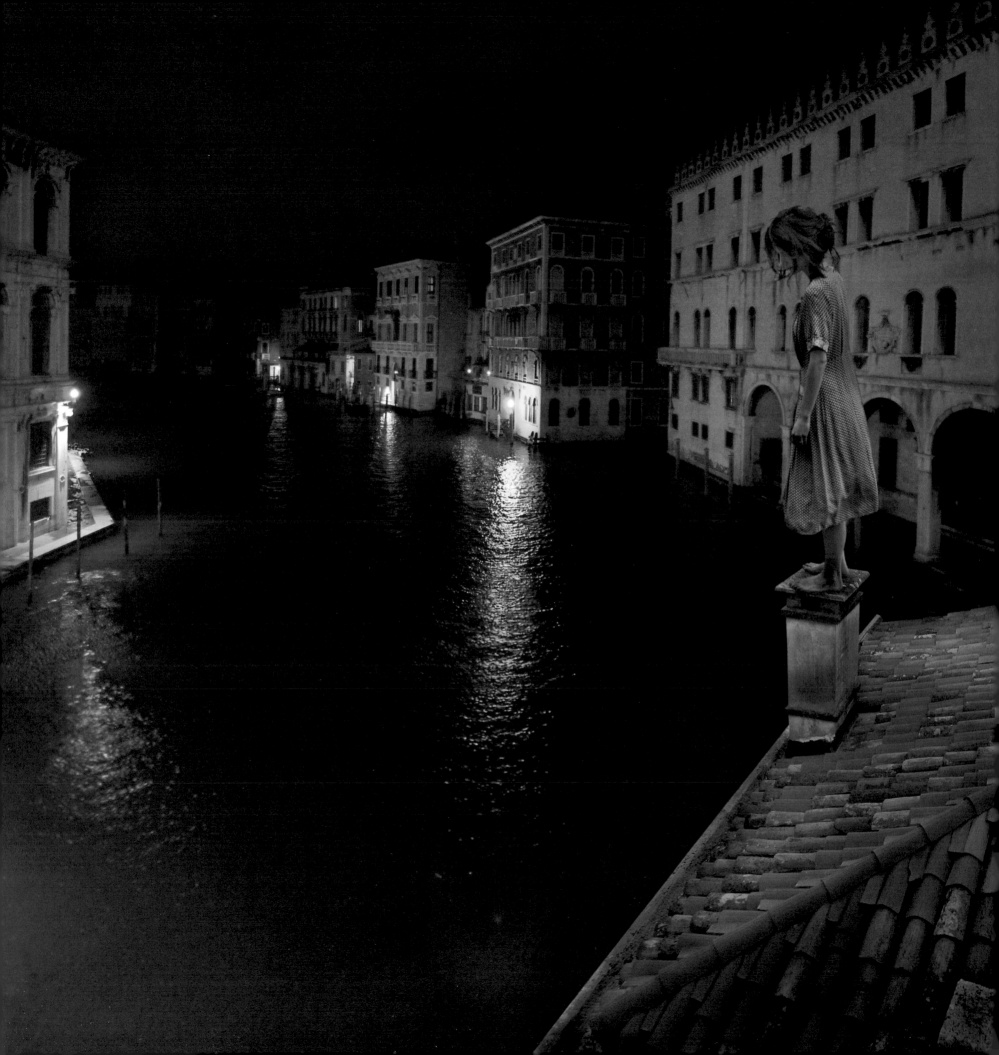

Animal Visions

2013

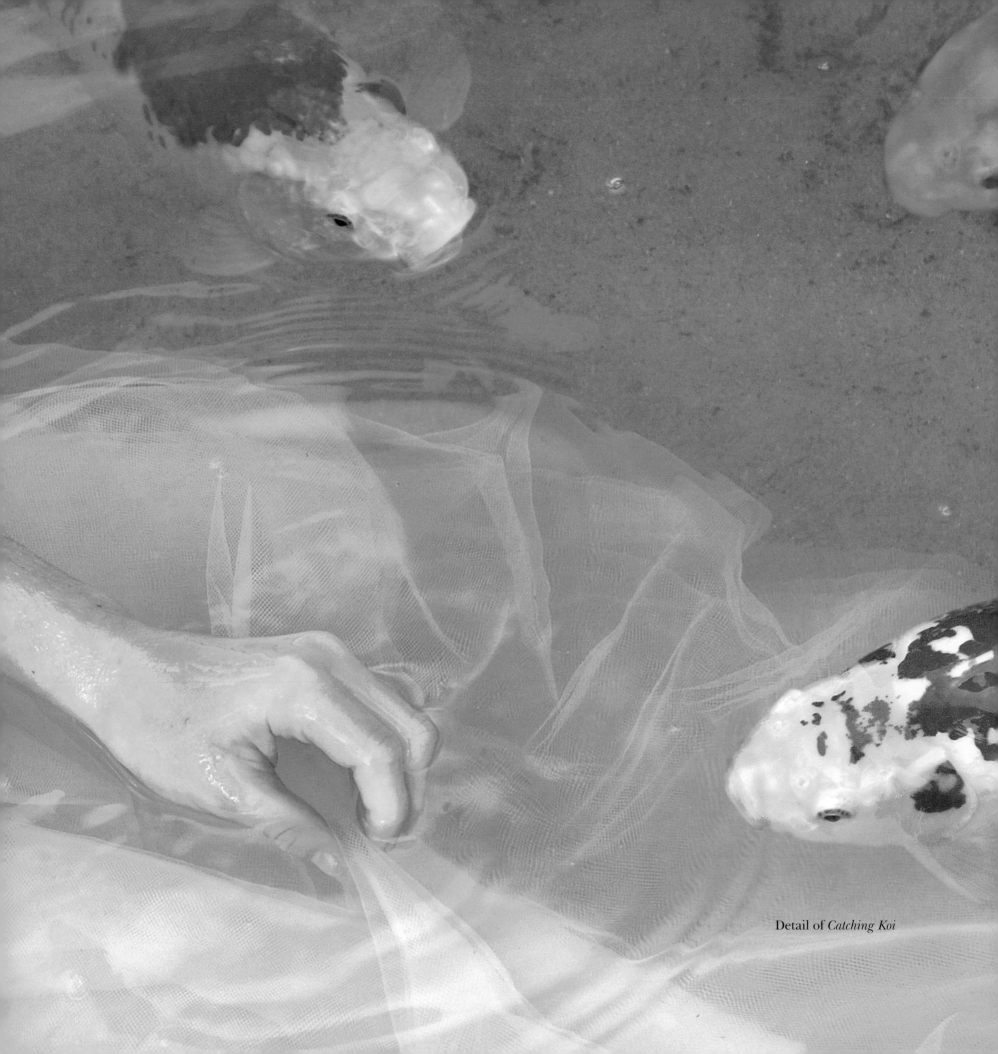

Detail of *Catching Koi*

Animal Visions

All my life I have held a fascination with the animal kingdom,
which began in my childhood growing up on a farm and extended
into my adult years. On some inexplicable level I feel a special
connection with both domesticated and wild animals. In this series "Animal
Visions" my photomontages tell stories about these relationships.

While working on "Animal Visions" I found myself circling
back to the influence of magic realism. In the early twentieth century Latin-
American writers and artists used magic realism to create images,
which with a simple twist go beyond the expected into the unexpected.
In this series I have constructed images to tell unfinished stories,
which initially might seem true and believable, but likely are improbable.
As I imagined in my childhood, the animals and humans
share a kindred connection.

. . .

Edge Of A Dream

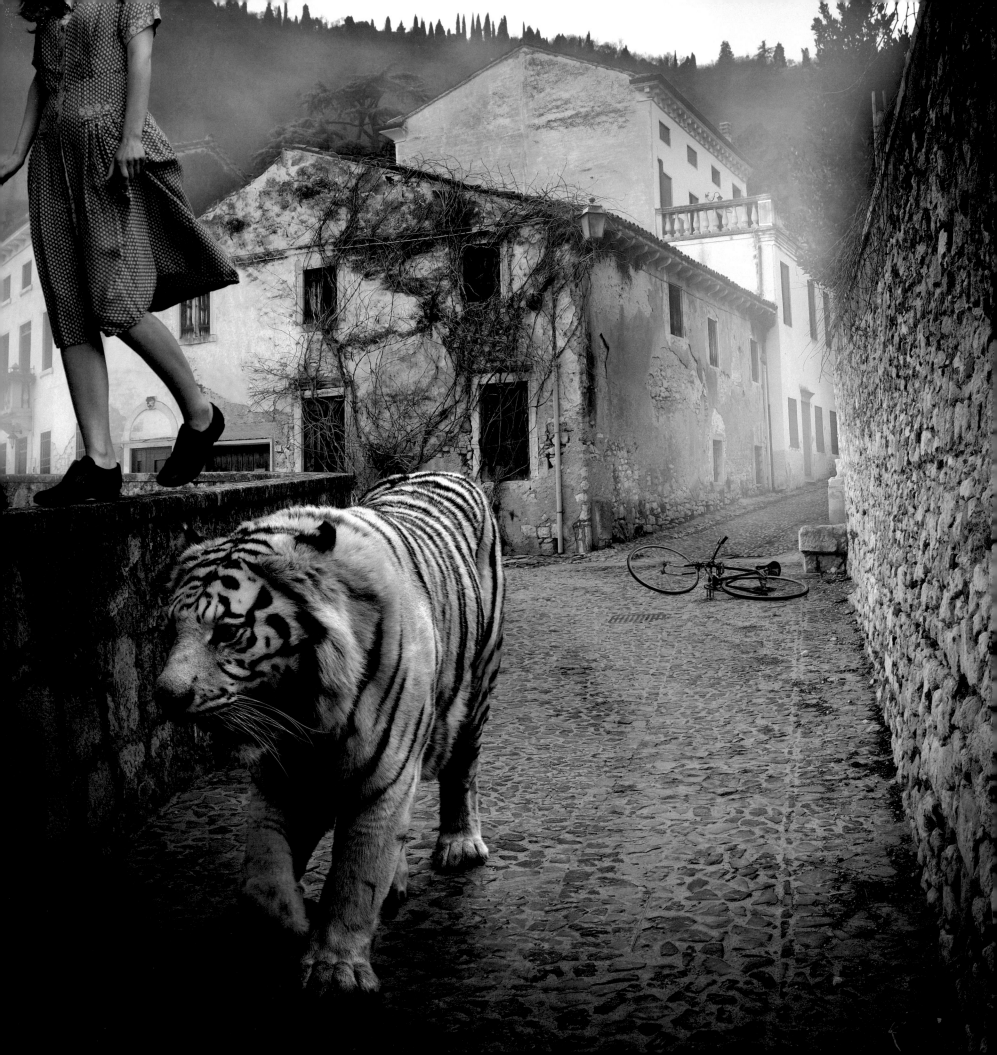

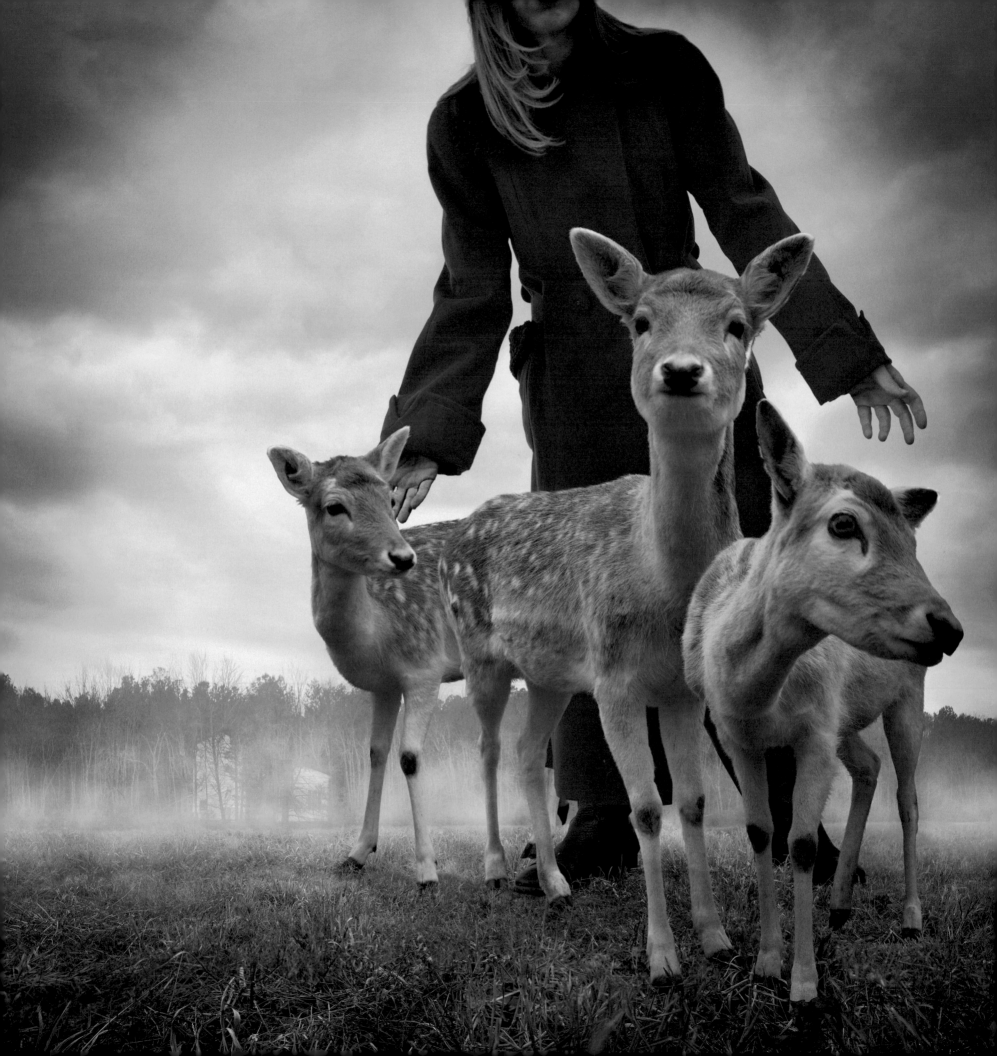

Daybreakers

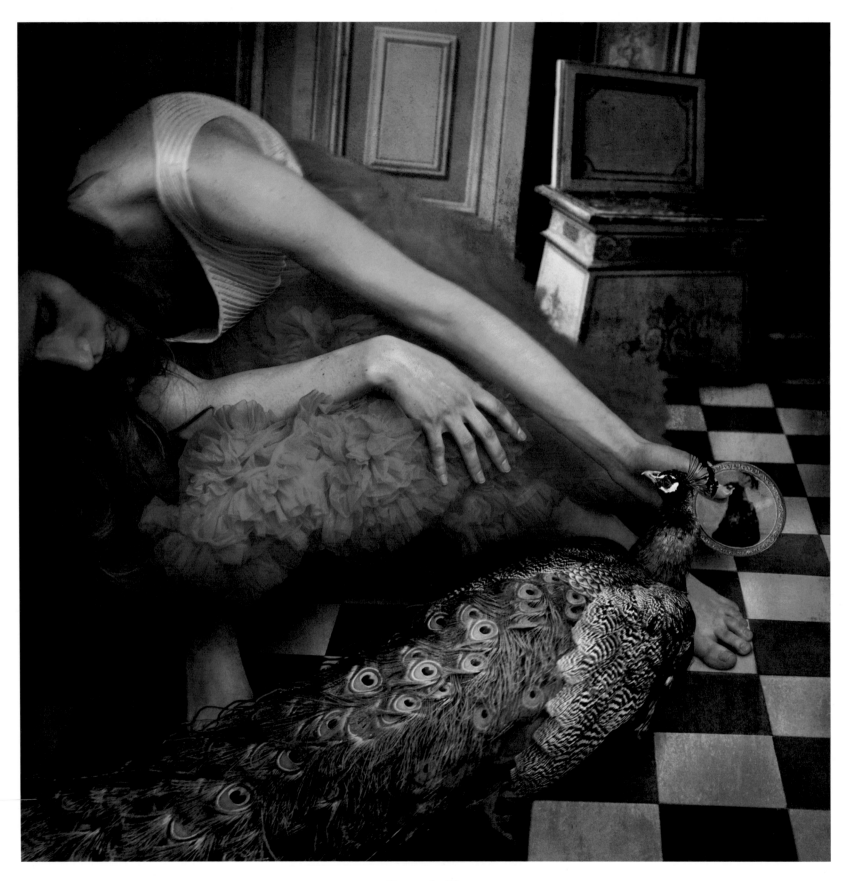

Pretty As Me

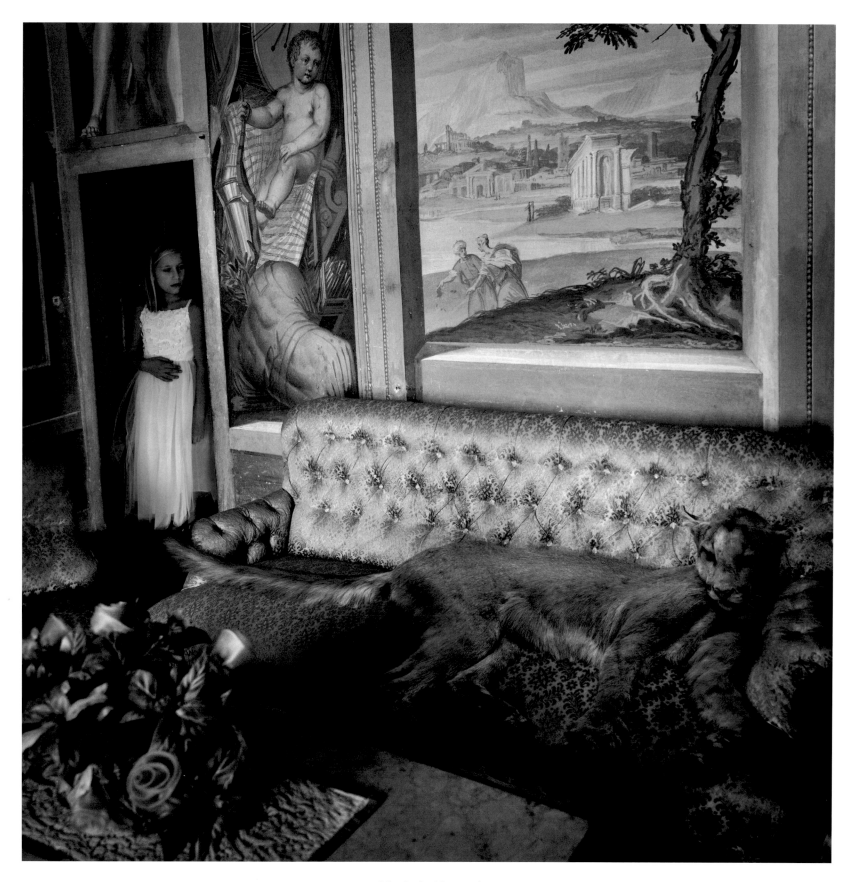

It's Only Natural

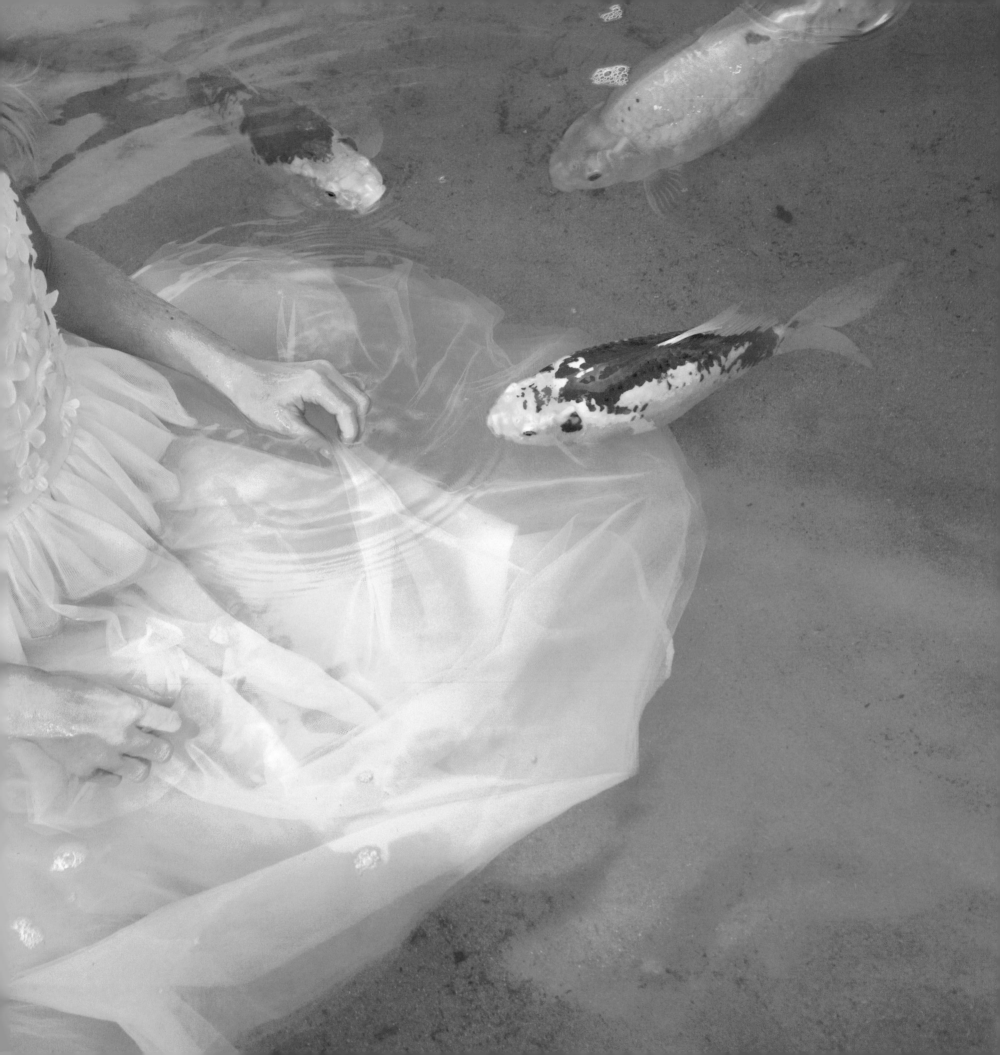

Catching Koi

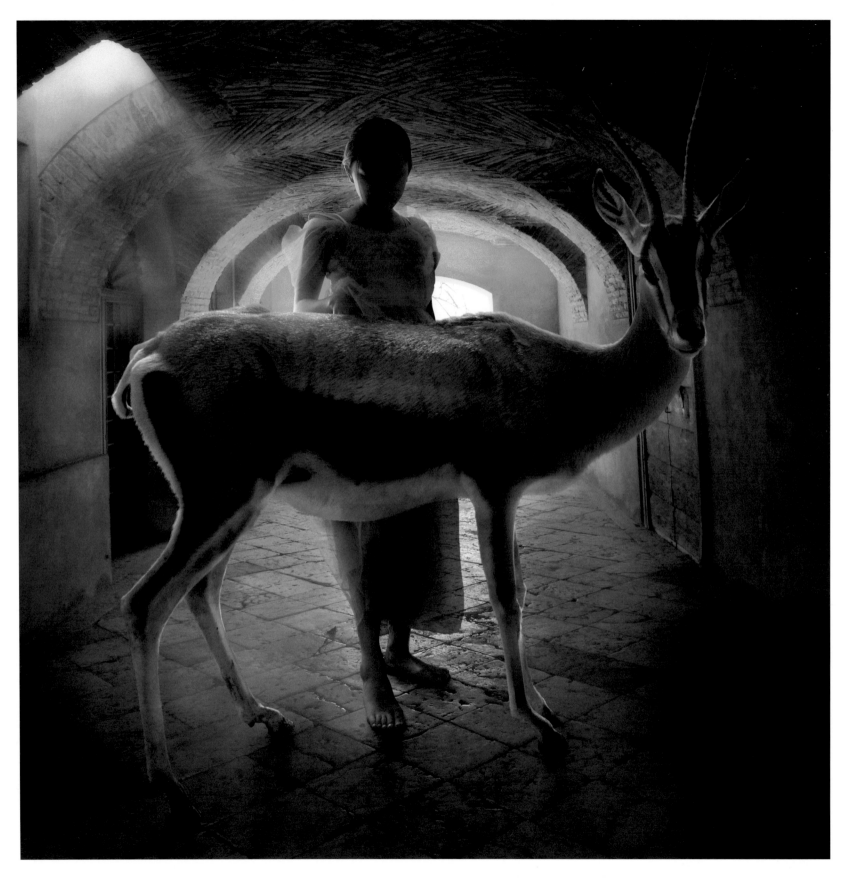

Tunnel Vision

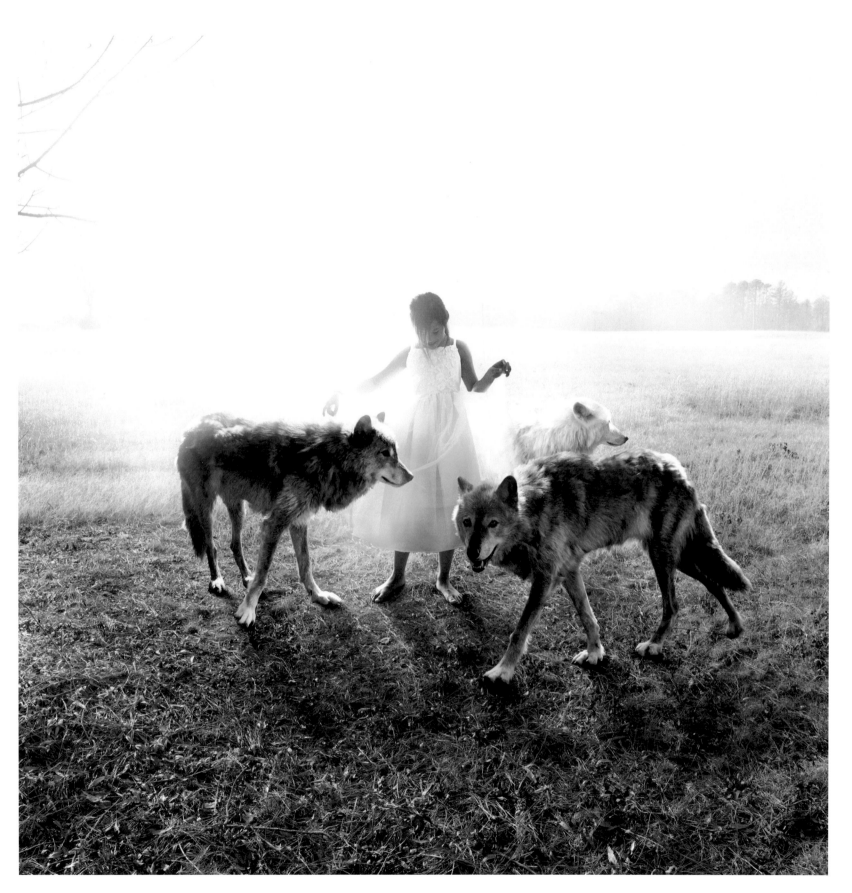

Middle Light

Burn To Shine

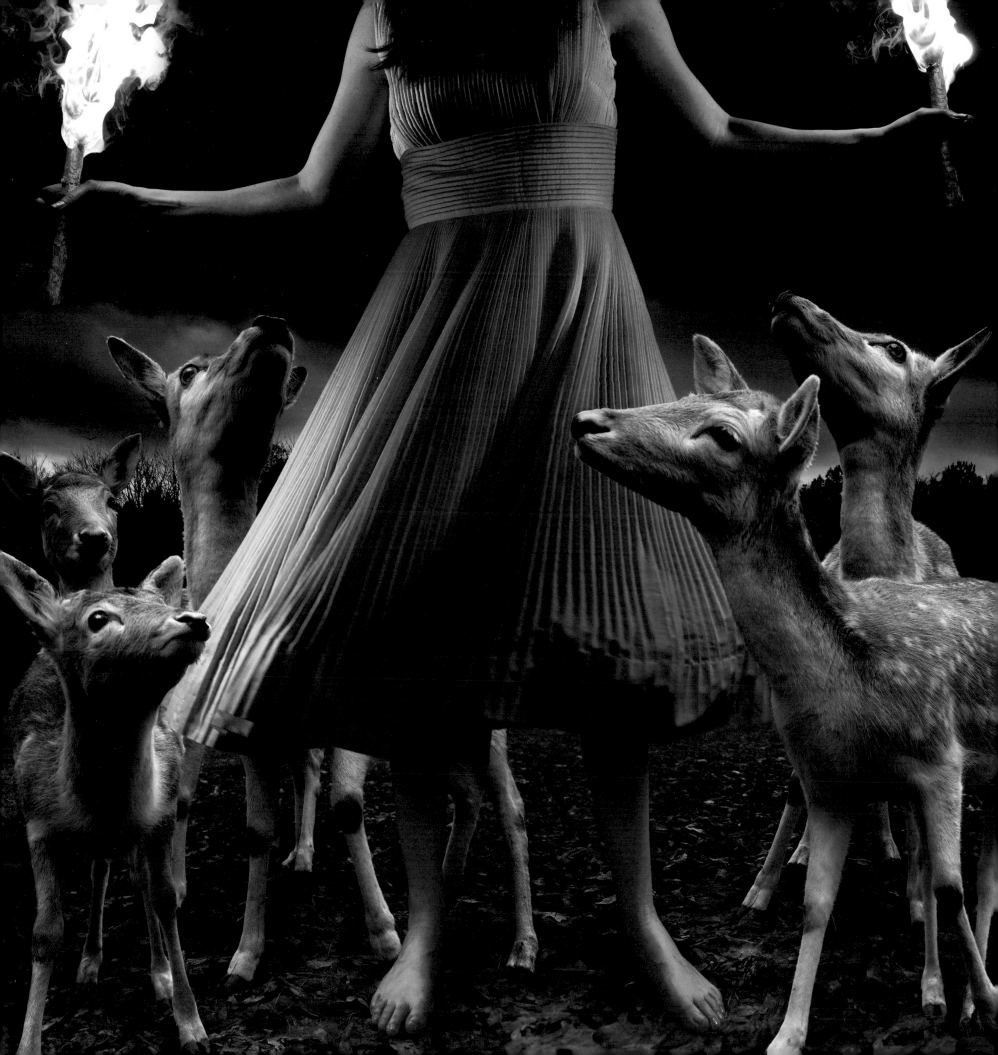

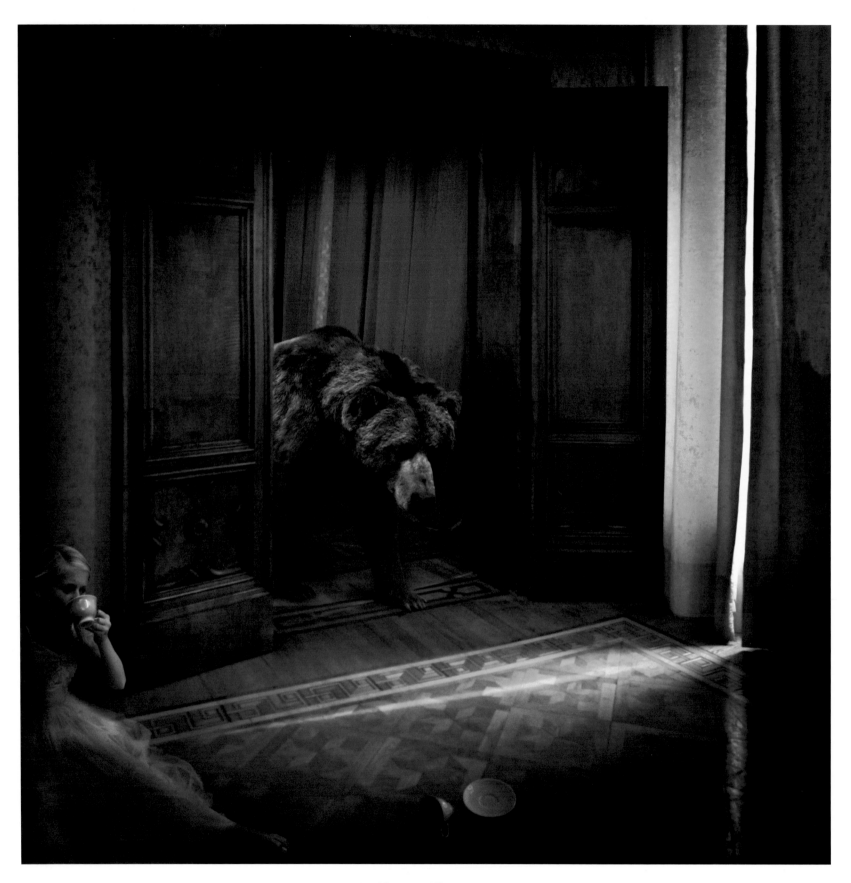

Accidents Will Happen

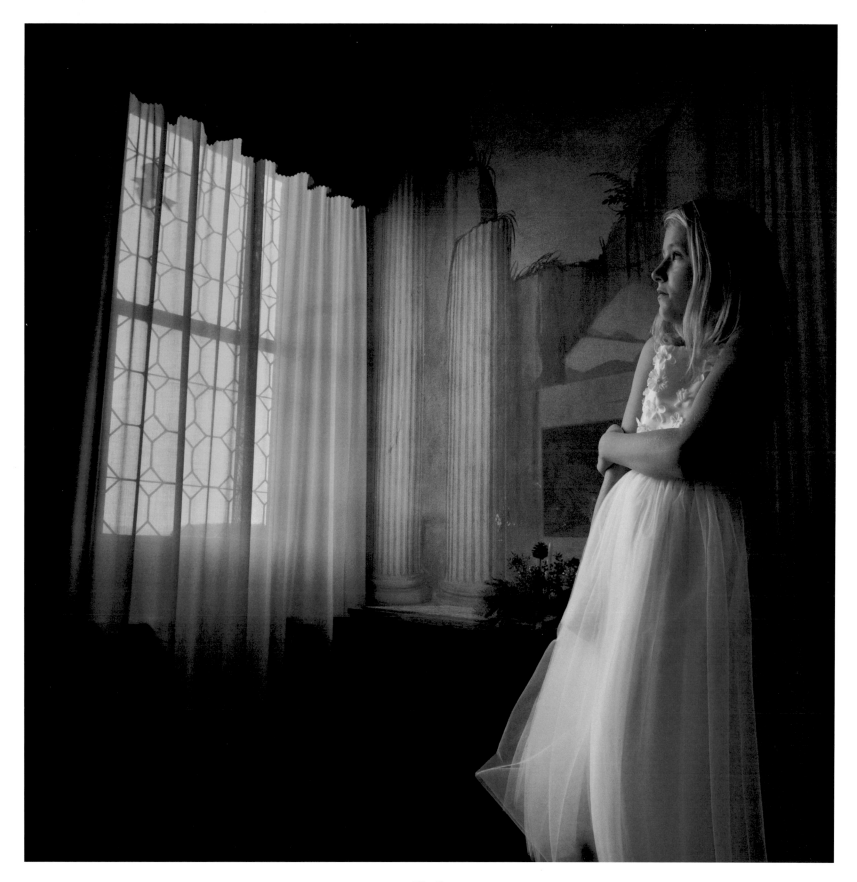

Fly By

Late For Dinner

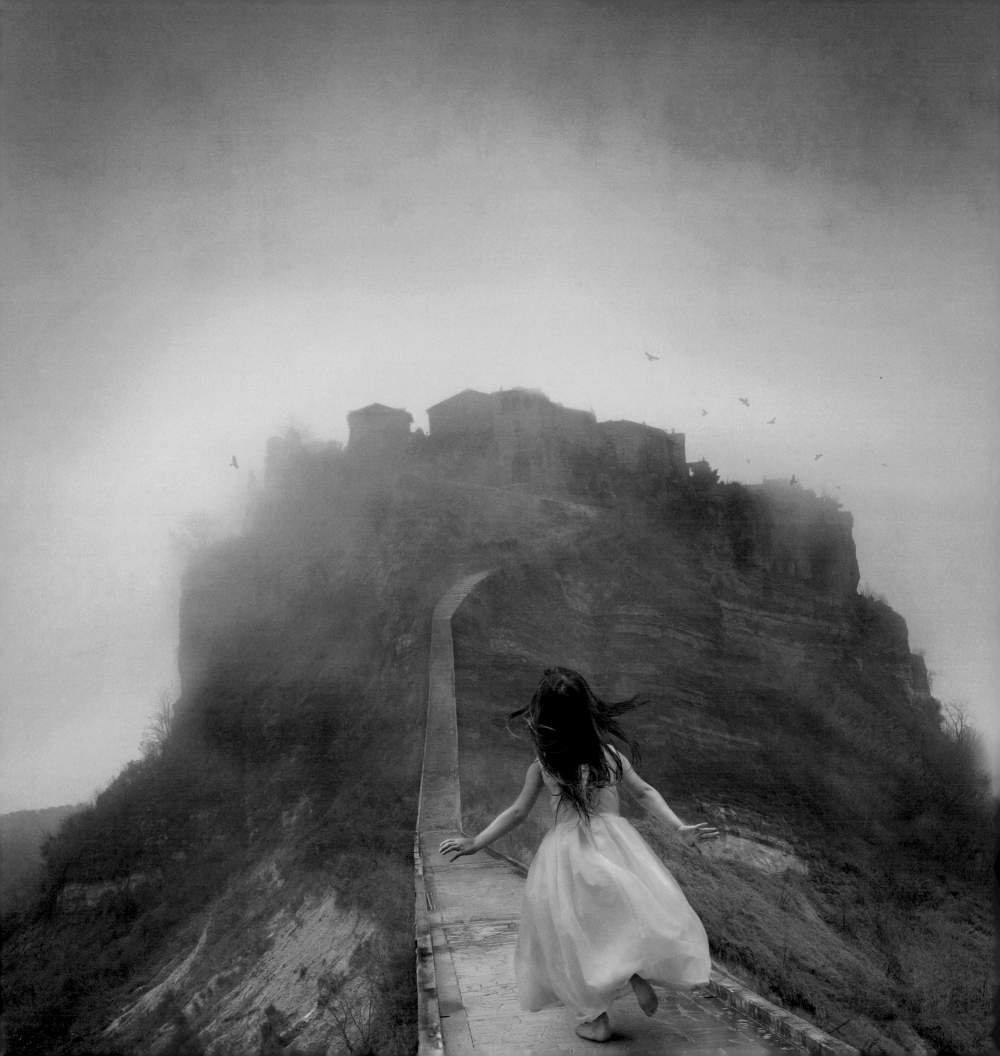

To The Edge

2015

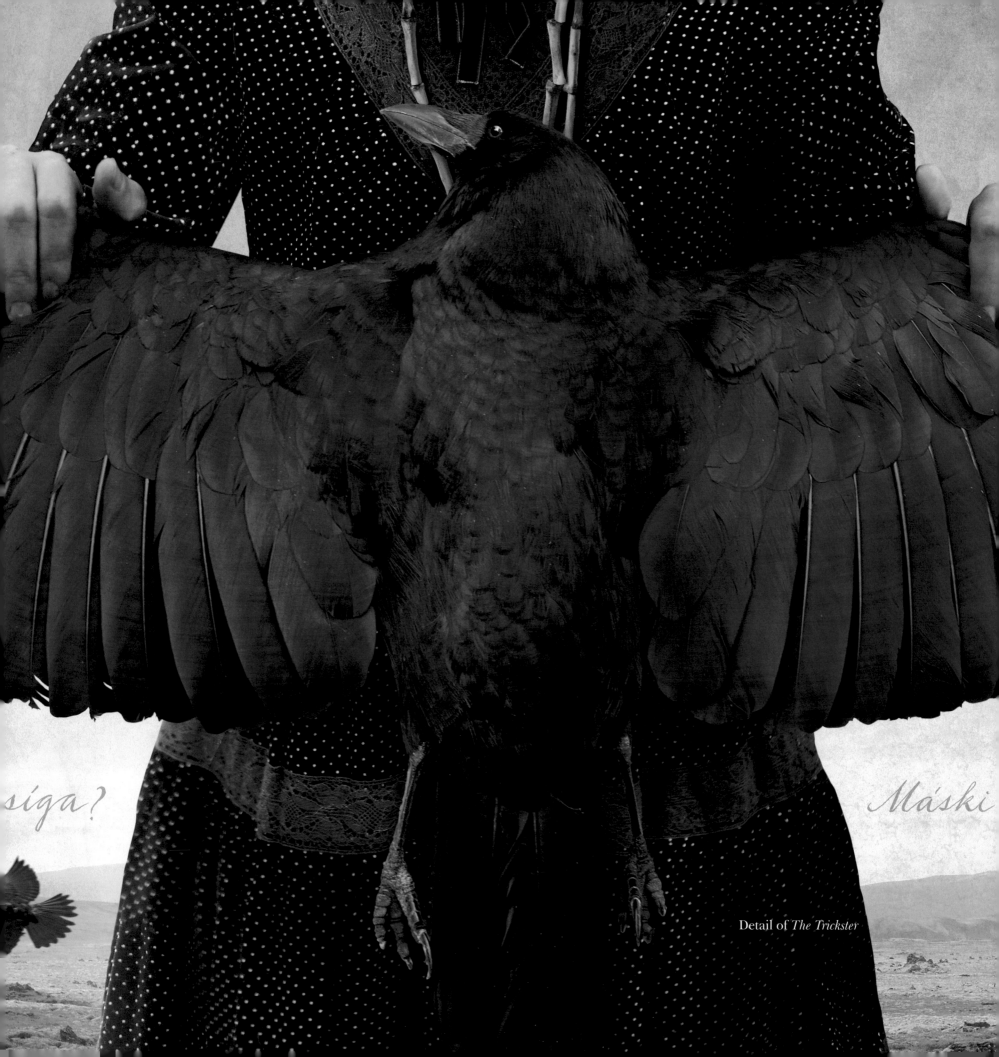

síga?

Máski

Detail of *The Trickster*

To The Edge

Exploring Iceland I stretched to look underneath, above, and
around the edges of the landscape. What mattered was not right before
my eyes, but delicately hidden in glaciers, volcanic rock, and ice,
all of which have endured over many millennia. My photomontage
series "To the Edge" celebrates the biodiversity of the natural world.
Poet Allen Chamberlain, inspired by my images, wrote this ghazal
entitled *Iceland*, lines of which are translated into Icelandic and
incorporated into each image of the series.

. . .

Iceland	***Ísland***
~ Allen Chamberlain	~ Allen Chamberlain

Clouds of tangled lichen cleave to the edge.
And now look to the frost-heave at the edge.

How does life hold? The branchlet and blood-bowl?
It holds the shape of the rock, sheathes the edge.

The dark-phase gyrfalcon mantles her prey.
Crowberries glow; amber eve at the edge.

In the plain of stone and sand grief takes hold.
There glacial rivers blue-sleeve to the edge.

How to hear pipe and wail from birds circling?
Wing and entrails burnt – cerise at the edge.

Table-land is set with stone lichen nets.
Rust-brown rosettes, goblets sheave at the edge.

Green luster of meltwater enfolds ice;
Skeins of aurora, reprieve from the edge.

Let grey ash imprison the horizon.
Light and pink gentian in-weave at the edge.

Does grief give way? Perhaps not. But enter –
A land of chambered ice – reeved to the edge.

Fléttuflækjur í breiðum loða við ystu mörk.
Og sjá nú frostlyfta jörð við ystu mörk.

Hvernig heldur lífið velli? Kvisturinn og blóð-skálin?
Það mótast af lögun steinsins, slíðrar hin ystu mörk.

Dökkur fálkinn vokir yfir bráðinni.
Krækiber geisla; rökkurglóðir við ystu mörk.

Í urð og sandi skýtur sorgin rótum.
Þar þræða jökulár stíginn við ystu mörk.

Hvernig má heyra kvak og köll hnitandi fugla?
Vængir og iður brunnin – blóðrauð við ystu mörk.

Hásléttan er hulin nót af skófum og grjóti.
Ryðbrúnar rósettur, bollar í knippum við ystu mörk.

Ísinn er hjúpaður grænum ljóma leysinganna;
Norðurljósaslæður, hopa við ystu mörk.

Lát gráa ösku fanga sjóndeildarhringinn.
Ljósgeislar og maríuvendir fléttast við ystu mörk.

Lætur sorgin undan síga? Máski ekki. En gakktu inn –
Land frerabása – þrætt í ystu mörk.

Fowl Play

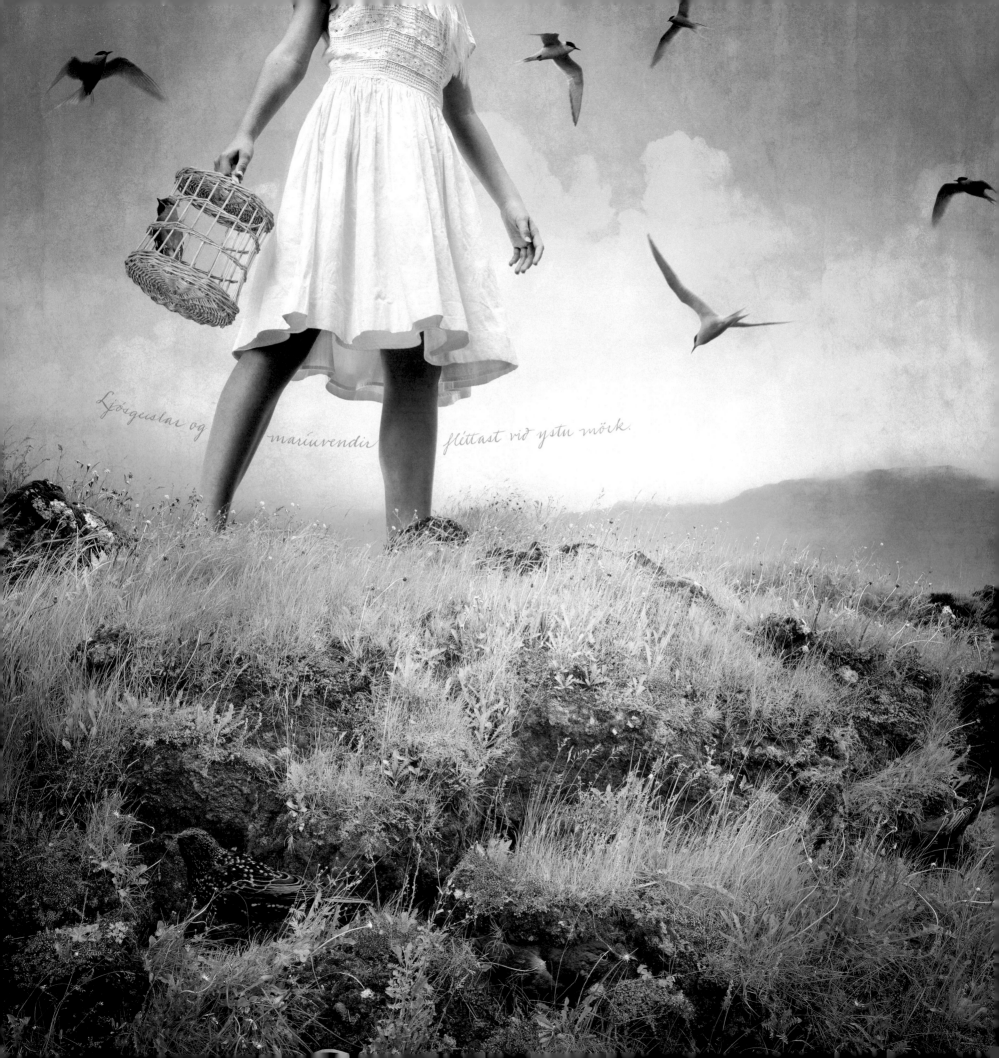

Ljósgeislar og maríuvendir fléttast við ystu mörk.

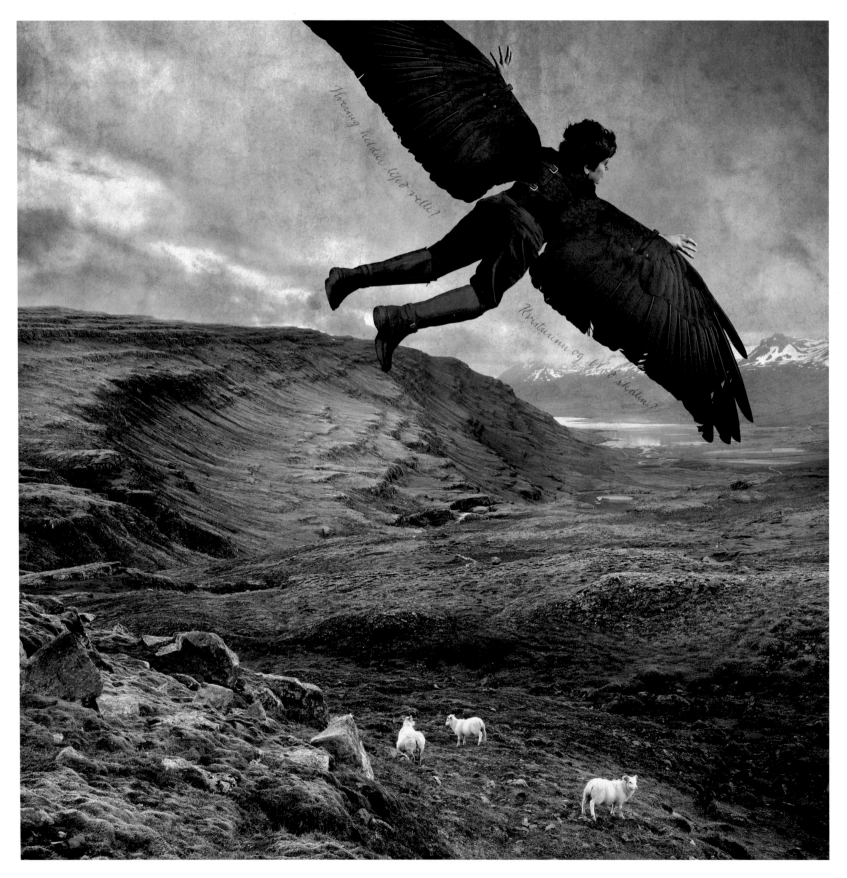

Winged Shepherd

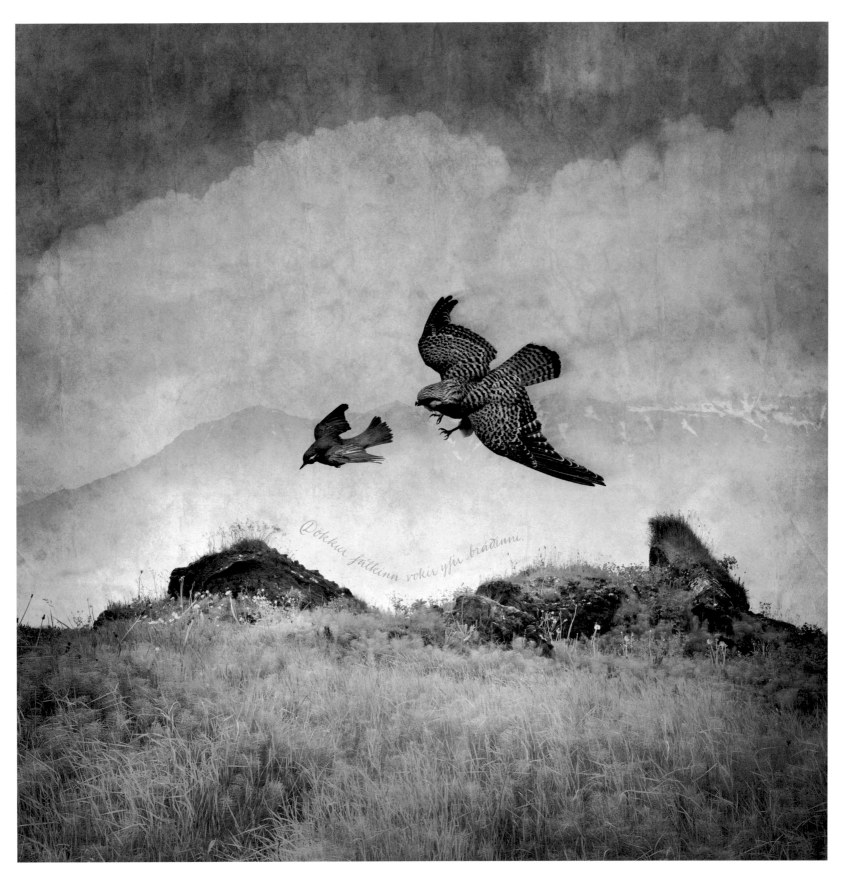

Dark-phase Falcon

One Oar Out

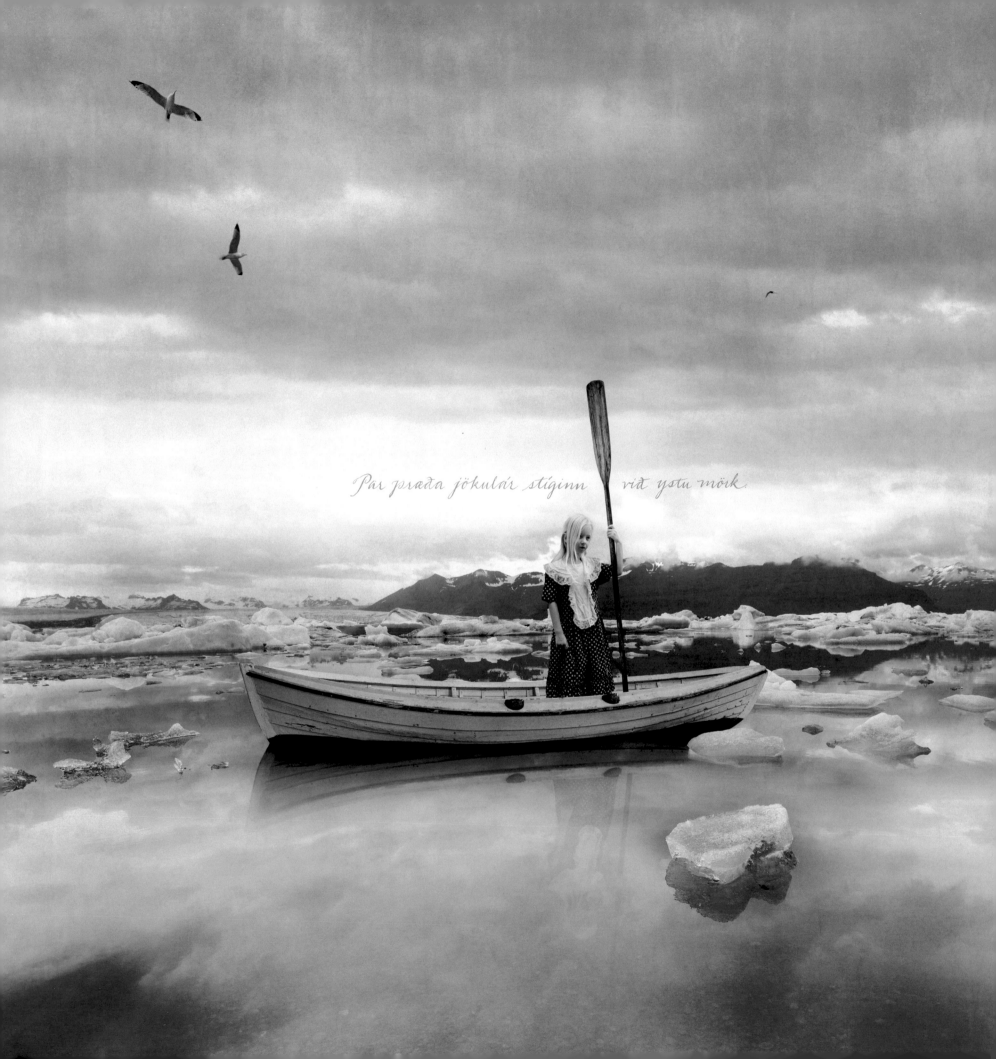

Þar þræða jökulár stíginn við ystu mörk.

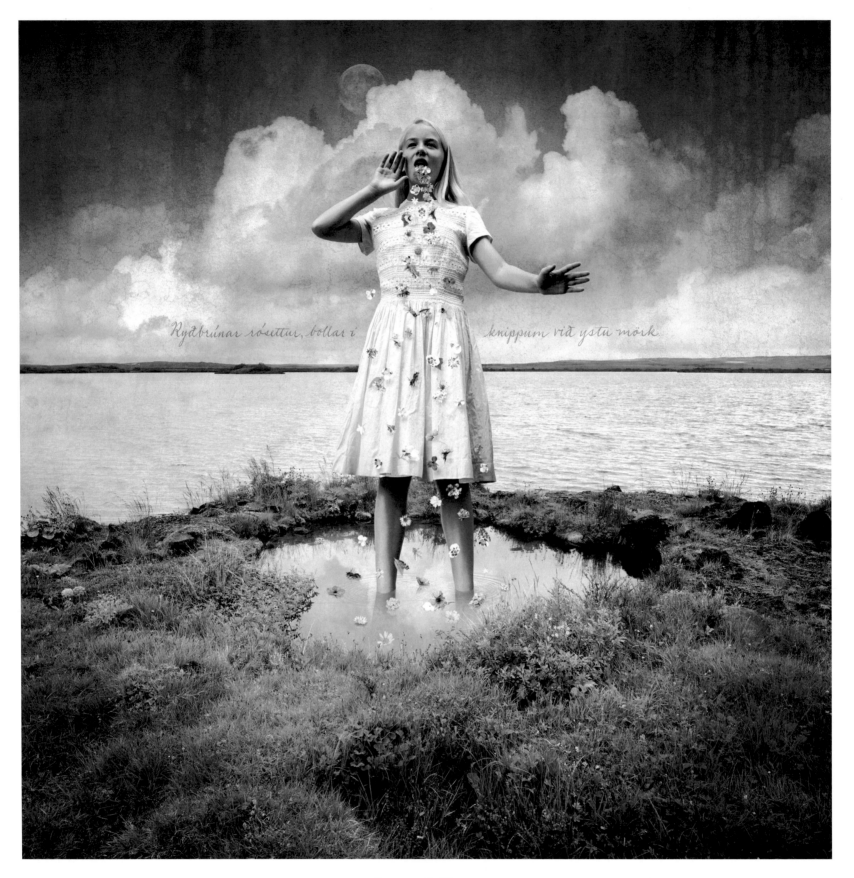

Summer Soliloquy

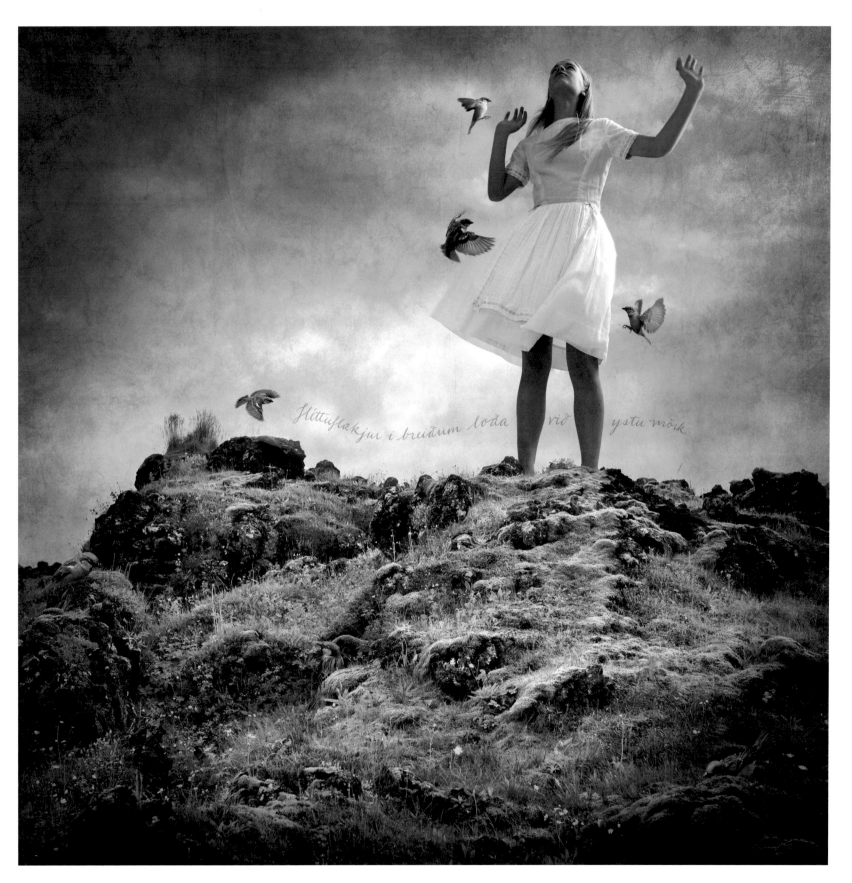

Clouds Touch Stone

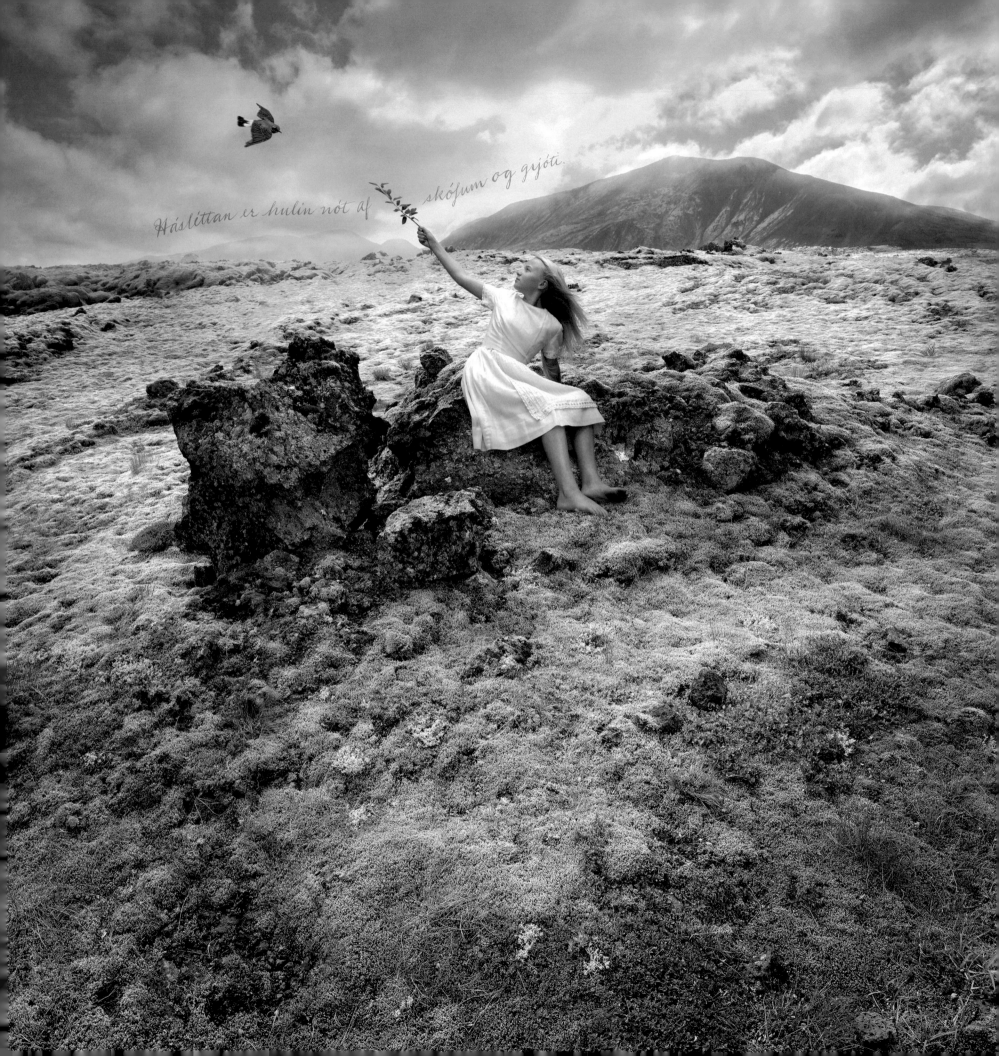

Háslíttan er hulin nót af skófum og gjóti.

Last Bough

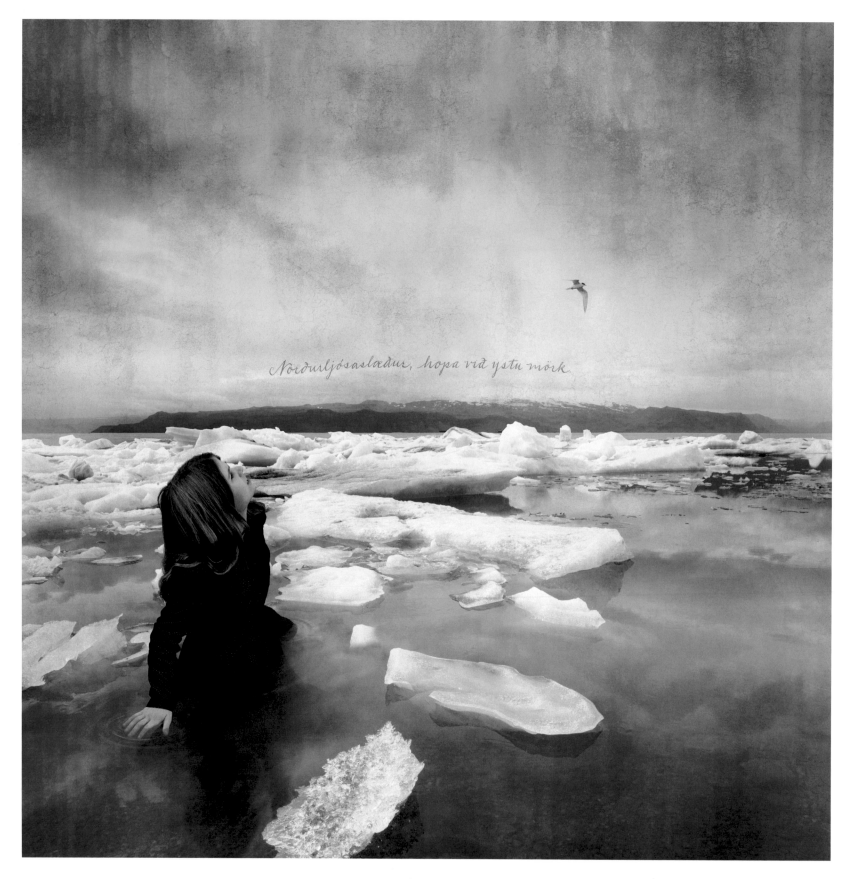

Aurora

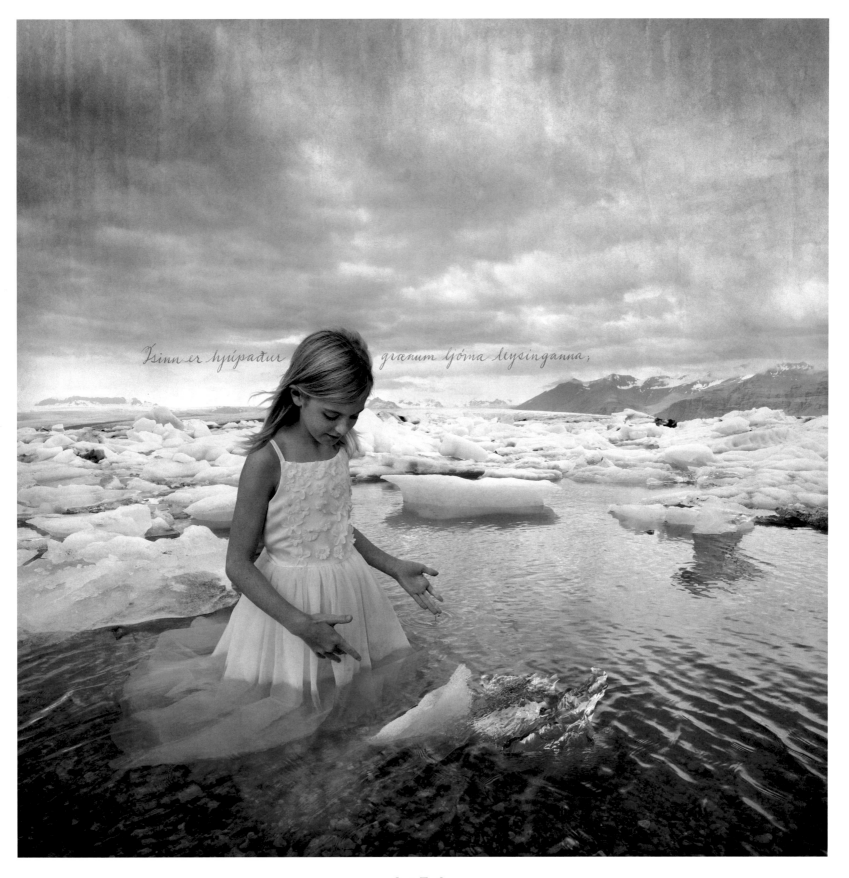

Ísinn er hjúpaður grænum bjarma leysinganna;

Out To Sea

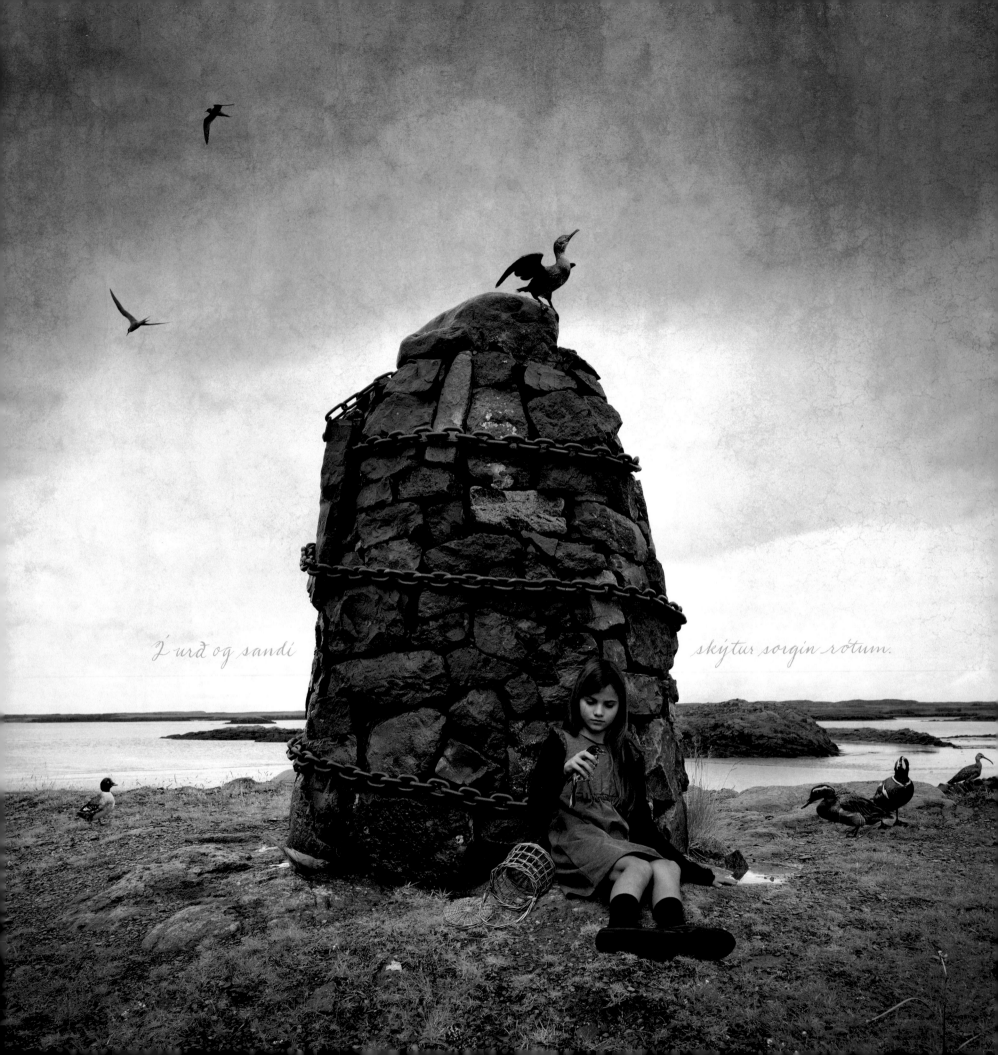

Í urð og sandi skýtur sorgin rótum.

Stone And Sand

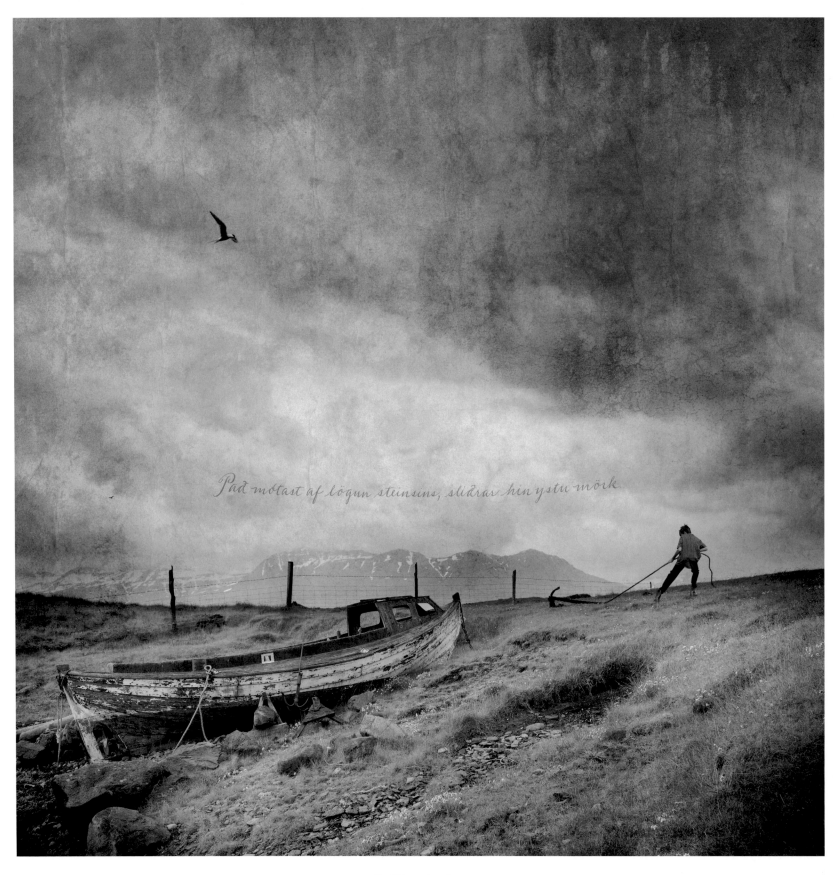

Pað mótast af lögun steinsins, sliðrar hin ystu mörk

Pulling Anchor

Right: *Object Of Curiosity*

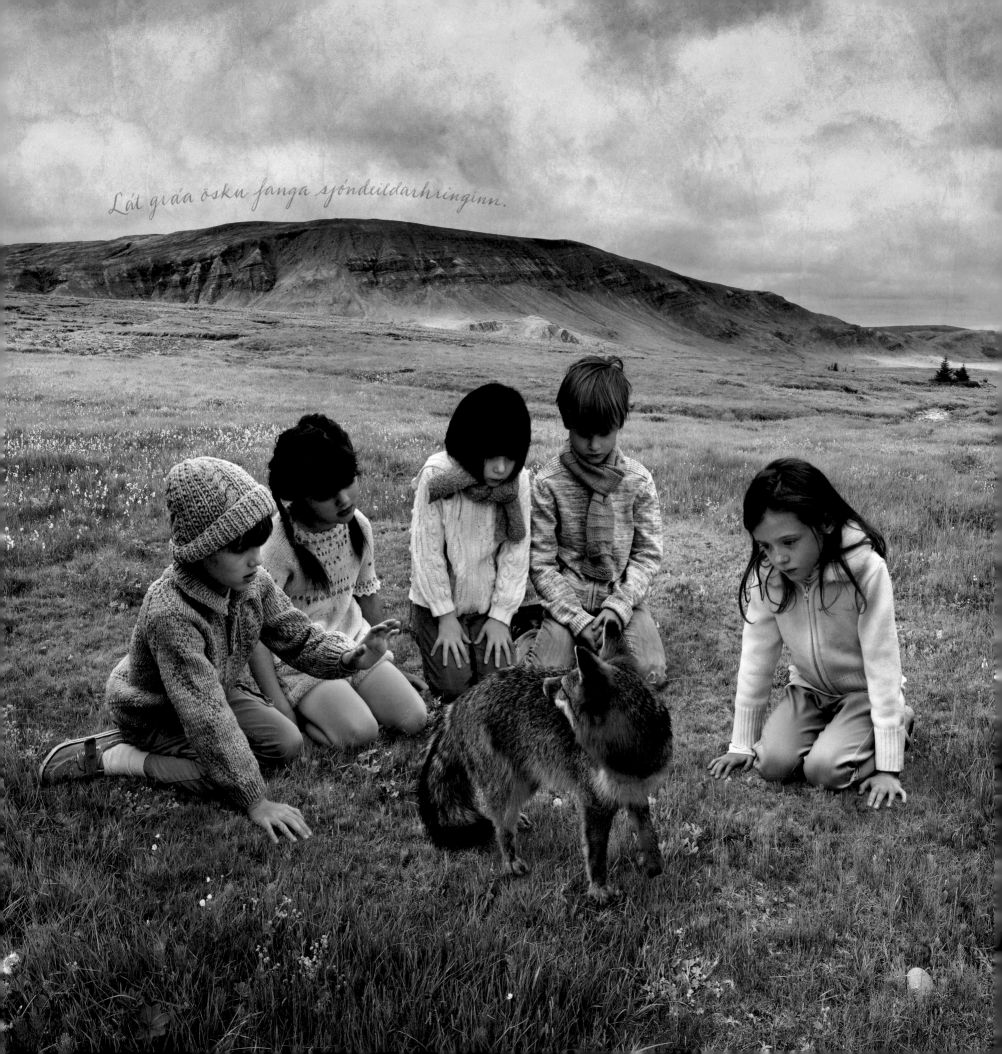

Lát gráa ösku fanga sjóndeildarhringinn.

The Trickster

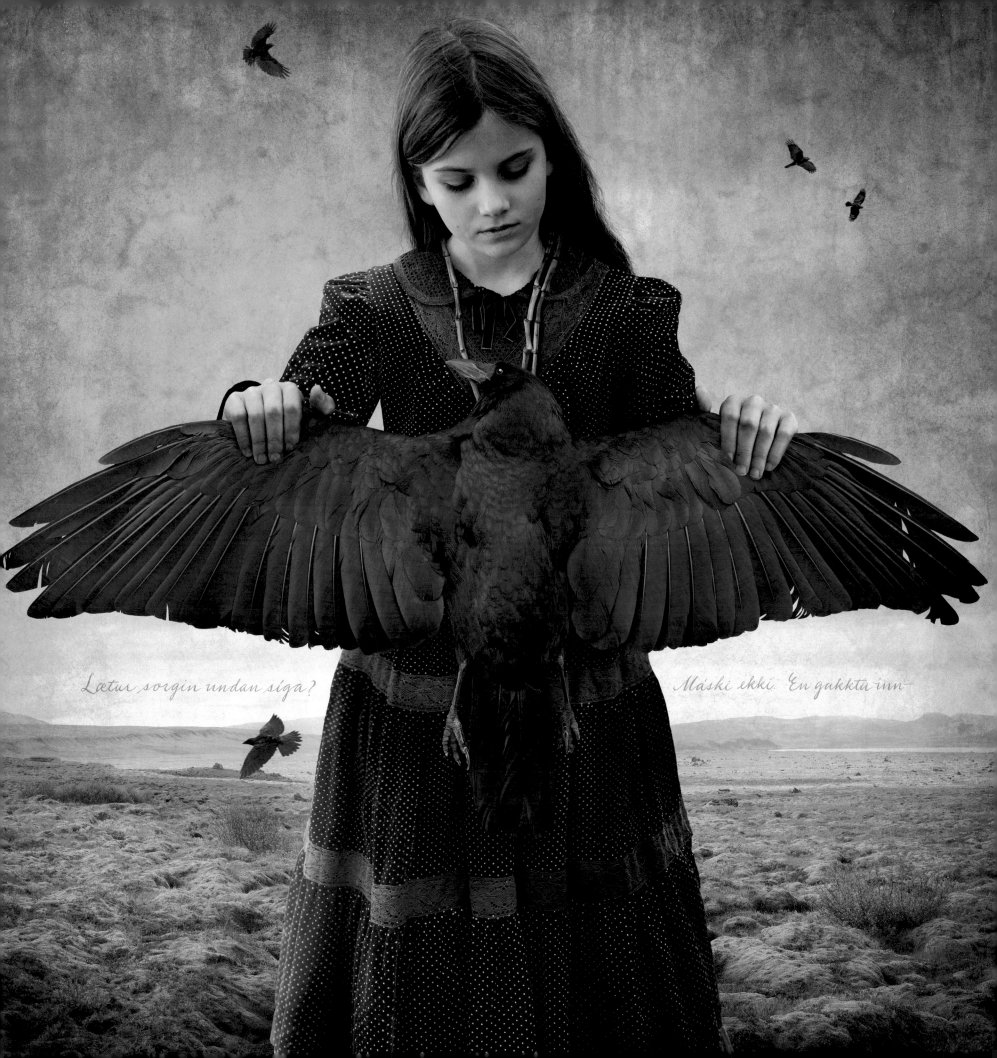

Lætur sorgin undan síga? *Máski ekki. En gakktu inn—*

Still Beating

2015

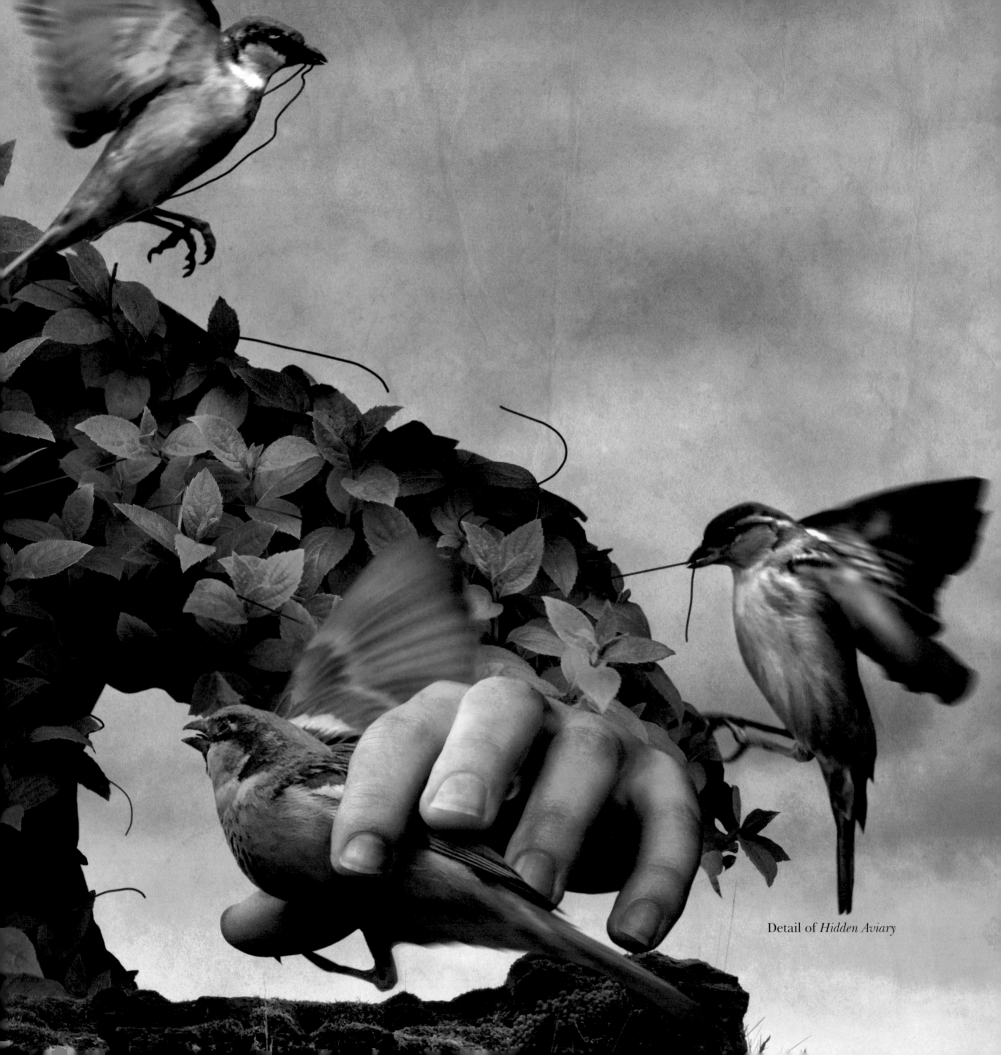

Detail of *Hidden Aviary*

Still Beating

Narrative Art refers to visual imagery which tells stories,
engages the imagination, and stirs the emotions. These stories transcend
culture and are relatable to all. My photomontage is narrative
art which additionally uses magic realism. Magic realism creates stories
which seem both true and believable, but likely are improbable.

Using magic realism, "Still Beating" presents narrative imagery about
the vitality of all living things whose survival is challenged. These living things
are the embodiment of contrasts, both weakness of body and
strength of emotions. As you hold a wild bird in your hand, you can feel both
its fragile bones contrasted with the fortitude of its beating heart.
And yet such creatures prevail through sheer grit. Witnessing the determination
for survival is a source of hope that the natural world will endure.

. . .

After You, Me

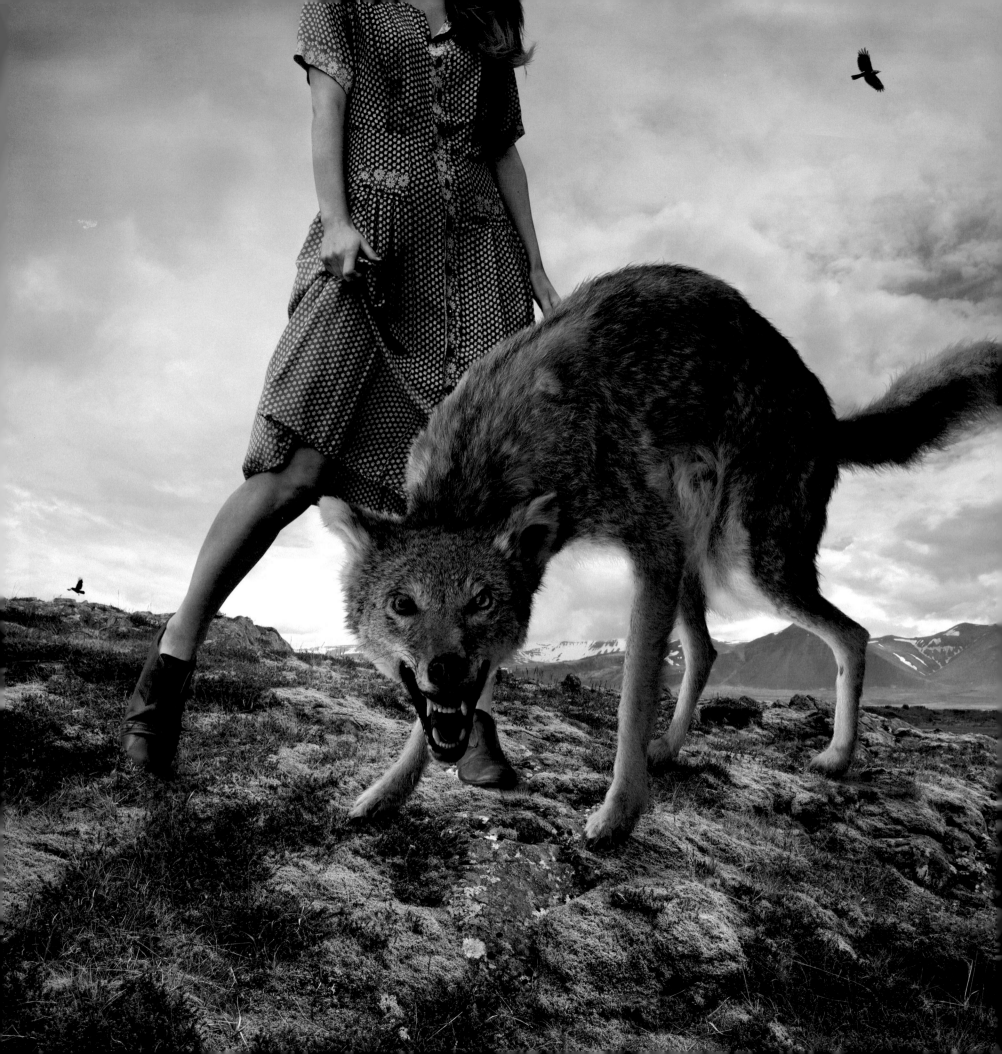

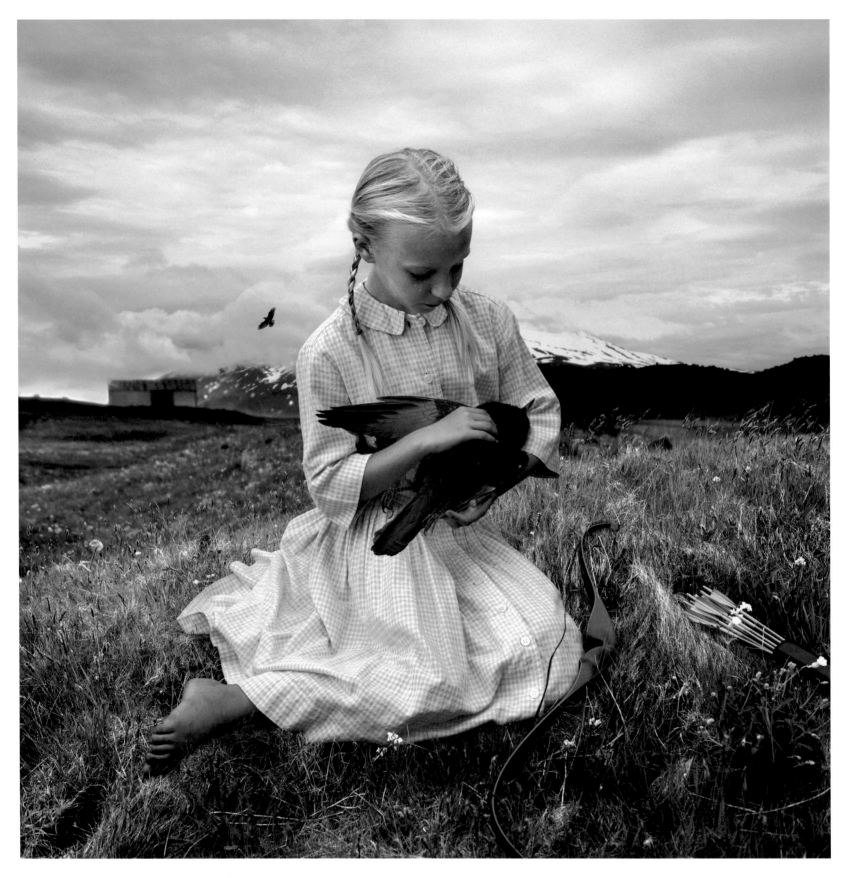

No Glory In Regret

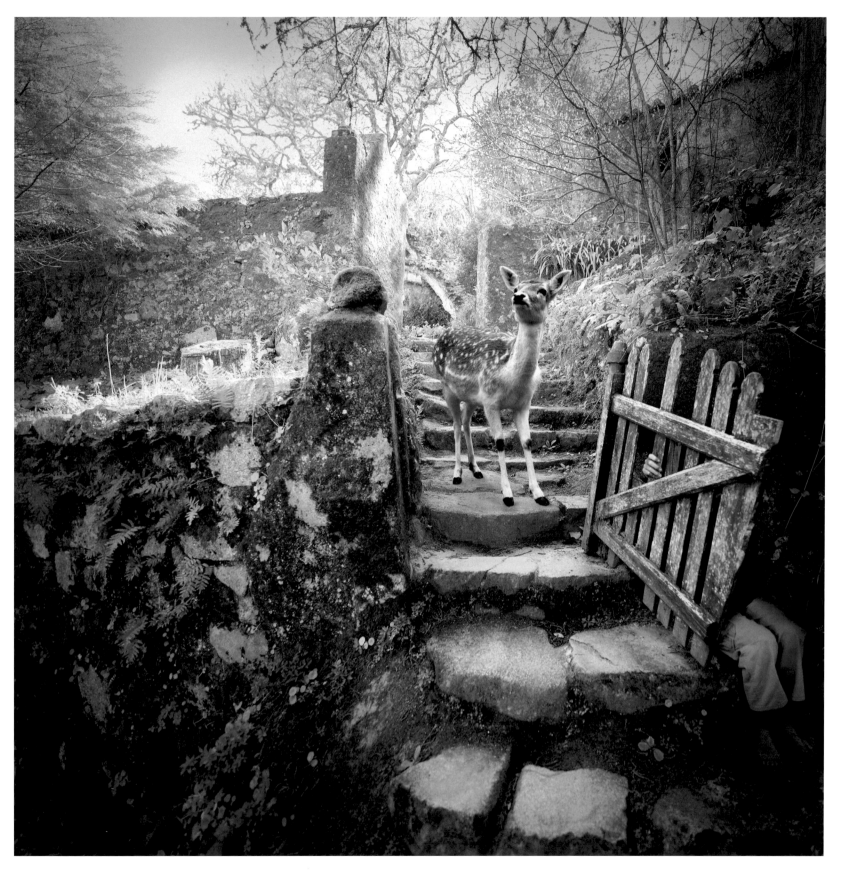

Garden Gate

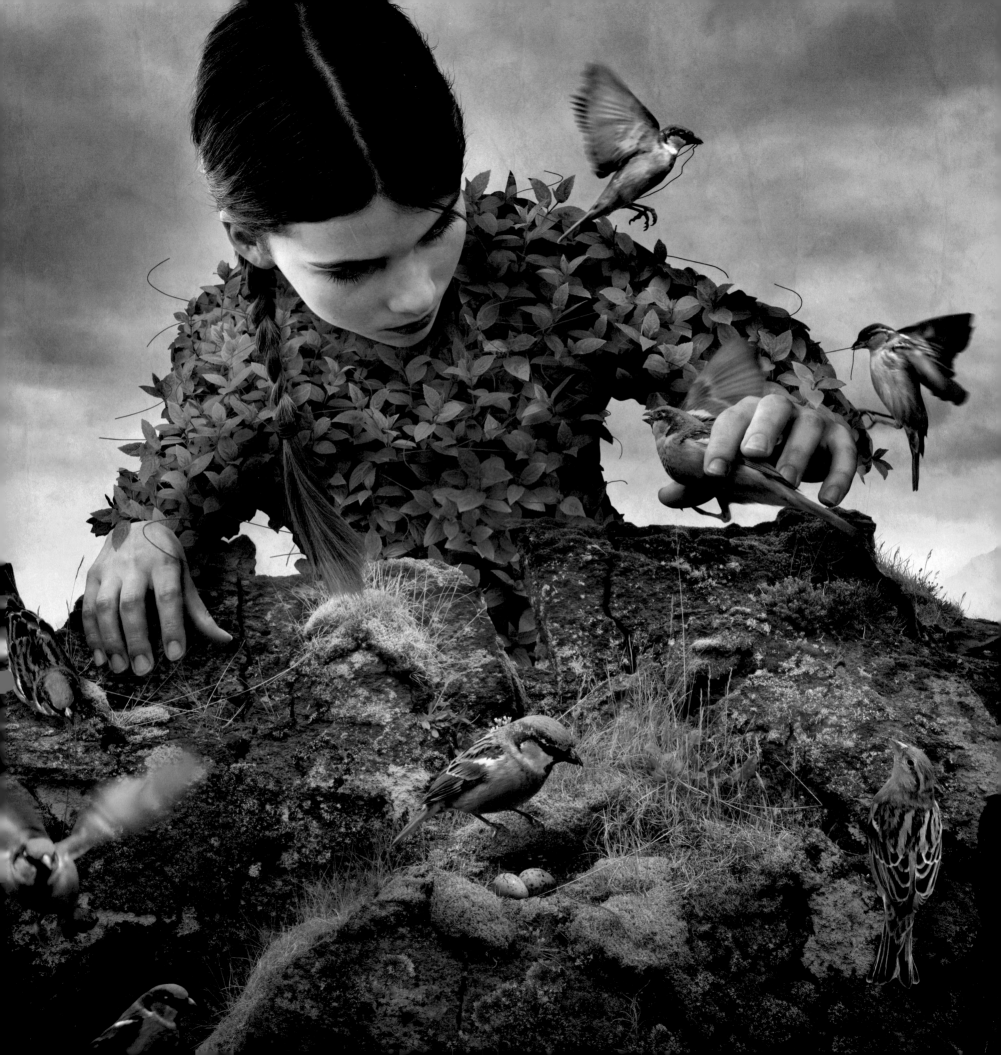

Hidden Aviary

Where Salt Meets Sky

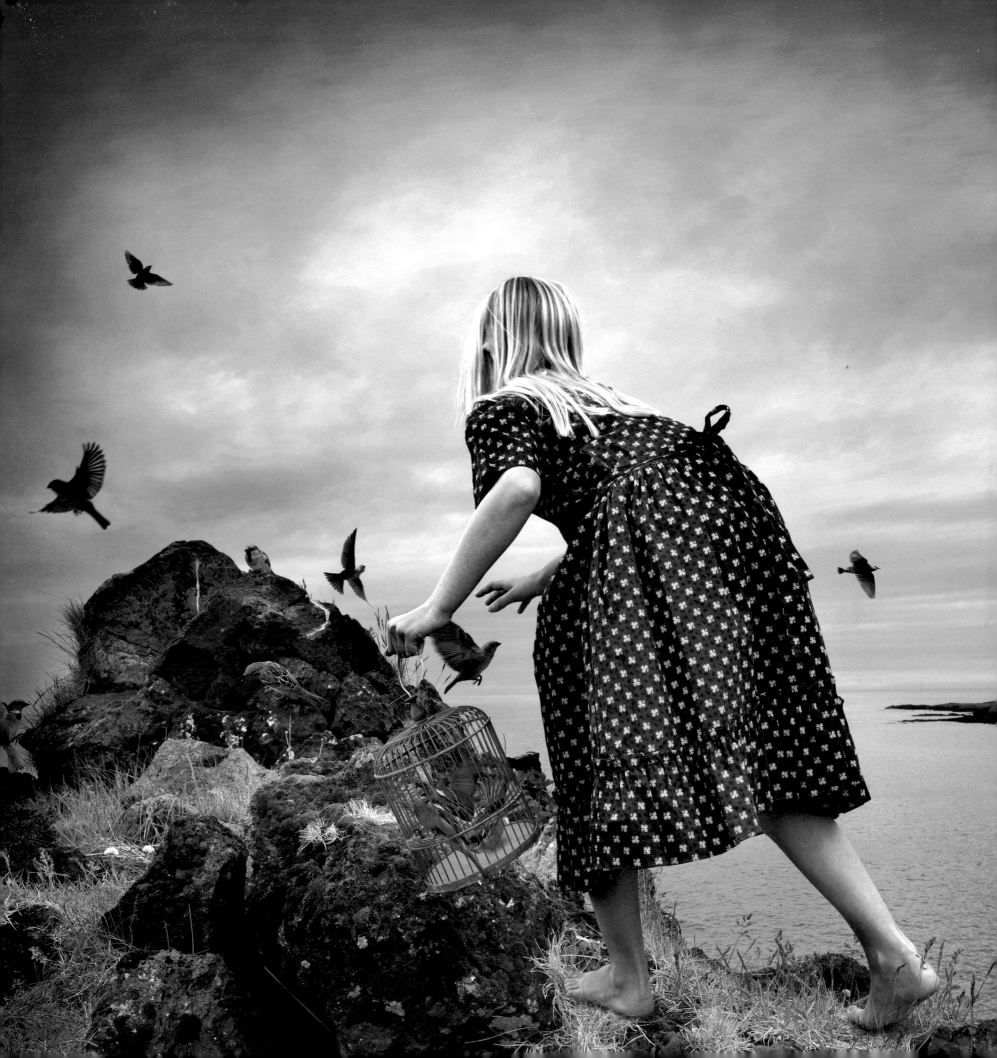

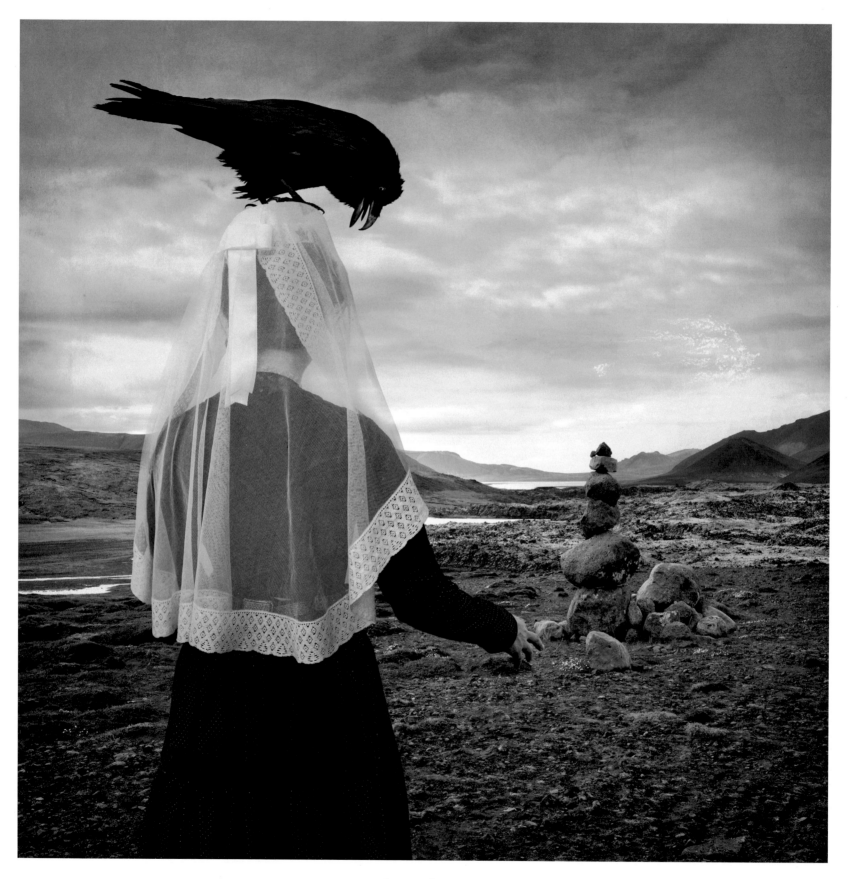

Come What Is

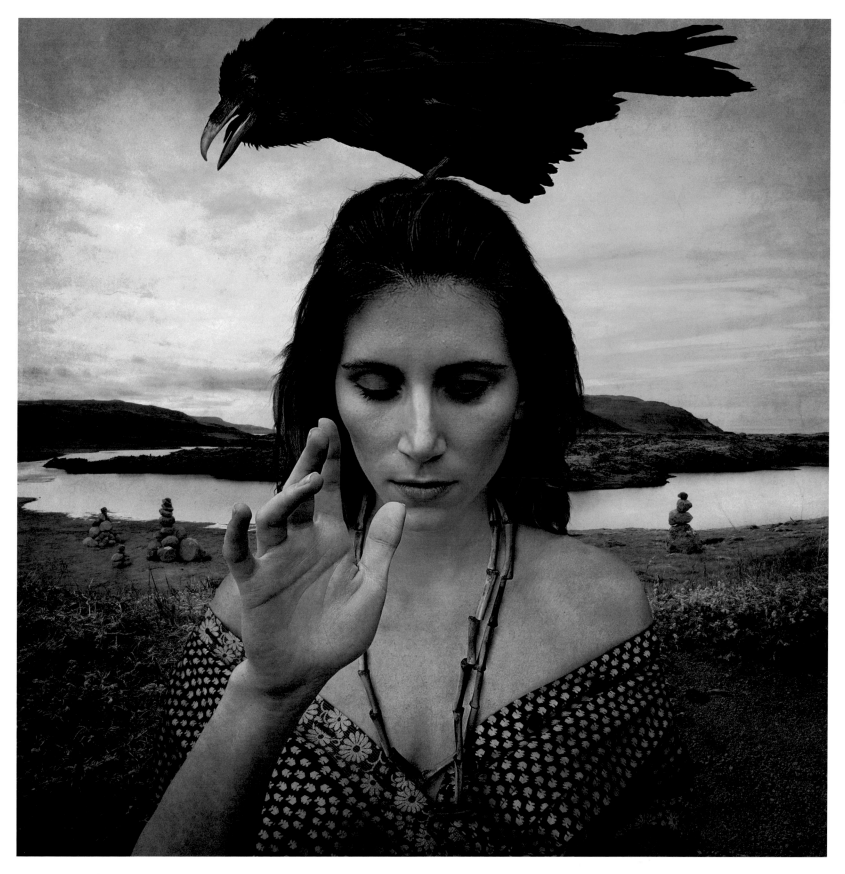

Totem

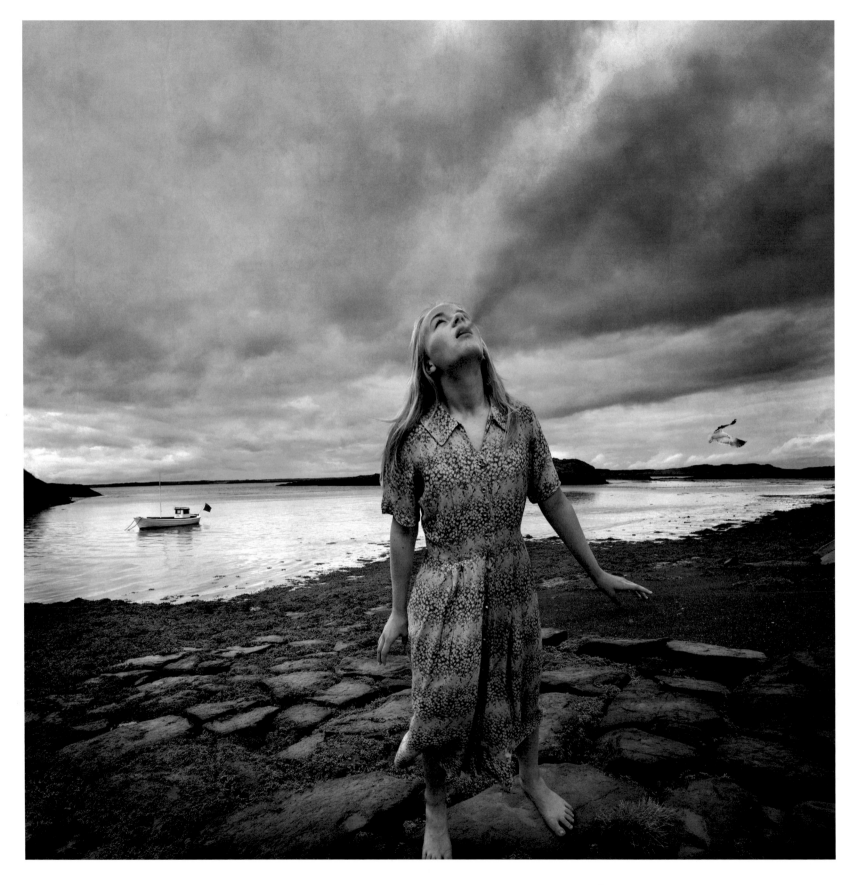

Storm Warning

Right: *Black From Blue*

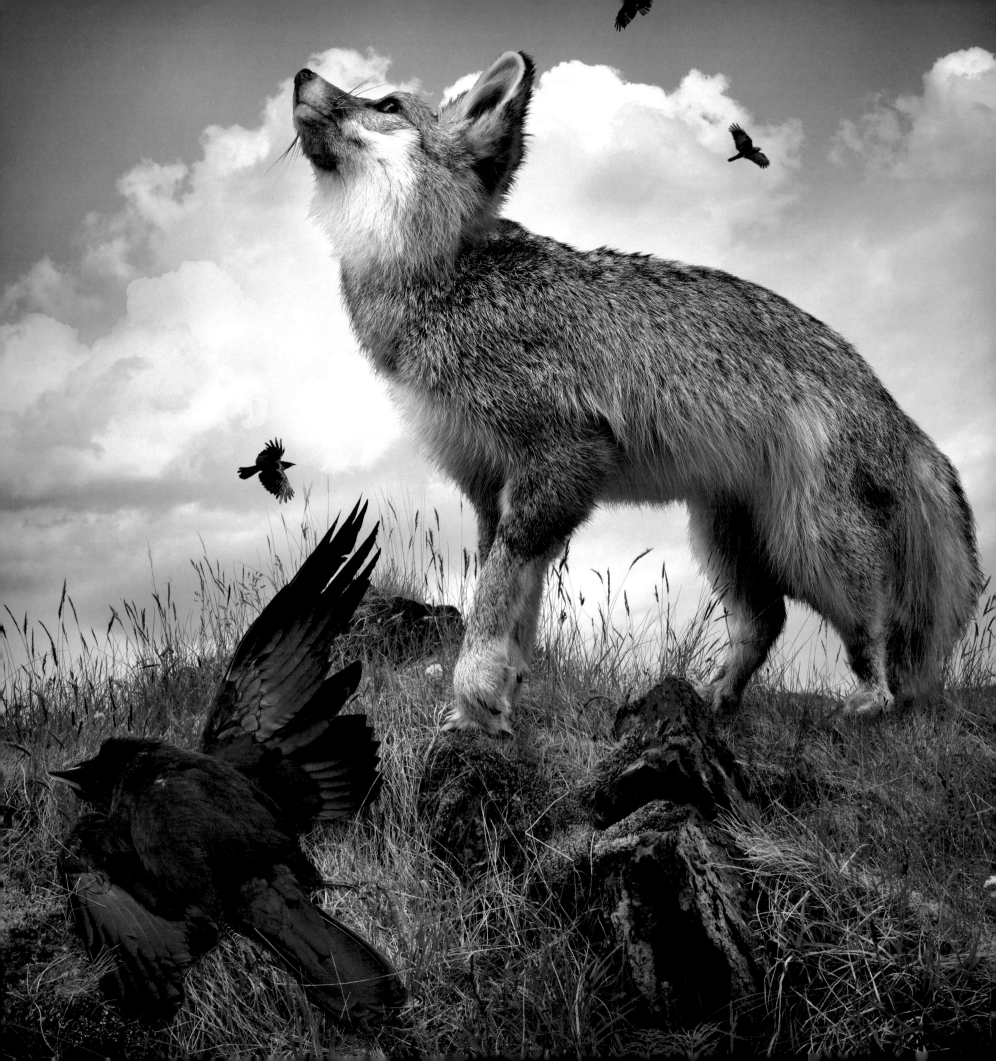

Fire And Ice

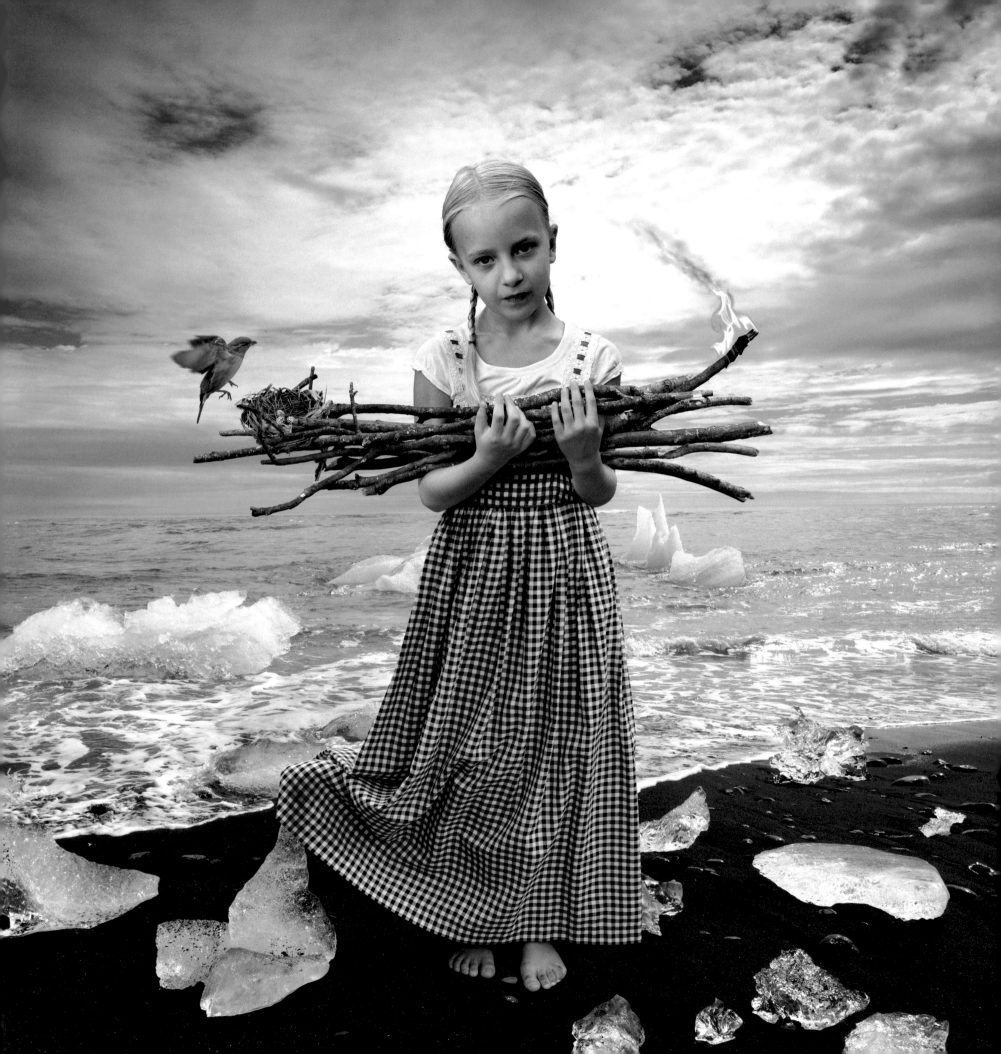

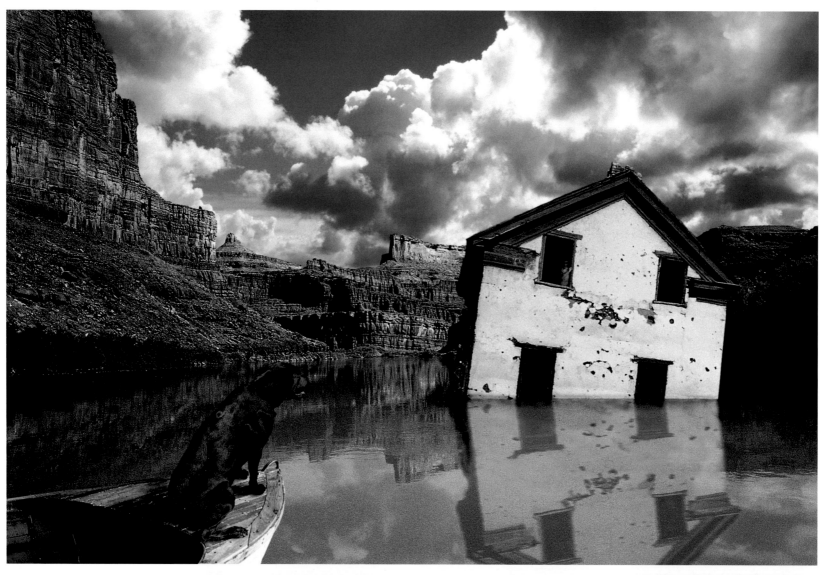

The six photos to the right
contain elements used to
construct the 2002 image,
Black Dog's Retreat, above.

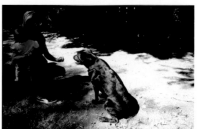

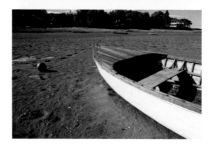

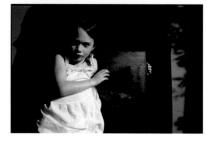

A Photomontage Journey

I grew up on a farm in Amish country, near Lancaster, Pennsylvania. The farm belonged to my grandfather and included 82 acres of rolling hills built for crops and cattle, a parcel of which was originally part of William Penn's Land Grant. My grandfather was a painter who did illustration work for books and magazines such as *Collier's*, *Philadelphia Inquirer*, and *Maclean's* in the 1920s through 1940s. My earliest memories of adventures on the farm include time spent in my grandfather's studio, amidst smells of turpentine and oil paints. A corner of the house contained folders of reference materials such as clippings of illustrations or photos of the human figure or animals in various poses. I remember that my grandfather spoke of another illustrator who visited our farm, a painter named N.C. Wyeth who brought along his "quiet boy" Andrew. I took all of this for granted at the time and had no inkling that later my career would take a path similar to my grandfather's.

In the early 1980s I attended the Ringling School of Art and Design in Florida where I majored in graphic design, which included a heavy emphasis on photography. I had a challenging teacher who was friends with Warhol in the 1960s and who pushed his students to experiment with weird, off-the-wall images. The stranger the better was his motto. A computer illustration class was offered, which consisted of a low-level drawing software and involved photographing the final work with a Polaroid camera and hood directly from the computer screen. I remember wondering if computer illustration would ever amount to anything substantial. It all seem so far-fetched.

In the late 1980s I worked as an art director for an ad agency in Richmond, Virginia. The agency purchased Photoshop 1.0 when it was first released. I recall experimenting with such things as duplicating an eye and placing it in the middle of a forehead. Eventually the software improved and allowed the ability to use multiple image layers and adjustment layers. At this point the software became exciting to me, which prompted me to experiment with adding extra images or elements into vacation photos. I could envision that this tool Photoshop might be something that would make its way into the fine art field. So, I created a series of fifteen images held together by subject matter, presented them to a local gallery and had my first solo show in 1998.

Working within a series is an important way to present work to galleries and I continue to do that today. Coming up with ideas for photomontage images is tricky. When creating an image there is a fine line to walk between reality and the surreal. Images created with Photoshop can easily go too far and become corny. I typically sketch an idea in a small thumbnail size which leaves plenty of room for interpretation. Then, I photograph the elements and background for the image using a D800 Nikon and combine them in Photoshop software on a Macintosh computer. After this I search through the raw images and choose ones which work well together. This is very similar to what my grandfather did with his reference material. The analog meets the digital. On the opposite page I have shown images which were used to make up the final montage image, *Black Dog's Retreat*.

I have been making photomontage images for twenty-eight years. It has served as a personal creative outlet and opened up opportunities to meet interesting people. I am wondering what the next twenty years will bring to the field of photography, which has experienced explosive growth as a fine art. It seems as though the software for still images has maxed out for now, so what will be next? Over time, the field of photography has splintered into many sub-genres and new tools have been developed that have allowed more and different ways of expressing oneself creatively. I suspect there will be many more to come.

Exhibition Highlights

Solo Exhibitions

(4) Chase Young Gallery, Boston, MA, October 2018, June 2014, October 2011 and May 2008

Themes+Projects, San Francisco, CA, July–August 2016

Gilman Contemporary, Ketchum, ID, August 2015

(4) Photo-eye, Santa Fe, NM, November 2018, July 2014, August 2011 and July 2007

Modernbook Gallery, San Francisco, CA, March–June 2012 + *Entropic Kingdom* book release

(2) Wall Space Gallery, Santa Barbara, CA, March 2011 and August 2007

Galería Clave, Córdoba, Spain, June 2009

National Museum of Photography, Bogotá, Colombia – Fotográfica Bogota, May 2009

Oswald Gallery, Jackson, WY, September and October 2008

George Billis Gallery, Los Angeles, CA, December 2007

Staunton-Augusta Art Center, Staunton, VA, September 2006

(2) OK Harris Gallery, New York, NY, October 2005 and December 2000

ArtSpace Gallery, Raleigh, NC, August 2005

Main Art Gallery, Richmond, VA, February 2001

University of Virginia, Charlottesville, VA, March 1998

Fellowships

Professional Fellowship, Virginia Museum of Fine Arts, May 2005

Visual Artist Fellowship, Virginia Commission for the Arts, December 2000

Collections

Santa Fe Museum of Art Santa Barbara Museum of Art

Museum of Contemporary Art (MOCA), Bangkok, Thailand

National Museum of Photography, Bogotá, Colombia Bronx Museum of the Arts, NYC

City of Jacksonville, FL - Art in Public Places The Comer Photography Collection, University of Texas

Houston Methodist Experience, Houston, TX University of Colorado Boulder (Special Collections)

The Channing Gilson Collection, California State Polytechnic University Texas Photographic Society

Royal Caribbean Cruises Sir Richard Branson, personal collection

Other Honors

World Photography Gala Awards (WPGA) Artistic Advisory Board, appointed May 2010

Builder of FOTOMUSEO, National Museum of Colombian Photography

Books

Hearts and Bones, Unicorn Publishing, London, UK, October 2018

Werkdruck No. 6, Illumination Series, Galerie Vevais, May 2015

Entropic Kingdom, Modernbook Editions, April 2012 ("Best Books: 2012" Photo-eye)

Dreaming In Reverse, Portfolio Box, Photo-eye Gallery, August 2011

List of Plates

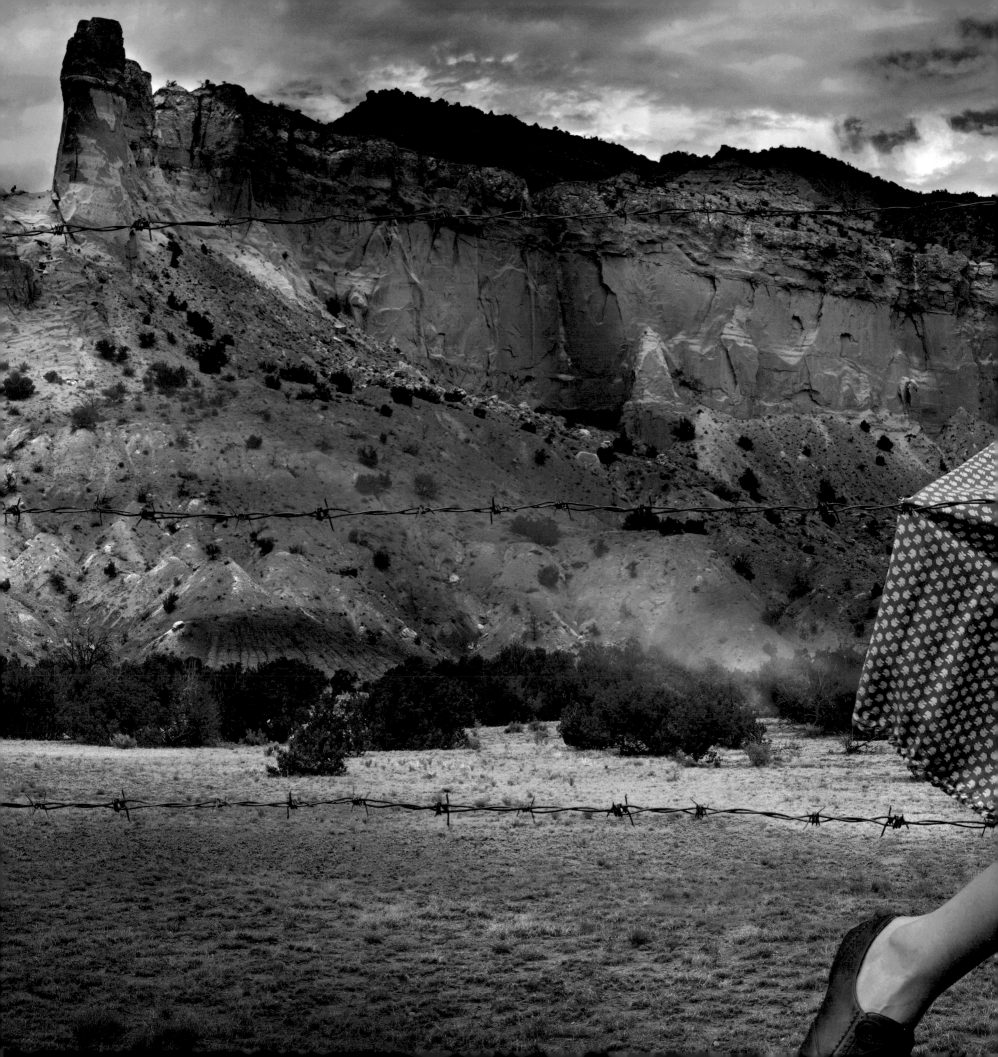

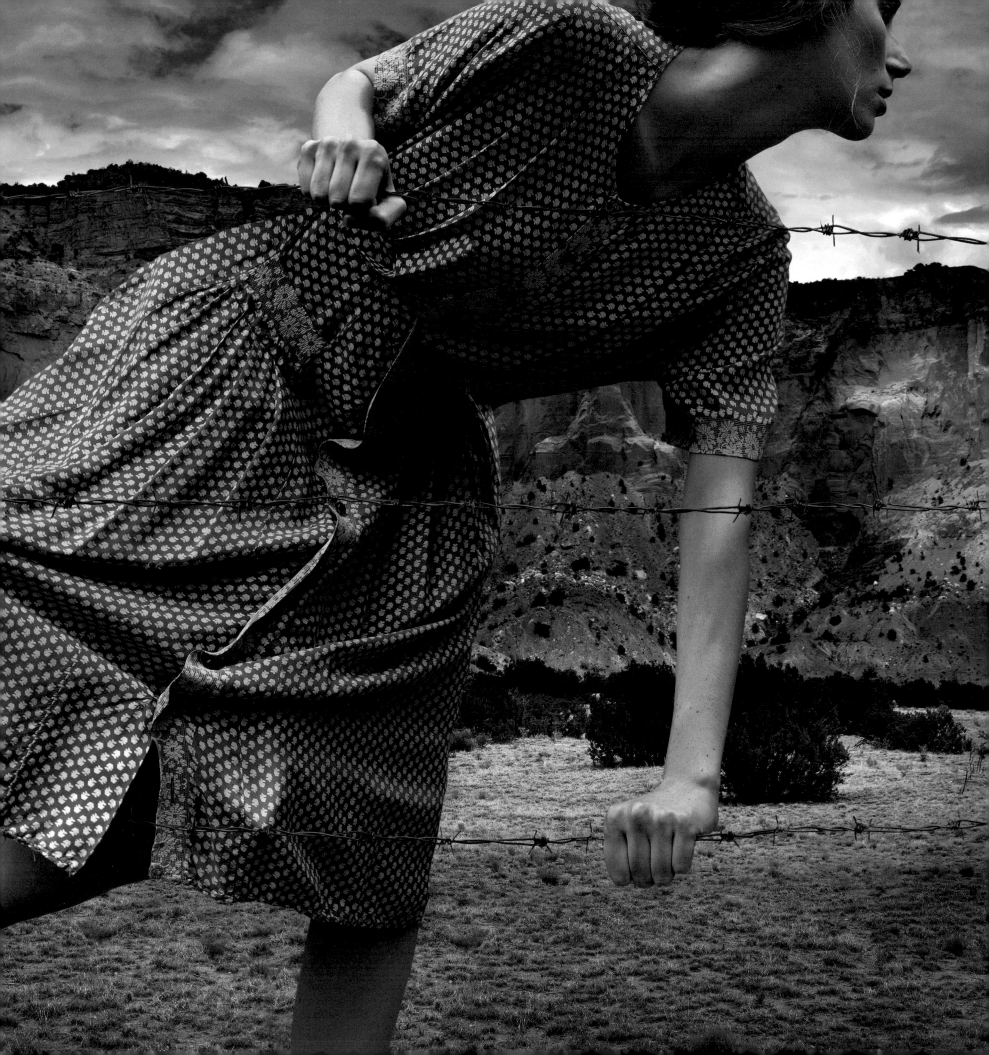

Burning Adoration

Preceeding page: *Faraway Nearby*